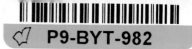
Hayward Gallery, London
13 December 1974–23 February 1975

Leicestershire Museum and Art Gallery,
Leicester
8 March–6 April 1975

Walker Art Gallery, Liverpool
25 April–25 May 1975

British Sporting Painting
1650-1850

The Arts Council of Great Britain 1974

© 1974 The Arts Council of Great Britain

Catalogue designed by
Herbert Spencer and Christine Charlton
Printed in the Netherlands by
De Lange/Van Leer, Deventer

Soft cover ISBN 0 7287 0037 a
Hard cover ISBN 0 7287 0038 7

Exhibition officer: Janet Holt

Cover:
43
George Stubbs
Gimcrack (detail)

Contents

Preface

Recent years have seen a remarkable growth of interest in British sporting painting both as an art form – or range of art forms – and as social history. We hope that an exhibition of this size and scope will indicate the attractiveness of sporting art to the wider public. We are extremely grateful to Lord Dufferin for accepting our invitation to select the paintings for this exhibition. He has travelled extensively in the British Isles and brought together pictures many of which have never been seen outside their owners' houses. Mr David Coombs, editor of the *Antique Collector*, has selected and catalogued the prints and Mr Howard Nixon has selected and catalogued the books.

Sir Oliver Millar has helped us most generously with information and advice and has written the extremely interesting and useful introduction that follows. The paintings catalogue has been prepared by Miss Mary Webster and Mr Lionel Lambourne; for practical reasons they were not able in each instance to examine the painting and have had to rely on information kindly supplied by the owners.

Her Majesty the Queen has graciously allowed us to borrow pictures from the Royal Collection. Special mention must also be made of Mr Paul Mellon, the Stewards of the Jockey Club, the Duke of Portland and the British Museum for generously lending to our exhibition. Altogether, we have received very warm support from many lenders; we have listed on page 158 those who did not prefer to remain anonymous. A version of the exhibition will be seen at the Leicestershire Museum and Art Gallery and the Walker Art Gallery in Liverpool.

We would like to join Lord Dufferin in thanking Mr David Coombs for undertaking the print section, Mr Howard Nixon the book section; and for various kinds of help and support: Sir Geoffrey Agnew, Mr David Alexander, Mr Howard Blackmore, Mr Claude Blair, Miss Sally Budgett, The Marquess of Bute, The Dowager Marchioness of Cholmondeley, Mrs H.Fayes, Mr David Fuller, Mr Alfred Gates, Mr R.G.Hollies Smith, Mr Simon Jervis, Mr Peter Johnson, Mr Henry Joyce, Lady Lambton, Mr R.W.Lightbown, Mr Roy Miles, Mr Peter Moore, Mrs Penny Morris, Mr A.V.B.Norman, Miss C.-A.Parker, Mr John Sabin, Miss Jennifer Sherwood, Miss Stella Walker and the staff of the London Library, the National Portrait Gallery, the Library of the Victoria and Albert Museum.

Robin Campbell, Director of Art
Norbert Lynton, Director of Exhibitions

Introduction by Oliver Millar

In the sixteenth chapter of *The Complete Gentleman*, first published in 1622, a chapter devoted to *Exercise of the Body*, Henry Peacham describes a reputation for horsemanship as an attribute 'of kings and princes, whose delight in ancient times was to ride and manage great horses'. 'Hawking and hunting' he writes, 'are recreations very commendable and befitting a noble or gentleman to exercise'. Repeating the commendations of such earlier writers as Castiglione and Sir Thomas Elyot, he cites the opinion of Eusebius (as well as adding the example of 'old Lord Gray, our English Achilles') 'that wild beasts were of purpose created by God that men by chasing and encountering them might be fitted and enabled for warlike exercises'.[1] It is from this period that we can date the beginning of sporting painting in England. The Tudors and the earlier Stuarts were devoted to the chase and James I's two sons, Henry, Prince of Wales, and his younger brother who came to the throne as Charles I in 1625, were expert horsemen. Elizabeth I, moreover, had gone to race-meetings at Croydon and on Salisbury Plain; James I developed Newmarket and in 1616 bought for £154 the Markham Arabian, ancestor of the modern thoroughbred.

Royal enthusiasm for the chase is first recorded on a large scale in Robert Peake's two portraits of the elder Prince (no. 1) in the hunting-field with a boon companion, a composition which takes up the theme of one of the woodcuts in George Turberville's *Noble Art of Venerie or Hunting* (1575) in which Elizabeth I stands with hunting-knife poised over a stag.[2] Paul van Somer's portrait of Queen Anne of Denmark dressed for the chase in the park at Oatlands in 1617 is an obvious sequel and also the immediate predecessor, and to some extent the source, for the most beautiful sporting portrait ever painted in England: Van Dyck's portrait (in the Louvre) of Charles I *alla ciasse*. The significance of his great equestrian portraits of the King and of Le Sueur's equestrian statue at Charing Cross lies to a great extent in their deliberate statement of the King's 'delight in the use of the great Horse, whom already dressed, no man doth more skilfully manage; or better break, if rough and furious.'[3]

Connoisseurs at court in the reign of James I had been interested in Rubens's magnificent hunting-pieces, which take up the themes as well as the heroic scale of Van Orley's hunting-scenes at the court of Maximilian I: and a *Caccia* from Rubens's studio was acquired for the Prince of Wales in 1621. It is essential to emphasise the importance of Flemish influence in the beginnings of English animal and sporting painting. It is an influence that persists down into the nineteenth century and can even be detected in Stubbs. Gainsborough's late *Greyhounds coursing a Fox*[4] is a nostalgic essay in the style of Snyders; the brushwork in James Ward's landscapes often reveals his admiration for the technique of Rubens and Teniers; and Landseer's early masterpiece, *The Hunting of Chevy Chase*[5], which he exhibited at the Royal Academy in 1826, is a brilliantly sustained tribute to the Flemish hunting-pieces which early seventeenth-century collectors had admired.

Life-size portraits of favourite horses are recorded from the later Tudor period. At Hatfield, for example, there still hangs a portrait of a large grey horse, painted in 1594, which probably belonged to Sir Robert Cecil[6]. John Aubrey noted at Wilton, at the end of the seventeenth century, 'the picture of Peacock, [a White Race-horse] with the Groom holding him, as big as the life. And to w^{ch} S^r Anthony gave many master-touches'.[7] The most important surviving set of early portraits of horses in England are traditionally attributed to another Fleming, Abraham van Diepenbeeck. Painted for that great authority on horsemanship, William Cavendish, Duke of Newcastle, they are still at Welbeck Abbey (nos. 3 & 4). There is, in fact, nothing stylistically to justify an attribution to Diepenbeeck, nor is there evidence that the painter was ever in England, although he was closely associated later with Newcastle during exile after his humiliation at Marston Moor. The backgrounds of some of the pictures contain charming views of Welbeck and Bolsover; and in the foreground of one there is a dog chasing a rabbit which foreshadows the work of Leonard Knyff.[8] Such huge pictures of favourite horses, moreover, must have been known to Stubbs, who painted at least two single portraits of horses on this large scale; and they anticipate the earliest of John Wootton's large pictures of single horses: the Countess of Oxford's dun mare which was finished in May 1715 (except for 'Thomas's sweet Face'); *Scarr* with his groom at Chatsworth (1714); or a comparable picture of the same period at Clandon.

Francis Barlow, the first native-born artist to specialize in animals and sporting subjects, emerges in England during the Commonwealth, while the exiled Newcastle was pursuing his studies of horsemanship in Antwerp and was living as a lodger in the house of Rubens's widow. William Sanderson wrote in his *Graphice* (1658) of those modern English masters 'comparable with any now beyond Seas' and included '*Barlo* for *Fowl* and *Fish*'. A few years earlier Richard Symonds had visited his studio in Drury Lane: 'he uses to make fowle & birds & colour them from the life'. Unlike his successors in this field, Barlow apparently 'paynts the ayre first then the cheife thing of his quadro afterward';[9] Stubbs, among later sporting painters, seems to have painted his animals and figures first and then to have worked the sky and the landscape up to them; and, in a picture on which Tillemans was working on the day before he died, one sees that the horse, groom and hounds have been finished, but that trees, landscape and foreground have been merely sketched in.[10] Barlow's most ambitious works, three large canvases painted to decorate the hall of Sir Denzil Onslow's house at Pyrford (one is dated 1667) are studies of country and farmyard life, perhaps remotely influenced by Hondecoeter and not strictly speaking sporting paintings; but he painted for the same patron a frieze-like canvas of Southern-mouthed hounds (no. 7). The idea of decorating the hall of a country house with large subjects of this kind foreshadows the hunting scenes which Wootton was to paint for Althorp, Longleat and Badminton. A parallel on the Continent would be the set of decorative hunting scenes

26
James Seymour
The Chaise Match

painted by Jan Miel (the dates on them run between 1659 and 1661) for Charles Emmanuel II of Savoy and now in the Palazzo Madama at Turin.

It is in his drawings and prints (nos.221, 222, 320–322) that Barlow made his most important contribution to the development of sporting paintings: in a succession of spirited designs where gentlemen are engaged in a variety of lively sporting activity fairly successfully integrated with the country setting and not, as with the huge horses at Welbeck, set against a stage landscape or a topographical backdrop. There is in Barlow the same unforced quality in sporting episodes that occurs in the work of Jan Siberechts, in contrast with the florid theatrical hunting-pieces and scenes of fighting animals by Abraham Hondius which represent the culmination of the tradition founded by Snyders. Barlow's prints and drawings provide a visual parallel with the account of Sir Roger de Coverley's coursing of the hare in 1711: 'the Brightness of the Weather, the Chearfulness of every thing around me, the *Chiding* of the Hounds . . . the Hollowing of the Sportsmen, and the Sounding of the Horn, lifted my spirits into a most lively Pleasure'.

Isolated sporting and animal pictures are found in the later Stuart period. A famous greyhound (no.8) was painted, with the collars he had won hung on a tree behind him, by the shadowy painter Otho Hoynck; fish of fabulous proportions were painted, such as the 'great Trout that is near an ell long' whose portrait was at *The George* at Ware;[11] Celia Fiennes saw at Newby Hall a painting of a large ox which had been 'fed in these grounds';[12] and many topographical pieces of the period are sprinkled with hawking-parties or little groups of huntsmen; but it is not until the end of the Stuart period that John Wootton emerges as the first English painter who in the course of a long painting career produced a considerable number of sporting subjects.

He is the earliest sporting artist in England whose career and circumstances can be reconstructed in some detail, whose principal patrons are known and whose methods can be studied. More cosmopolitan in outlook and training than Barlow, he was influenced by animal and battle painters of the Netherlands and, in his landscapes, principally by Gaspar Poussin. In his vigorously designed hunting scenes he comes close to Oudry and in some of his less formal compositions—made up of hounds, instruments of the chase and dead game – he can remind one, especially in his early manner, of Desportes. He painted many portraits of horses (the earliest often very large in scale), at a period when the principal thoroughbred lines were being established in this country, with the import of the three great sires, and when owners wished to record the horses they owned or had bred with the same thoroughness as they commissioned portraits of themselves and their families. Wootton painted many accomplished and airy hunting-scenes and developed the sporting conversation piece: a nobleman with his

family and servants drawn up for a moment at a recognisable spot on the estate and informal groupings of horses, grooms and dogs. These sporting subjects were in fact evolved by Wootton from the example of his predecessor, the Dutchman Jan Wyck with whose work Wootton's can frequently be confused. There is at least one English collection in which a close association between the two men can be demonstrated. Wootton's accessories, against which a horse or hounds would be set, and his landscape backgrounds, frequently have a general, unlocalized late baroque or rococo air, unless he was commissioned to paint a specific topographical scene: the race-course, the country round Henley or Goodwood, Badminton, Windsor Great Park or Orchard Portman. His compositions are more decorative than the drier, perhaps more deeply felt studies of Leonard Knyff,[13] whose paintings of hounds and game can, on the one hand, remind one of Barlow and, on the other, look forward to Stubbs or Agasse.

Barlow had produced a print (no.222) of the last race-meeting held, in 1684, at the Mead near Datchet Ferry, a course abandoned by Queen Anne in favour of Ascot; and Wootton (no.20) and Peter Tillemans were the first to paint the scene at Newmarket: races in progress, long panoramic views of the area with troops of spectators and coach-parties, and rubbing-down scenes which show for the first time the racing world in action. Tillemans's repertory was as wide as Wootton's, but his style is perhaps lighter and more rococo. His most important contribution to the development of the sporting genre was perhaps the shooting picture, such as the one at Thoresby which shows the Duke of Kingston with his pointers: a type to be developed in four magnificent compositions by Stubbs.

A contemporary described Wootton in 1741 as the highest-paid artist in England: 'a cunning fellow, and has made great interest among the nobility, but he is the dirtiest painter I ever saw.' But it is a surprise to read in Horace Walpole's *Anecdotes of Painting* that James Seymour 'was thought even superior to Wootton in drawing a horse'. With the work of Seymour, a talented amateur who received no professional training, and with painters influenced by him such as Thomas Butler (no.37), who ran a highly organised studio and shop in Pall Mall, Spencer, David Morier (no.31) and, to a lesser extent, the Sartorius family, the art-historian is faced for the first time with genuinely primitive painters whose work reveals almost nothing of the usual influences to which he can peg a thesis. Their careful observation, dry paint, linear rhythm and austere narrative sense can produce an eccentric air of unreality; but their work was highly prized by lovers of the turf and other sports at the time, for whose benefit they were repeatedly copied and further transmitted in large numbers by means of the sporting print.

It was such painters as Seymour (nos.24–30) and Butler (no.37) who had won for the English sporting painter a notice in André Rouquet's *L'Etat des Arts en Angleterre*: 'We may rank among the number of portrait painters, those who are employed in drawing the pictures of horses in England. As soon as the race horse has acquired some fame, they have him immediately drawn to the life: this for the most part is a dry profile, but in other respects bearing a good resemblance; they generally clap the figure of some jockey or other upon his back, which is but poorly done.'[14] The decade of the 1760s, when painters of the older generation were dead or nearing the end of their lives, is the watershed in the development of sporting painting in England. During this period Sawrey Gilpin and Stubbs exhibited regularly at the exhibitions of the newly-formed Society of Artists. It would be wrong to ignore the traditional elements in their subject-matter. Both artists produced portraits of horses with grooms; but even in Gilpin's earliest essays in this genre, in those tentative little images which he painted at Windsor when he was closely associated with the Sandbys in the services of the Duke of Cumberland, there is a new feeling for atmosphere and a more developed interest in the relationship of the animal to his surroundings. In their mature work Stubbs and Gilpin were fascinated by the temperament of animals and were repeatedly to experiment with the theme of animals at the mercy of the elements. Both men painted hunting-scenes. Stubbs's *Grosvenor Hunt* (no.41), on which he inscribed the date 1762, has superficial points of contact with Wootton – with for instance, the hunting-pieces painted for the Prince of Wales – but is also the most sublime of all English sporting pictures, a classic statement as a whole and in its marvellous detail on the very essence of hunting. The hunted animal is still the stag; but by now fox-hunting was becoming established all over the country. Artists were being commissioned to paint hunters and fox-hounds as well as famous race-horses and were beginning to record actual events in the hunting field. Gilpin exhibited his masterpiece in this vein *The Death of the Fox* (no.59), at the Royal Academy in 1793, and produced several other versions of it. Painted for a wildly enthusiastic Yorkshire sportsman, Colonel Thornton (no.80), it records with a new realism the savagery and violence at the end of a famous run of twenty-three miles. The hunting field – the meet, the run, the kill and the falls at fences and hedges, moments either comical or tragic – were soon to demand specialist treatment from the sporting painter and engraver. Both Gilpin and Stubbs developed a whole new range of subjects for their patrons, what has been described by Basil Taylor as a 'new abundance of pictorial ideas'. They developed the informal, more personal, less organised moments in the sportsman's world: quiet groups of sportsmen with their animals; huntsmen and animals moving off to the meet; scenes before or after a race at Newmarket; and – their most important innovation – variations on the theme of brood mares and foals (nos.47,56). Stubbs exhibited pictures of this subject at the Society of Artists from 1762, Gilpin from 1764, when he exhibited a painting of the brood mares belonging to his early patron, the

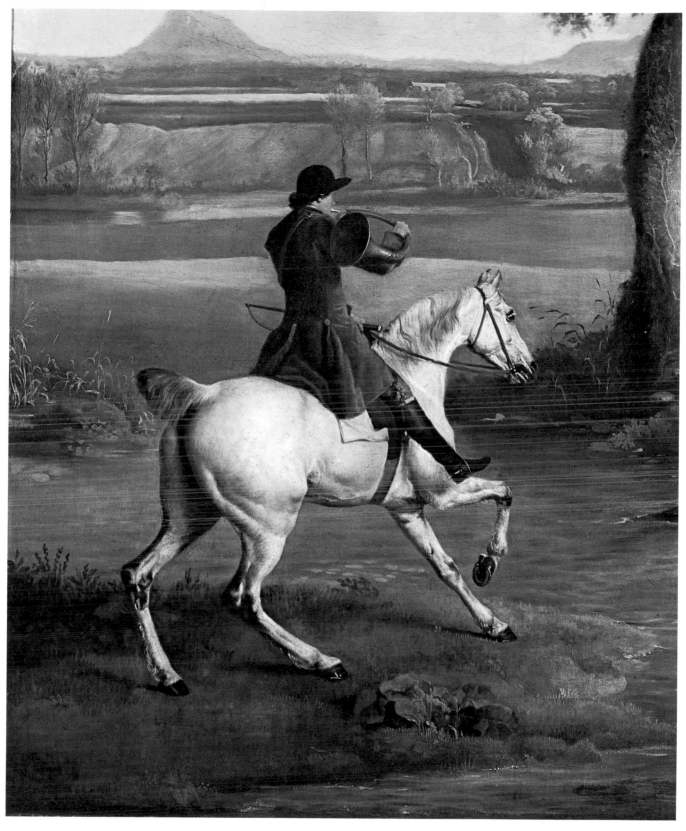

41
George Stubbs
The Grosvenor Hunt (detail)

Duke of Cumberland, who had played a prominent part in the founding of the Jockey Club in 1750. In 1771 Gilpin exhibited his masterpiece in this vein (no.61), in which the horses are informally grouped in a spacious and atmospheric environment which is also a charming record of their actual habitat in the shadow of the great trees in the Long Walk at Windsor. The interest of an enthusiastic group of aristocratic owners in the breeding of bloodstock provided Stubbs with the commissions for the series of mares and foals in which he varied the rhythms and moods within the groups of the animals themselves and the emotional emphasis which the setting could give: even, in one instance, leaving the background entirely empty. The magic of these lovely designs is partly dependent on Stubbs's, unerring, and unprecedented, knowledge of the structure and nature of the horse. In 1766 he published his famous treatise, *The Anatomy of the Horse* (no.349), which he hoped, in his introductory note, would be 'by no means unacceptable to those gentlemen who delight in horses, and who either breed or keep any considerable number of them.'

The unique position which Stubbs occupies in the English school as a whole, as well as in the sporting field, is to some extent the result of a paradox. He was an artist profoundly and humbly dedicated to observation, who studied with equal sympathy animals and the men who were occupied about them. He produced an infinitely varied series of colloquies between horses and the grooms, stable-lads and jockeys who hold them still or approach them with harness or sieves of oats. Every detail is observed with patient, loving naturalism. He was, unlike any of his predecessors in the sporting field, a profoundly sympathetic portrait-painter[15]. The trainer, stable-lad and jockey in his famous painting of Gimcrack (no.43) are among the most unforgettable images in British art. At the same time Stubbs developed a highly selective and refining sense of form in handling individual elements in a composition and a uniquely lucid, unequivocal sense of design at once elegant and austere: an 'intense commitment to the particular, combined with a command of generalization' (to quote Mr Basil Taylor), a sure understanding of balance, intervals and poise. There is a stillness and inscrutability, a natural sense of order, even in Stubbs's most exciting subjects. Nor, with all his profound understanding of the animal's structure and his interest in its temperament, does Stubbs ever romanticize it or attempt to endow it, as such painters as Ward and Landseer were to do, with something akin to human emotions. He is at once dispassionate and sympathetic, curious and kindly. His technique, though many of his pictures have been grievously damaged by unskilful cleaning and restoration, is minutely refined and very restrained, even when the pigment is fairly boldly applied. His handling is unlike any other painter's. He was a masterly draughtsman and a subtle colourist. To contemplate a masterpiece by Stubbs in fine condition is a rewarding aesthetic experience on both the intellectual and the sensual plane.

56
Sawrey Gilpin
Cypron with her brood

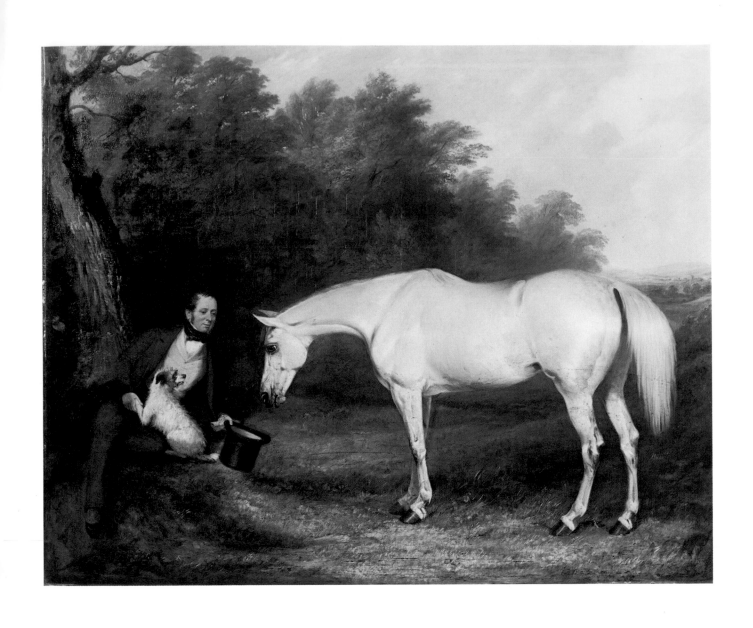

114
John Ferneley
John E. Ferneley and his favourite hunter

Of the three most significant sporting painters of the next generation, James Ward, Ben Marshall and the Swiss Jacques-Laurent Agasse, it is only in the work of the last (nos.126, 127), who came to London in 1805 and exhibited regularly at the Royal Academy, that we find something of the combined sympathy and restraint, the profound observation of animals of all kinds, the subtle colour and the classicizing sense of design that we admire in Stubbs. James Ward, neurotic, unbalanced, intensely ambitious, was the animal painter most closely caught up in the Romantic Movement. He was much influenced, at the outset of an inordinately hard-working career, by his brother-in-law, George Morland, whose pictures of the countryside, its inhabitants and occupations carry to excess the picturesque nostalgia of which Gainsborough's landscapes and fancy pictures are the most beautiful expression. Ward felt a perpetual conflict between the position which he considered an animal-painter should aspire to and the undignified hardships which the professional sporting painter was expected to endure. He hoped, in his dealings with the royal family for example, to be treated in the same way as Lawrence, West or Beechey had been, and complained about the discomfort of actually having to work in the royal stables.[16] In fact his sporting pieces (nos.137, 140), and his single portraits of horses (no.141), painted under the discipline imposed by a sporting painter's practice and patrons, who would reject his wilder flights of imagination, are among his finest works precisely because his natural fire and dashing technique are rigorously controlled. Some of his single figures of horses have a sheer sense of latent power which, like many passages in his landscapes, reveal the extent of Ward's admiration for Rubens. Two of the portraits of horses which he painted for George IV, probably under the conditions which so irked him, were painted in 1821, the year Géricault visited the Royal Academy and paid his famous tribute to English animal painters: 'Vous ne pouvez pas vous faire une idée des ... animaux peints par Ward et par Landseer ... les maîtres n'ont rien produit de mieux en ce genre.'[17]

Ben Marshall was the most professionally-minded of all English sporting painters. He wrote regularly as 'Observator' in *The Sporting Magazine* and many of his pictures were published therein. He actually moved to Newmarket in 1812. His earliest work, especially his admirable single pictures of horses, was inspired by Gilpin. He is said to have been particularly impressed by *The Death of the Fox* (no.59). The writer of the obituary notice of Marshall published in *The Sporting Magazine*[18] described the animals in Gilpin's masterpiece as portrayed from life, the size of the originals and thought by professional judges to be 'the most faithful, and at the same time the most animated production of the kind that had ever appeared'. And we find in Marshall's work the same interest in the relation between horse, landscape and the elements which we find in Gilpin. No sporting painter could convey more skilfully the subtlest effects of the English climate, the texture of mist, broken sunshine or hoar-frost. Marshall's pictures of the racing world – his larger set-pieces or the brilliant

studies of jockeys (no. 132) – are painted with understanding and with an enthusiasm for the appearance of a world which he could describe to the racing public with equal vigour in his articles. A good example of his literary style is his account of Epsom Races in 1830[19] written with a fine feeling for landscape and weather; evoking 'the number and diversity of figures that ornament . . . this gay festival' in a style which is almost a literary parallel to Frith's famous painting of the same scene; and describing the excitement of the Thursday when 'the art of cramming horses down people's throats has been practised more successfully than ever was known'. To Marshall's sporting articles, as well as to his pictures, we could apply a tribute to Nimrod's literary style: 'I can hear the horses breathe, and the silk jackets rustle, as they go by me.'

The first half of the nineteenth century has been described as the golden age of fox-hunting. It was also the period which saw the rise and fall of the great stage coach service which rattles and spins so evocatively through the pages of Dickens and produced its own special iconography in the work of James Pollard. Fox-hunting was becoming a great national sport, no longer a private pursuit enjoyed by the squires and noblemen who had patronised Gilpin and Stubbs. It was the age of legendary masters and huntsmen, when the sport was enjoyed by increasing numbers of middle-class supporters and when more and more hunts were being financed by subscriptions: when Mr Jorrocks can ride alongside the descendants of Sir Roger de Coverley. The fox was now being chased by a larger following and at greater speed – almost at a racing speed – and over more exciting – and better-drained – country as pasture was being improved and enclosures began to cover the countryside with hedges and fences. This new enthusiasm for fox-hunting gave birth to a splendid literature and is perhaps most delightfully recorded by Surtees, nowhere with more spirit than in his *Analysis of the Hunting Field*. Published in 1846, it was a collection of papers which had appeared during the previous hunting season ('the best hunting one in the author's recollection'). Alken's lively and highly informed illustrations are intertwined with the text and Surtees himself writes with a graphic, almost a painterly, touch: 'let us paint away at the Colonel, for he covers a great breadth of canvas.'

The chase, its hazards and its eccentricities were illustrated in the humorous vein by Alken (nos. 278–287) and Leech; but the big hunts needed to be recorded on a lavish formal scale by such painters as John Ferneley (nos. 106, 107), John Frederick Herring (no. 184) and Francis Grant (no. 191), all of whom have something of the enthusiasm and essential expertise of the amateur. Ferneley began life as apprentice to his father, a Leicestershire wheelwright. He studied painting under Ben Marshall and in 1806 received his first important commission, from Thomas Assheton Smith, Master of the Quorn, 'the straightest man across country that ever rode to hounds'. In 1814 he established himself at Melton Mowbray.

His practice among the great sportsmen of the day was almost unrivalled, and a painting such as his huge picture of the Quorn at Quenby (no.104) in 1823 is a superb record of a great hunt in the golden age. Herring likewise had no formal training as a painter, but was a professional coach-driver on the Doncaster to Halifax run, inspired to paint (according to tradition) by seeing the St. Leger in 1814. Of his immense output the most attractive pictures are perhaps his less formal studies of horses, a group of post-horses waiting to be changed or a pair of riding-horses standing quietly with a groom below a flight of steps at Windsor Castle. His pictures, however, have often the unpleasant oleographic texture which disfigures so much mid-Victorian painting.

In 1797 there had been surprise when Gilpin had defeated Beechey in the election to a vacant place among the Royal Academicians. A writer in the *Oracle* had pointed out that visitors to the annual exhibition had come principally to see the portraits by Hoppner, Beechey and Lawrence: 'However excellent are the animals of Mr Gilpin's pencil they would never bring in ten pounds to the Academy – in this view the portrait painter has the preferable claim.'[20] After the death of Eastlake in 1865 Landseer was elected President of the Royal Academy by an overwhelming majority. He was forced by ill-health to decline and, at a second election, the majority of votes went to Francis Grant, a distinguished gentlemanly artist whose enthusiasm as a young man had been divided equally between fox-hunting and painting. By 1831 he had 'honorably & manfully resolved to cultivate his taste for painting, & become a professional artist'. He did not, in fact, exhibit at the Royal Academy before 1834, when, at the age of thirty-one, he showed his famous *Breakfast Scene at Melton*, one of the archetypal illustrations of the nineteenth-century sporting world. Thereafter the long succession of handsome and accomplished portraits which Grant exhibited at the Academy was regularly interspersed with sporting portraits and set pieces of the sporting world: *The Meeting of His Majesty's Stag Hounds* (1837), *The Melton Hunt going to draw the Ram's Head Cover* (1839), *Party at Ranton Abbey* (1841), *Sir Richard Sutton's Hounds* (1846) and the like. One of his last exhibited portraits was of the Master of the Puckeridge. Sir Walter Scott had said of him in 1831 that he possessed, 'with much taste, a sense of beauty derived from the best source, that of really good society'.[21] A great step forward in his career as a painter was taken when his good looks and gentlemanlike manners gained the favour of Lord Melbourne and the young Queen Victoria (no.192). For the delightful equestrian group which he exhibited in 1840 the Queen first gave a sitting on horseback, perhaps in the riding-school at Buckingham Palace. Two days later she saw Lord Conyngham sitting on a wooden horse for Grant's benefit; and one of the further sittings she gave to Grant was on his wooden horse: a glimpse of the sporting painter's method as useful as Herring's account of the stable he had constructed in which the horses he had to paint could be accommodated.

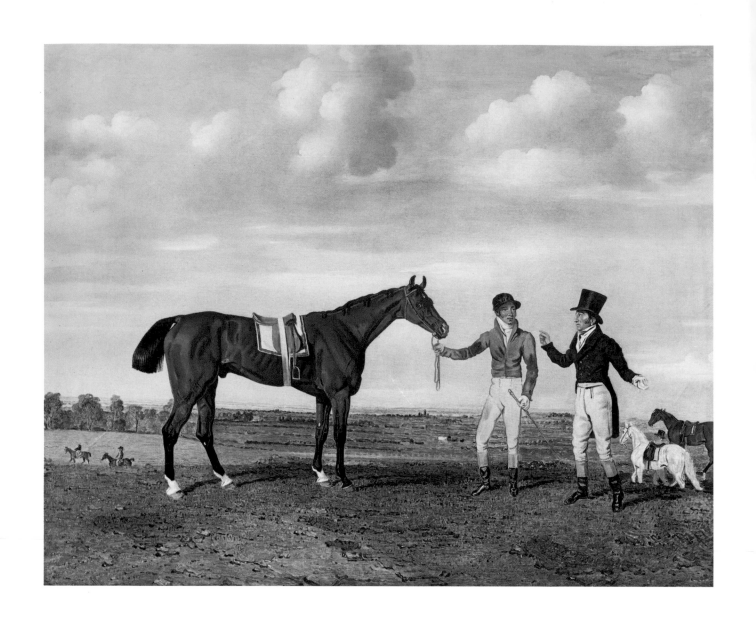

132
Benjamin Marshall
Zinganee held by Sam Chifney junior, with the owner,
Mr W. Chifney at Newmarket

20

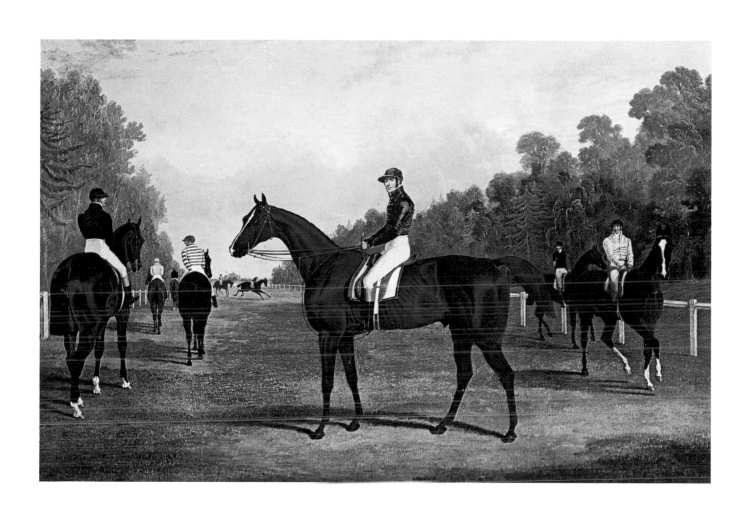

180
John Frederick Herring
Rubini, before the start of the Goodwood Gold Cup, 1833

Grant, however, was never so popular with the Queen and her family as Landseer, the last great animal painter this country has produced and one of the most brilliant and disturbing. Unlike such painters as Ferneley, Herring and Grant, the young Landseer was brought up in a professional environment. He was technically precocious and acquired at an early age a sound knowledge of animal structure, partly under the influence of Ward and J.F.Lewis; as a young man he bought from Colnaghi Stubbs's drawings (nos.326, 327) for the *Anatomy of the Horse*. He first exhibited at the Royal Academy in 1815, when he was only thirteen; six years later his pictures, and Ward's, at the Academy were to evoke Géricault's famous tribute. The *Hunting of Chevy Chase* shows what Landseer might have done as an animal painter on a large scale and in an heroic vein, remembering perhaps the encouragement he had received as a boy from Haydon as well as his debt to Rubens, Snyders and Ward. Unfortunately, although he never lost his fluent touch, he to a large extent debased his rare gifts by infusing into his paintings and drawings of animals a nauseating sentimentality, infusing human emotions into animals, moralising animal subjects, creating, in the words of T.S.R.Boase, 'a parade of beasts as classic worthies'[22].

The turning-point in his career – an important moment in the history of sporting painting – came in 1824, when he first visited the Highlands. Thereafter he paid regular visits to Scotland, staying with and working for the grand folk who enjoyed his good looks, his charm, his humour and his easy manners: the Russells, the Hamiltons and the royal family, all of whom, between them, probably ultimately and unconsciously destroyed him. Under their patronage he developed new themes in sporting painting: large groups of stalking parties, freely painted informal Highland fishing scenes and brilliantly drawn or painted studies of Scottish animals (nos.188, 189) and birds. His liquid rendering of the head of a dying stag is charged with the same emotions as the upturned head and adoring eyes of a favourite ghillie who holds the boat steady while the Queen steps ashore at Loch Muich.

Sporting painting has either been wholly neglected, by such writers on English art as Alan Cunningham or Roger Fry, or treated with an uneasy and rather distasteful superiority by more recent authors. It is perhaps remarkable that the standard account of English art in the nineteenth century contains no mention of Ben Marshall, Ferneley or Herring; and that a special survey of painting in England between 1740 and 1770 should, although principally devoted to the influence of light from Italy, ignore the pictures exhibited in the 1760s by Stubbs and Gilpin and the light they can throw on tendencies in English patronage and taste. It is true that much sporting art has been given exaggerated prominence in the art-trade and is frequently seen in a glossy, uncongenial context; nevertheless sporting painting cannot continue to be treated as if much of it did not exist. And it does not become the art-historian to suggest that the study of

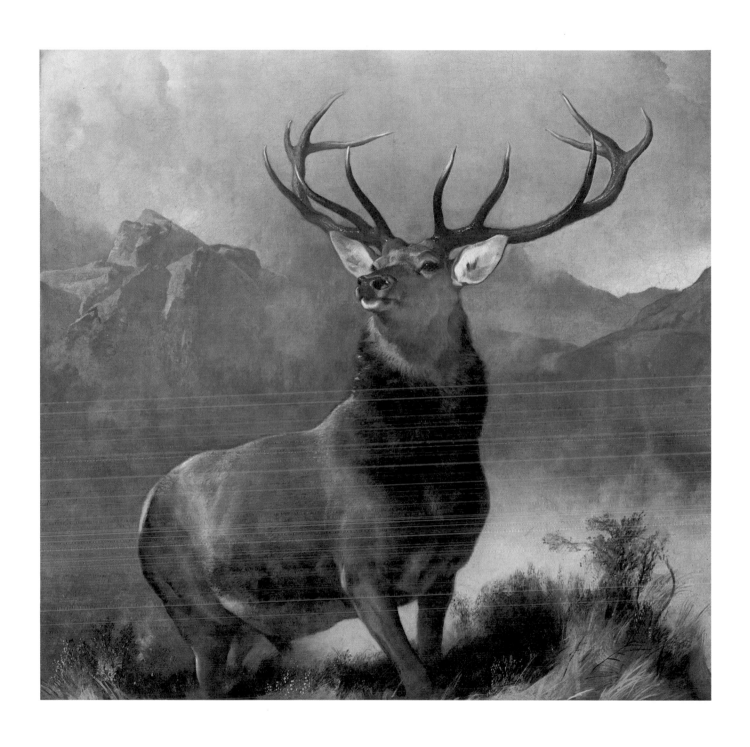

188
Edwin Landseer
The Monarch of the Glen

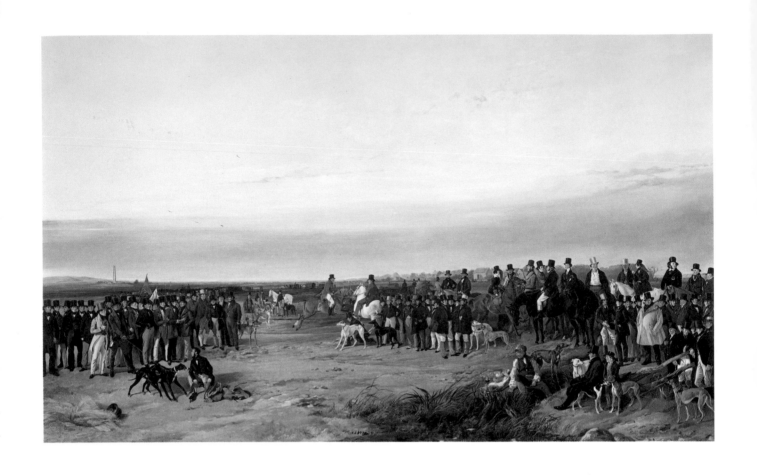

200
Richard Ansdell
The Waterloo Cup coursing meeting

sporting art in England leads him towards fields in which he is not required
to trespass. If we are prepared to devote study to a collection of family
portraits in the hall of a country house on which a patron has carefully
inscribed details of the sitters, or has painted an heraldic achievement
beside them, we cannot logically ignore the record the same patron may
have commissioned of the animals in his stables and their breeding.
If he is prepared to tackle his material with humility our historian will be
able to analyse with sympathy the significance of the work of such
painters as Seymour and Alken. One must fight against taking refuge
with the jaded intellectual in Kipling's short story, *My Son's Wife*, who
finds himself in a dank country house and, with the rain pelting down
outside, turns to the few books left by his predecessor: 'It was a foul world
into which he had peeped for the first time – a heavy-eating, hard-drinking
hell of horse-copers, swindlers, matchmaking mothers, economically
dependent virgins selling themselves blushingly for cash and lands: Jews,
tradesmen, and an ill-considered spawn of Dickens-and-horsedung
characters . . . but he read on, fascinated . . .'

We cannot attempt, in short, accurately to define the nature of English
patronage if we ignore the immense and persistent enthusiasm for country
life and sporting pursuits in just those characters on whose other
proclivities we lavish such attention. In a sporting context Charles
Loraine-Smith, a famous fox-hunting gentleman from Leicestershire and
Morland's protector, produced a number of accomplished sporting-prints.
His masterpiece is laconically entitled *The Loss of the Parson*. In another
context he is transfixed by Zoffany sketching a famous marble in the
Tribuna of the Uffizi. Some of the young Englishmen who sat to Pompeo
Batoni chose to be treated as huntsmen. Lord Denbigh, whose family
contributed to the connoisseurship of the Caroline court, strides forward in
Van Dyck's full-length clasping a fowling-piece, and one can think of
countless sporting portraits by Van Dyck's successors in England. The
3rd Duke of Beaufort, whose passion for the chase is recorded in some
thirty canvases by Wootton at Badminton, travelled to Rome, was painted
by Trevisani and was the friend of Cardinal Alberoni. The mingled
enthusiasm in Grant's career for painting and fox-hunting is an object-
lesson in itself. The Prince Consort, who made such notable and original
contributions to the royal collection, is seen in numerous hunting-scenes by
Landseer and others and in Landseer's *Windsor Castle in Modern Times*
(no.187) has actually brought his bag indoors to drip on to the carpet of
one of George IV's drawing-rooms on the east front of Windsor Castle.
Perhaps the most illuminating commentary on the combination in so many
highly civilized Englishmen of discernment in the arts and enthusiasm for
sport is provided by Dobson's portrait of Endymion Porter (no.6):
clasping a German wheel-lock sporting rifle against a mingling of
allusions to the arts and the chase.[23]

The account of the development of sporting art in England can, of course, be enriched by drawing on the parallel stream of an incomparably rich literature. The glorification of the horse carried out under the auspices of the Duke of Newcastle almost rises to the pitch of enthusiasm lavished by Shakespeare on Adonis's 'trampling courser': 'A breeding jennet, lusty, young and proud . . . Look when a painter would surpass the life in limning out a well-proportioned steed'. A sympathetic approach to the later painters is stimulated by coming to them through the pages of Nimrod and Surtees or by thinking of Lord Chiltern and Burgo Fitzgerald sitting to Ferneley.

In one of his articles Nimrod speaks of 'the *romance* of hunting – the remote scenes we should perhaps never visit for their own sake, the broken sunlight glinting through copse and gleaming on fern'. This almost literally describes the treatment of landscape in such painters as Gilpin and George Garrard and is a reminder that English sporting painting contains a wealth of landscape painting, some of it great or exceedingly good and almost all of it delightful. Gainsborough's early masterpiece, *Mr and Mrs Robert Andrews*, has after all a very strong sporting element, although Gainsborough left unfinished the dead pheasant which was to lie on Mrs Andrews's pretty frock; it is in the tradition of small sporting conversation pieces established by Mrs Carlile (no. 5) about a hundred years earlier. Our ideal historian would need a sympathy with the sporting world as well as an understanding of nothing less than the history of the English countryside and of English country life. He would then be able to see the work of even the least distinguished English sporting artists as an essential source for creating a picture of the vanished beauties and silence of the English rural scene. 1850, the limit in time set for this exhibition, marks the end of the decade in which over 5000 miles of railway lines had been completed. The railway came to be regarded as the great divide between the old world and the new, between the world of Pollard's coaching pictures and the conquering engines driven by a force which was, for Dickens, 'a type of the triumphant monster, Death'. To Thackeray, to have lived before railways were made was to belong to another world.[24] '*Then* was the old world. Stage-coaches, more or less swift, riding-horses, pack-horses, highwaymen, knights in armour, Norman invaders, Roman legions, Druids, Ancient Britons painted blue, and so forth.'[25] If we wish to comprehend the old world which lay on the other side of the embankment there is no richer source than the work of the English sporting painters.

Notes

1

The chapter occupies pp.135–43 in the edition of Virgil B. Heltzel (Cornell University Press, 1962).

2

Facsimile (1908), p.133, showing Elizabeth I about to break up the deer.

3

Sir Henry Wotton, *A Panegyrick to King Charles* (published in *Reliquiæ Wottonianæ*, 3rd ed., 1672).

4

E.K.Waterhouse, *Gainsborough* (1958), p.106 (No.823).

5

Paintings and Drawings by Sir Edwin Landseer, R.A., 1961 (76).

6

Erna Auerbach and C. Kingsley Adams, *Paintings and Sculpture at Hatfield House* (1971), pp.65–66 (No.58).

7

Bodleian Library, MS. Aubrey, 2, f.32.

8

R.W.Goulding and C.K Adams, *Catalogue of the Pictures . . . at Welbeck Abbey . . .* (1936), pp.438–9

9

B.M., Egerton MS.1636, f.95.

10

The picture is among those commissioned for Dr Cox Macro of Little Haugh Hall and now in the collection of Miss Patteson.

11

Izaak Walton and Charles Cotton, *The Compleat Angler*, part I, ch.v.

12

Journeys, ed C.Morris (1947), p.84.

13

See particularly, H.Honour, 'Leonard Knyff', *Leeds Art Calendar*, vol.7, No.23 (1953), pp.20–24; on Wootton there is much useful material in G.E.Kendall, 'Notes on the Life of John Wootton', *Walpole Society*, vol.XXI (1933), pp. 23–42. Wootton's work for the Harley family, a useful example at this early date of the relation between painter and patron, can be studied in Goulding and Adams, op.cit., pp.492–4.

14

Rouquet's work appeared in 1755. The extract comes from the English translation, facsimile reprint with Introduction by R.W.Lightbown (1970), p.58.

15

Painters such as Wootton, indeed, had frequently had recourse to professional face-painters (Kneller, Dahl, Gibson, Hudson and Hogarth) for the heads of their sitters on horseback. One has only to compare Stubbs's wonderful heads of grooms and boys with the blurred and characterless smudges which often pass for heads in Wootton's designs.

16

Windsor Castle, Royal Archives, Georgian 26517–26.

17

Géricault raconté par lui-même et par ses Amis (Vésenaz-Genève), 1947, pp.103–4.

18

Vol.XI, 2nd series (August, 1835), pp.297–9.

19

The Sporting Magazine, vol.I, 2nd series (July, 1830), pp.178–85.

20

W.T.Whitley, *Artists and their Friends in England 1700–1799* (1928), vol.II, p.207.

21

The Journal of Sir Walter Scott 1829–32 (1946), pp.155–6.

22

One must remember, however, what contemporaries thought of this. Cosmo Monkhouse wrote of Landseer: 'As an artist he may be said to have raised animal painting to the rank of moral and intellectual art' (printed in additions to A.Cunningham's *Lives of the most eminent British Painters* (1880), vol.III, p.389).

23

W.Vaughan, *Endymion Porter & William Dobson* (1970).

24

The point is well made in Kathleen Tillotson, *Novels of the Eighteen-Forties* (1954), pp.104–9.

25

W.M.Thackeray, *De Juventute* in *Roundabout Papers*.

Bibliographical Note

There are sections on sporting painting in E.K.Waterhouse, *Painting in Britain 1530 to 1790* (3rd.ed., 1969) and, for the earlier period, in M.Whinney and O.Millar, *English Art 1625–1714* (1958). The earlier works by W.Shaw Sparrow, *British Sporting Painters* (1922), and *A Book of Sporting Painters* (1931) are discursive but written with knowledge and enthusiasm. The same can be said of Sir Walter Gilbey, *Animal Painters of England from 1650* (1900). A survey by Stella Walker, *Sporting Art, England 1700–1900*, with good illustrations, was published in 1972.

Much information on sporting painters is to be found in special studies of two collections: O.Millar on the Tudor, Stuart and Georgian pictures in the Royal Collection (1963, 1969) and Basil Taylor's catalogues of part of the Mellon Collection, *Painting in England 1700–1850* (Richmond, Virginia, 1963; Royal Academy, 1964–5; the former fully illustrated, the latter accompanied by an illustrated souvenir). On Landseer there is useful material in two exhibition catalogues: *Paintings and Drawings by Sir Edwin Landseer*, R.A. (1961), with introductions by J.Woodward and others, and *Landseer and his World*, Mappin Art Gallery, Sheffield (1972), with an introduction by Mrs Judy Hague.

Basil Taylor's *Animal Painting in England from Barlow to Landseer* is a brilliant essay which is undeservedly out of print. Likewise the same author's *Stubbs* (1971) is the most distinguished and sensitive account so far published of an English sporting artist. It sums up much of the research which the author had put into more ephemeral publications. A good biography is Constance-Anne Parker, *Mr Stubbs the Horse Painter* (1971).

As an example of the kind of well researched and fully documented account of the country and sporting background which the historian of sporting art requires, the reader is recommended to consult two works by E.W.Bovill, *The England of Nimrod and Surtees 1815–1854* (1959) and *English Country Life 1780–1830* (1962).

Catalogue Note

Within each section of this catalogue the artists are arranged chronologically by birth date (when known) so that the illustrations indicate the development of each genre. Each artist's work is listed chronologically. Books are arranged chronologically by publication date. Paintings are in oil on canvas unless otherwise stated: measurements are given in centimetres, height preceding width. (L) indicates that a work will be shown in London only; ★indicates exhibits that are illustrated in black and white; †indicates illustrations in colour.

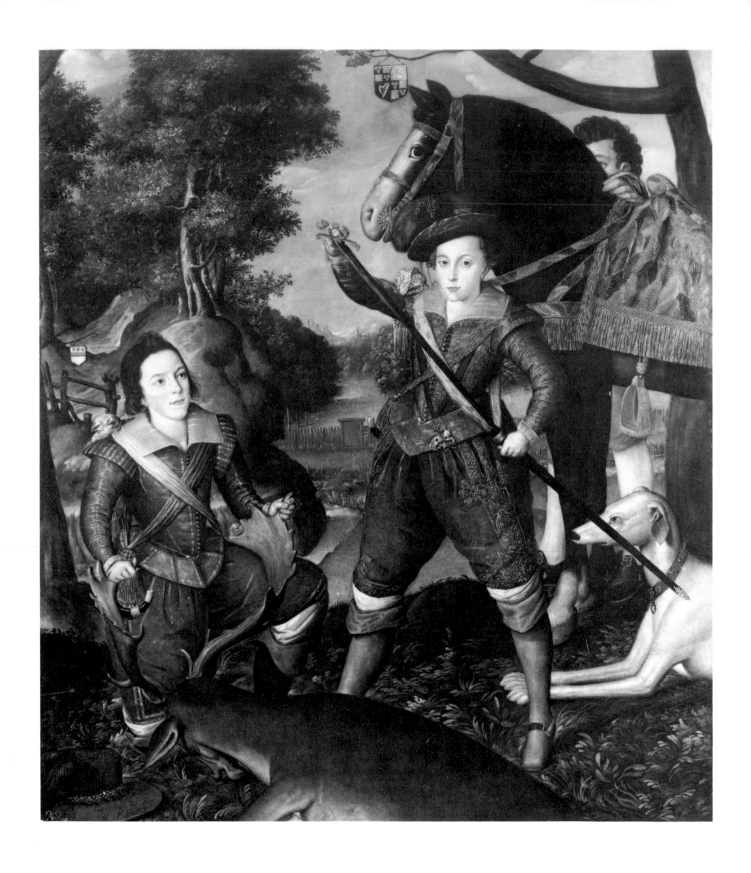

1
Robert Peake
Henry, Prince of Wales, in the hunting field

PAINTINGS

Robert Peake *fl.*1575–1623

Portrait painter. Principal painter to Henry, Prince of Wales and, jointly with John de Critz, Serjeant Painter to James I in 1607. A prolific artist who maintained a large studio.

***1 Henry, Prince of Wales, in the hunting-field** L
Canvas: 190.5 × 165.1
Exh: Tate Gallery, *The Elizabethan Image*, 1969 (110)
Lit: O.Millar, *The Tudor, Stuart and Early Georgian Pictures in the Collection of Her Majesty The Queen*, 1963, no.100
Lent by Her Majesty The Queen

Henry, Prince of Wales (1594–1612) dressed in hunting costume and wearing a fine jewelled George, has dismounted from his horse to deliver the *coup de grâce* to a stag whose antlers are held by Robert Devereux, 3rd Earl of Essex (1591–1646). The arms of the Prince and Earl are suspended behind them; in the background are an enclosed deer park and a view of a town and castle.
A reflection of the passionate interest of the early Stuarts in horses and hunting.

Anonymous

2 Sir Thomas Southwell in hunting attire, holding a snaphance fowling piece
Canvas: 208 × 103
Inscribed: HIC.ET.UBIQUE
Lit. H.L.Blackmore, *Hunting Weapons*, 1971, p.226–7
Lent by the Hon. J.E.S.Russell

Sir Thomas Southwell (1596–1643) in hunting costume holding a snaphance gun of the proportions and finish of a musket, with his retriever. Painted about 1630.
Early in the seventeenth century the new flintlocks began to supersede the wheel-lock gun; the considerable advantages they offered to hunters were realised as early as 1621 when Gervase Markham in *Hungers Prevention* advising on the selection of a fowling piece stated 'tis better it be a fire-locke or snaphance than a cocke or tricker, for it is safe and better for carriage, readier for use, and keepes the powder dryer in all weather, whereas the blowing of a coale [the slow match] is many times the losse of the thing aymed at'.

Abraham van Diepenbeeck 1596–1675

Glass painter, painter, draughtsman and engraver. A pupil of Rubens, Diepenbeeck was a member of the guild of glass painters in Antwerp in 1623. According to Walpole he came to England and painted views of the Duke of Newcastle's seats at Bolsover and Welbeck, but his known association with Newcastle was only during the latter's exile in Antwerp, where he engraved the plates to Newcastle's *Méthode et Invention Nouvelle de Dresser les Chevaux*, 1658. Diepenbeeck is said to have worked as an engraver for Plantin during the later part of his life.

3 The Duke of Newcastle – horses on the manège L
Canvas: 75 × 89
Prov: Painted for the 1st Duke of Newcastle, by descent.
Lit: M.Whinney & O.Millar, *English Art 1625–1714*, 1957, p.277
Lent by the Duke of Portland, K.G.

William Cavendish, 1st Duke of Newcastle (1595?–1676), was an ardent Royalist who sacrificed all to the cause. One of the greatest riders of his time, he taught Charles II when Prince of Wales the art of horsemanship, being appointed Tutor 1628. He went into exile at Antwerp where he produced in 1658 his celebrated book *Méthode et Invention Nouvelle de Dresser les Chevaux* with plates engraved by Diepenbeeck
See no.220

4 Horses with Bolsover Castle in the background
Canvas: 161.5 × 183
Prov: Painted for the 1st Duke of Newcastle, by descent
Lit: A.M.Hind, *Catalogue of Drawings by Dutch and Flemish Artists . . . in the British Museum*, 1923, pp.100–1, 105; A.S.Turberville, *A History of Welbeck Abbey*, 1938, pp.136–40; R.W.Goulding, *Catalogue of the Pictures . . . at Welbeck*, 1936, pp.438–9; M.Whinney & O.Millar, *English Art 1625–1714*, 1957, pp.276–7
Lent by the Duke of Portland, K.G.

One of the series of large pictures of horses traditionally attributed to Abraham van Diepenbeeck, painted for the 1st Duke of Newcastle. The artist, however, is not known to have come to England and his association with Newcastle was during the latter's exile in Antwerp. Bolsover Castle was the Riding House where the Duke trained his *manège* of horses; the present castle was begun about 1613. The Duke's famous stud was at Welbeck, where the stables were pillared, heated, ventilated and sluiced out by a diverted river. A number of Eastern horses stood there making an early contribution to the English thoroughbred. The Duke had a private racecourse at Worksop, near Welbeck.

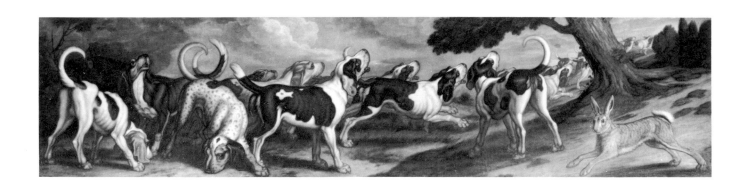

7
Francis Barlow
Southern-mouthed hounds

Joan Carlile 1606?–1679

The daughter of William Palmer, an official in the Royal Parks, Joan Carlile was an amateur painter of some distinction with influential patrons before, during and after the Civil War. She married Lodowick Carlile in 1626. About 1653 she moved to Covent Garden 'resolved to use her skill for something more than empty fame'.

5 A stag hunt

Canvas: 61 × 74
Prov: by descent from Miss Vere Isham (d.1760) who bequeathed it to her nephew Justinian 7th Bt. as a 'picture with several figures in it, in which is that of my grandfather Sir Justinian Isham'; by descent
Exh: Northampton Art Gallery 1952; Worcester City Art Gallery, *Exh. of Paintings 1642–51* (59); Birmingham, *Works of Art from Midland Houses*, 1953 (4); Sheffield, *Famous British Women Artists*, 1953 (18); Tate Gallery, *The Age of Charles I*, 1972 (164)
Lit: M.Toynbee and Sir G.Isham, *Burlington Magazine*, XCVI, 1954, pp.275–7
Lent by Sir Gyles Isham Bt.

Presumably painted 1649–50 when Sir Justinian Isham was staying with the Carliles at Petersham. The artist is seated on the right with Sir Justinian behind her. Her husband, Lodowick stands on the left with their children James and Penelope and other friends.
Lodowick Carlile, Gentleman of the Bows to Charles I was a Keeper at Richmond Park. A minor poet and dramatist he described himself as one who 'hunts and hawks, and feeds his Deer, Not some, but most fair days throughout the yeer'.

William Dobson 1610–1646

Portrait painter. Apprenticed to Peake. Entered the King's service by 1642 when he painted many of the royalist officers in the war-time court at Oxford. His portraits represents a new departure and a highly personal form of English baroque.

6 Endymion Porter

Canvas: 150 × 127
Prov: ? Walsh Porter; ? Woodburn Senior, sale Christie's 12 May 1821 (55); Gatton Park before 1857; Frederick John, Lord Monson, sale Christie's 12 May 1888 (17), bt. National Gallery
Exh: Tate Gallery, *William Dobson*, 1951; Tate Gallery, *Endymion Porter & William Dobson*, 1970
Engr: William Faithorne, by 1646
Lit: O.Millar, 'A Subject Picture by William Dobson', *Burlington Magazine*, XC, 1948, pp.97–9
Lent by the Trustees of the Tate Gallery

Endymion Porter (1587–1649) holding a flint-lock, leans on a ledge on which are carved emblematical figures of the Arts. A dead hare is held by a page, and a dog thrusts his head forward to smell the game. Painted c.1643–5.
An ardent royalist Porter spent much of his early life in Spain. After his return to England he became groom of the bedchamber to Prince Charles, whom he accompanied with the Duke of Buckingham to Spain in 1623. The friend and patron of poets – to which the wreathed bust in this portrait presumably refers – Dobson was employed by Charles I in the formation of his great collection of pictures. He was a friend of Rubens and Van Dyck. He left England in 1645.

Francis Barlow c.1626–1704

Painter and etcher of birds, animals and sporting subjects. Barlow may have studied with William Sheppard, a portrait painter in Drury Lane, but was in independent practice by 1662. Well known as a painter in his own time – recorded by Evelyn as 'ye famous painter of fowls, birds and beasts – he was the first Englishman who specialised in sporting scenes. Barlow is now remembered as an engraver and etcher, in which he was technically more able. In 1686 Barlow designed illustrations for Richard Blome's *The Gentleman's Recreation* (no.346).

*7 Southern-mouthed hounds L

Canvas: 90 × 355.5
Prov: Probably painted for Denzil Onslow, by descent.
Exh: Brussels, *Europalia*, 1873 (1)
Lit: W.Shaw Sparrow, *British Sporting Artists*, 1965, p.29; B. Taylor, *Animal Painting in England*, 1955, p.54
Lent by H.M. Treasury and the National Trust, Clandon Park

For Evelyn's friend Denzil Onslow of Pyrford, Surrey, Barlow painted in the mid 1660s his most important works in oils, large canvasses of 'fowle and huntings' to decorate the hall at Pyrford. Denzil Onslow (d.s.p.1721) of Pyrford was M.P. for Guildford and for Surrey. This life-size frieze shows the polyglot hunting packs used towards the end of the seventeenth century. Big, heavy and slow, the dogs conform to Gervase Markham's ideal; 'respect only cunning and depth of mouth. Compose your kennel of the biggest and slowest dogs you can get'. (*Country Contentments*. 1615, the most popular treatise on riding, hunting, and household management until the Restoration.)
Hare hunting was enjoyed by both farmer and aristocracy and packs of hounds were expected to hunt any quarry they encountered. The universal desire for speed in hunting did not develop until the early nineteenth century. In *The Gentlemen's Recreation*, 1686, Richard Blome recommended the southern-mouthed hounds as being 'thick-skinn'd and slow footed, they are most proper for such as delight to follow them on foot', and he notes that they worked well in woodlands and hilly districts, but were too slow 'for one that would keep himself in vigour'.

Otho Hoynck *fl.*1661–1686

From The Hague where he became Master in the *Confrérie* in 1661, he came to England as 'painter to the Duke of Albermarle'.

8 A greyhound
Canvas: 113 × 145.5
Signed and dated: *Otho Hoynck: fecit: 1673*
Inscribed: *May the 6 A 1671: My Lord Shaftesbury's collor was given Red which hee won. March the 7th Ao 1671/2 the Duke of Albermerle's collor was given Blue which hee won then*
Prov: Sir Archibald Buchan-Hepburn, Christie's, 23 February 1934 (138); Christie's 16 March 1956 (121)
Exh: Royal Academy, *The Age of Charles II*, 1961 (299)
Lit: *Oud Holland*, L, 1933, p.179; E.K.Waterhouse, *Painting in Britain*, 1969, pp.77–8
Lent by Mark Gilbey Esq.

Two collars won by the greyhound hang on a branch of the tree, behind the running dog.

Jan Wyck 1652–1700?

Painter of animals and battle pieces. He was in England by 1674, being one of the Dutch artists employed at Ham House. He made drawings for a book on Hunting and Hawking, painted equestrian portraits and hunting pictures. John Wootton was his pupil.

9 Stag-hunting
Canvas: 101.5 × 127
Prov: London Art Market, bt. 1962
Lent by Lady Thompson

Anonymous

10 Harraton Hall 1687
Canvas: 122 × 244
Lent by Lord Lambton

Harraton, near Chester-le-Street, Co.Durham, on the banks of the Wear. Originally the seat of the D'Arcy family, Harraton Hall was conveyed to the Hedworths, who remained possessors until 1688, when John Hedworth died. His elder daughter Dorothy married into the Lambton family. The Hall became well-known as a hunting centre in the late eighteenth century, for it was there that the pack of hounds made famous by Ralph Lambton was set up (no.140).

Peter Tillemans 1684–1734

Came from Antwerp to England in 1704 and settled here. He was employed in copying old masters and later became an antiquarian and topographical draughtsman. Best known as an animal painter and landscape artist he soon became popular and found many patrons amongst the nobility including the Dukes of Somerset and Rutland, and the Earl of Portmore, painting their country seats, their horses and their hounds.

★11 Mr Jemmet Browne at a meet L
Canvas: 97.7 × 123.5
Signed: *P. Tillemans P*
Prov: Painted for Jemmet Browne, by descent until 1958; London Art Market
Exh: Bath, City Art Gallery, *Art Treasures*, 1958 (287); Liverpool, Walker Art Gallery, 1958 (56); Virginia Museum of Fine Arts, *Painting in England 1700–1850*, 1963 (300)
Lit; A.Bury, *Connoisseur*, August 1958, pp.42–43; S.A.Walker, *Sporting Art: England 1700–1900*, 1972, p.122
Lent from the Collection of Mr and Mrs Paul Mellon, Upperville, Virginia

By family tradition the setting is at Riverstown, Co. Cork.

★12 View of Great Livermere Park L
Canvas: 104 × 128.2
Lent by Oscar and Peter Johnson Limited

A view of Great Livermere Park, near Bury St. Edmunds. In 1790 Humphrey Repton prepared designs for the extensive landscaping of the gardens for Nathaniel Lee Acton. The property was later in the possession of the de Saumarez family. The house was demolished early this century and only the kitchen garden walls survive.

John Wootton 1686?–1764

Painter of landscapes and military scenes, Wootton was the first distinguished English sporting painter. A member of the circle of Tory artists, grouped round the 2nd Earl of Oxford, an extensive collection of his work is still at Welbeck, including two large and ambitious early works of Lady Harley. His skill in composing the group of figures in a wide panoramic landscape, under a light sky is new to English painting. His portraits of horses shown in profile are records of a great age of horse-breeding.

13 Lady Henrietta Harley hunting the hare on Orwell Hill 1716
Canvas: 294.6 × 211
Prov: Painted for Edward Lord Harley, later 2nd Earl of Oxford; Wootton's account for this picture and its companion (no.14) dated 10 November 1716 is still at Welbeck: each picture cost £53 15s.; by family descent
Lit: W.Shaw Sparrow, *British Sporting Artists*, 1665, p.112;

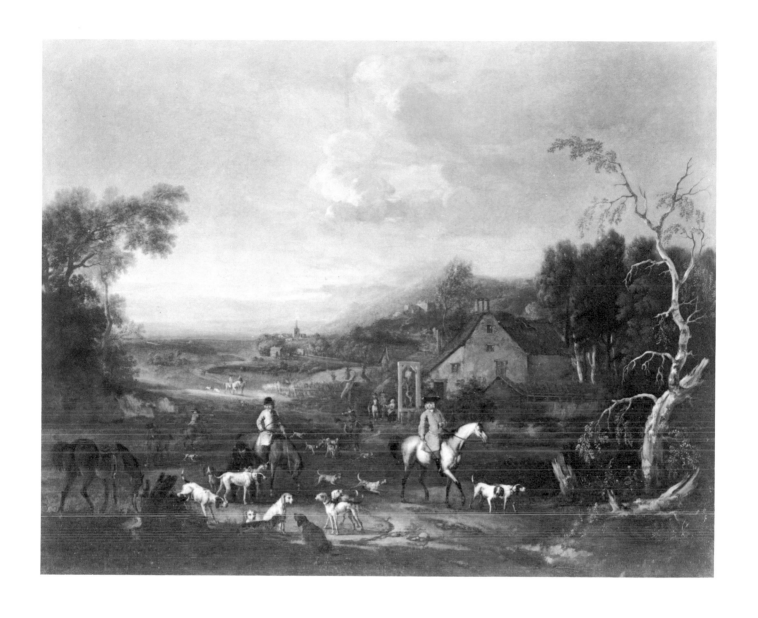

11
Peter Tillemans
Mr Jemmet Browne at a meet

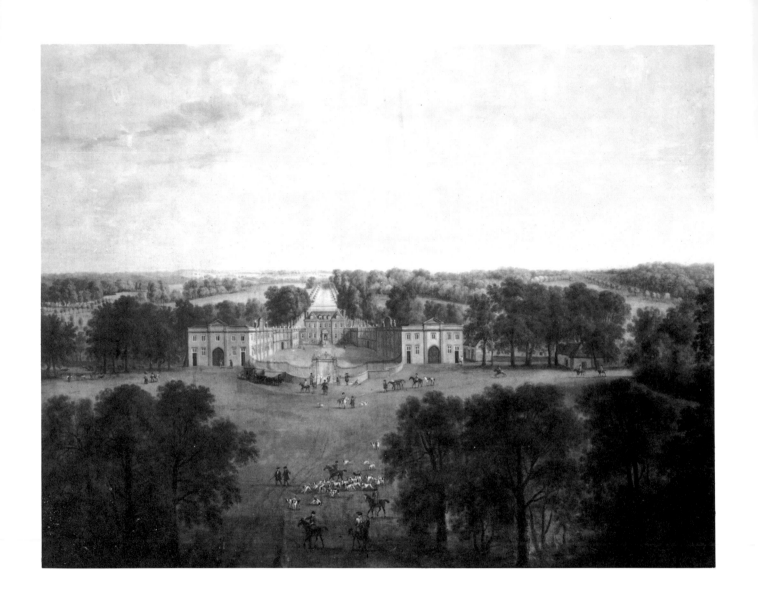

12
Peter Tillemans
View of Great Livermere Park

M.Whinney & O.Millar, *English Art 1625–1714*, 1957, p.276
Lent by the Duke of Portland, K.G.

Lady Henrietta Harley (1693/4–1755) wife of Edward Harley 2nd Earl of Oxford was considered a dull, worthy woman who disliked most of the wits who surrounded her husband. Swift, writing to Stella 8 November 1711 says of Lord Harley's rumoured engagement to Henrietta 'They say the girl is handsome, and has good sense, but red hair'. The daughter of the Duke of Newcastle, Lady Harley followed her family tradition of enthusiastic horsemanship. At this period women were few in the world of field sports and grew less in number after Queen Anne gave up hunting.
Lady Harley wears a green and silver habit and rides a dun mare. The background shows a vivid hunting scene with a rider who has lost control of his horse, hounds in full cry and two running footmen.
Lord Harley was a great admirer and patron of Wootton, he owned some forty sporting pictures, portraits and landscapes by Wootton.

14 Lady Henrietta Harley hawking in Wimpole Park 1716
Canvas: 304.8 × 216
Prov: see no.13
Lit: W.Shaw Sparrow, *British Sporting Artists*, 1965, p.112
Lent by the Duke of Portland, K.G.

See no.13. Lady Harley in scarlet and gold habit is attended by running footmen in blue and white liveries. Two groups of gentlemen and falconers with spaniels, complete the scene.

15 Edward Roper, Master of the Charlton Hunt L
Canvas: 132.5 × 105
Lit: M.Brockwell, *Country Life*, 12 November 1932. LXXII
Lent by the Stewards of the Jockey Club

Edward Roper (1640–1723) Master of the Charlton Hunt. The Charlton, the first hunt to be established on modern lines, became one of the most fashionable sporting centres in England. It was founded by the Duke of Monmouth about 1675. At the time of Monmouth's abortive rebellion Roper, who hunted the pack, fled to France where he is said to have enjoyed good sport at Chantilly. He returned to England with William of Orange and, at Charlton resumed management of the pack of foxhounds. In the late 1680s the Charlton hunted the fox. This was probably the first pack of hounds kept solely for the chase of the fox, a practice which did not become common until the mid-eighteenth century. Roper died at a meet, the hunt diary reads: 'On 26th Feby 1722/3 being Shrove Tuesday, Mr Roper died at Moncton Furzes a quick and sudden death, and in the Feild.' (P.Chalmers, *The History of Hunting*, 1936, p.352.)

16 Benjamin Hoare and groom 1732
Canvas: 123 × 166
Lent by Hoare's Bank

*17 The shooting party L
Canvas: 88.9 × 74
Signed and dated: *JW/1740*
Prov: Presumably painted for Frederick Prince of Wales
Lit: O.Millar, *The Tudor, Stuart and Early Georgian Pictures in the Collection of Her Majesty The Queen*, 1963, no.547
Lent by Her Majesty The Queen

Frederick, Prince of Wales (1707–51) seated wearing the hunting livery and the Ribbon and Star of the Garter, with dead game at his feet; behind him are two grooms in Royal livery as loaders. To the left John Spencer (1708–46), grandson of Sarah, Duchess of Marlborough, whom he succeeded in 1744 as Ranger of Windsor Great Park. Charles Douglas, 3rd Duke of Queensberry (1698–1778) points to the distance; he was a Gentleman of the Bedchamber to the Prince of Wales (1733–51) and Captain-General of the Royal Company of Archers (1758–1778).

On 1 February 1746 Paul Petit was paid £21 for 'a Rich picture frame Carved with birds Richly Ornamented neatly repair'd and Gilt in Burnished Gold to a picture of His Royal Highness painted by Mr Wootton', this was probably the magnificent frame still on the picture.

18 Lady Henrietta Harley hunting with harriers
Canvas: 82.5 × 137
Signed: *J.Wootton*
Prov: Possibly Wootton's sale 12 March 1761 (13); Maria Cowley, wife of the 1st Lord Ashburnham, brought as her dowry £200,000 and six pictures by Wootton; Ashburnham sale, Sotheby's 15 July 1953 (185)
Lit: See W.Shaw Sparrow, *British Sporting Artists*, 1965, p.97
Lent by Lady Thompson

For Lady Henrietta Harley see no.13.
Painted *c*.1740.

19 Hawking
Canvas: 74 × 122
Signed: *J.Wootton*
Prov: W.Hutchinson
Lent by Lady Thompson

Painted *c*.1740.

20 Race meeting on Newmarket Heath L
Canvas: 84.5 × 142.25
Prov: 4th Duke of Leeds, by descent to the 11th Duke, sold Sotheby's 14 June 1961 (16)
Exh: Virginia Museum of Fine Arts, *Painting in England 1700–1850*, 1963 (304); Royal Academy, *Painting in*

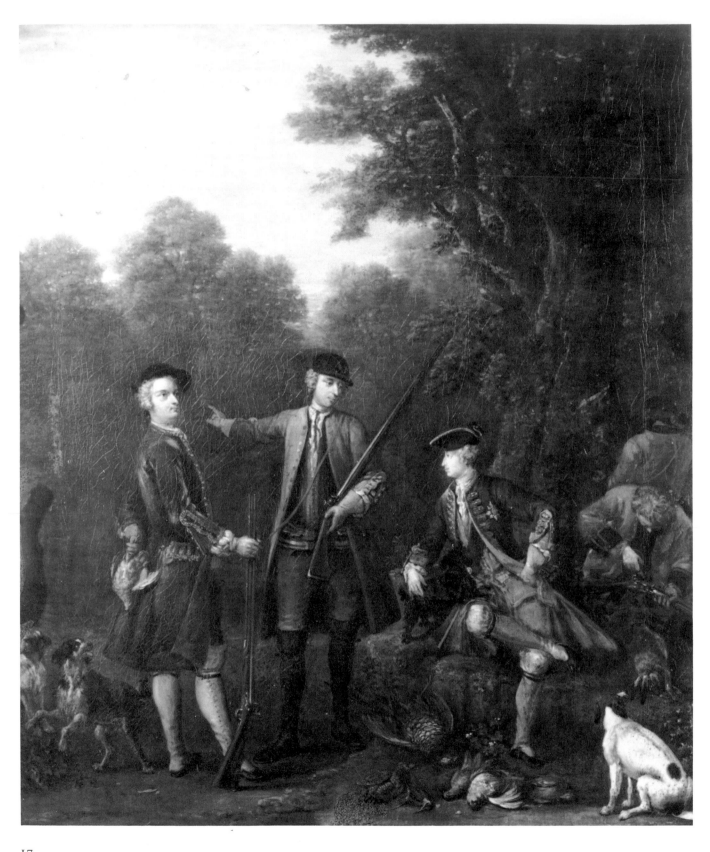

17
John Wootton
The Shooting Party

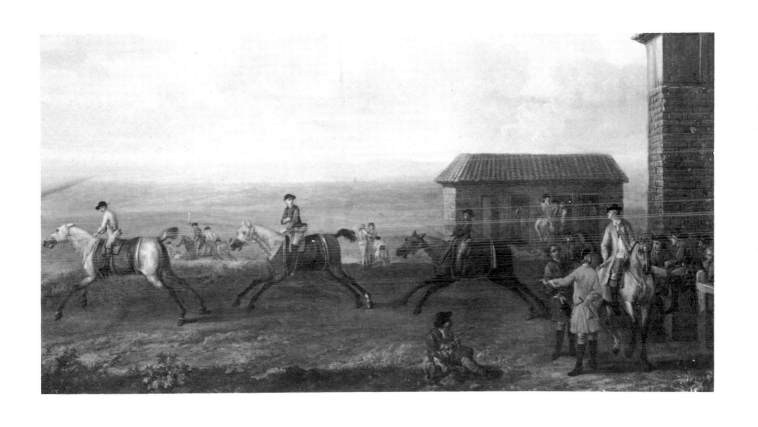

21
John Wootton
Charles, 2nd Lord Portmore and his trainer watching King
George I's racehorses at exercise

England 1700–1850, 1964 (1); Yale, *Painting in England 1700–1850*, 1965 (229)
Lit: *Hornby Castle Catalogue*, 1902, no.23; *Apollo*, April 1963, p.284; *The British Racehorse*, XVII no.2, 1965, p.174; *The British Racehorse*, XXIV no.5, 1972, p.592
Lent from the Collection of Mr and Mrs Paul Mellon, Upperville, Virginia

George II and Frederick, Prince of Wales with the Queen in a carriage behind. Tregonwell Frampton (*c*.1641–1747), Keeper of the Running Horses at Newmarket for four sovereigns, is seen speaking from the window of the carriage to the left.

★21 Charles, 2nd Lord Portmore and his trainer watching King George I's racehorses at exercise L
Canvas: 67.5 × 124.5
Inscribed: *J.Wootton*
Prov: Rev.E.H.Dawkins 1857; Christie's 28 February 1913 (25); Earl of Derby, Christie's 2 April 1971 (94)
Lit: W.Shaw Sparrow, *British Sporting Artists*, 1965, pl.13; G. Paget, *Apollo*, 1944, p.143
Lent from the Collection of Mr and Mrs Paul Mellon, Upperville, Virginia

William Hogarth 1697–1764

Portrait and history painter, engraver, author. Apprenticed to a silver plate engraver. Began publishing engravings in the 1720s. Studied under Thornhill whose daughter he married 1729. Early paintings were mostly small portraits and conversation pieces. 1732–45 painted five series of modern moral subjects, which through their engravings became lastingly popular. Founded St. Martin's Lane Academy 1735. Decorated staircase of St. Bartholomew's Hospital 1735. Governor of the Foundling Hospital 1739, for which he painted life-size portrait of *Captain Coram* 1740, as a challenge to the fashionable portrait painters – who were mostly foreigners. Painted many lively, sympathetic and successful portraits for remainder of his life, unlike history painting which culminated in the bitter failure of *Sigismunda*, 1759. Visited Paris 1743 and 1748. Published *Analysis of Beauty* 1753. Sergeant painter to George II 1757. Exhibited at Society of Artists 1761.

★22 A fishing party
Canvas: 54.9 × 48
Prov: C.Fairfax Murray; given anonymously, 1911
Exh: Royal Academy 1908 (113)
Lit: Dulwich College Picture Gallery Catalogue (562); F.Antal, *Hogarth and his place in European Art*, 1962, pp.35, 111; R.Poulson, *Hogarth: His Life, Art and Times*, 1971, I, p.218
Lent by the Governors of the Dulwich College Picture Gallery

A small early conversation group painted about 1730, the

identity of the sitters has been lost. Although painted in Hogarth's most Frenchified manner with a delicate landscape, the realistic treatment of the fishing accessories betokens a very English enthusiasm for sport.

23 James Figg, Champion of England
Canvas: 72.4 × 61
Lit: Bohun Lynch, *The Prize Ring*, pl.32
Private collection

The sport of boxing, in decline at the beginning of the reign of George I, was revived by Figg who was at his acme in the 1730s.

James Seymour 1702–1752

The son of a banker, wealthy collector and amateur artist who was a member and subscriber to the first Academy to be set up in London by a group of artists and connoisseurs in 1711. James Seymour the younger, who was popularly supposed to be able to draw horses better than any man in England, was a spendthrift and a gambler who died a bankrupt. His experiences on the Turf however, enabled him to become a successful and painstaking animal painter and he was able to make a living by painting portraits of horses, lively hunting scenes and races. What seems today a somewhat curious conformation of his horses derives in part from the fact that racehorses were normally kept indoors in the eighteenth century and very well covered lest they should catch a chill. It was not until the second half of the nineteenth century that with the aid of a camera artists were able to depict the correct movements of horses.

24 Flying Childers and grooms
Canvas: 60 × 71
Exh: Virginia Museum, *Sport and the Horse*, 1960
Lent by the Earl of Jersey

The first great thoroughbred racehorse, Flying or Devonshire Childers was foaled in 1715 by the Darley Arabian out of Betty Leedes, his maternal grandsire Careless was the best racehorse in late-seventeenth century England. The purity of his imported blood proved reliable and he became most valuable at stud.
He was bred by Colonel Childers of Doncaster who used to employ him in his early days to carry the letter bag for whom he won every time he started; the Devonshires had been connected with the Turf since its pioneering period and Flying Childers was the most famous of all their horses. Considered in his own day and for long after the best horse ever seen. Although he was undoubtedly the fastest horse of his time, his 'mile a minute' believed in the eighteenth century was definitely a legend. (Henry de Gelsey, 'Prime Ministers on the Turf', *The British Racehorse*, VIII, 1956, p.178.)

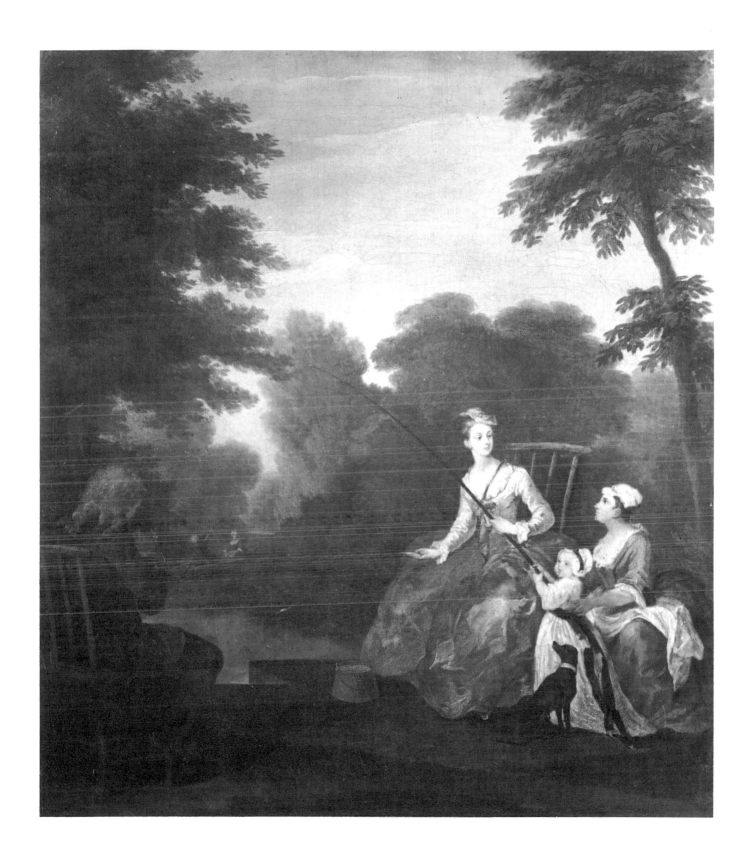

22
William Hogarth
A fishing party

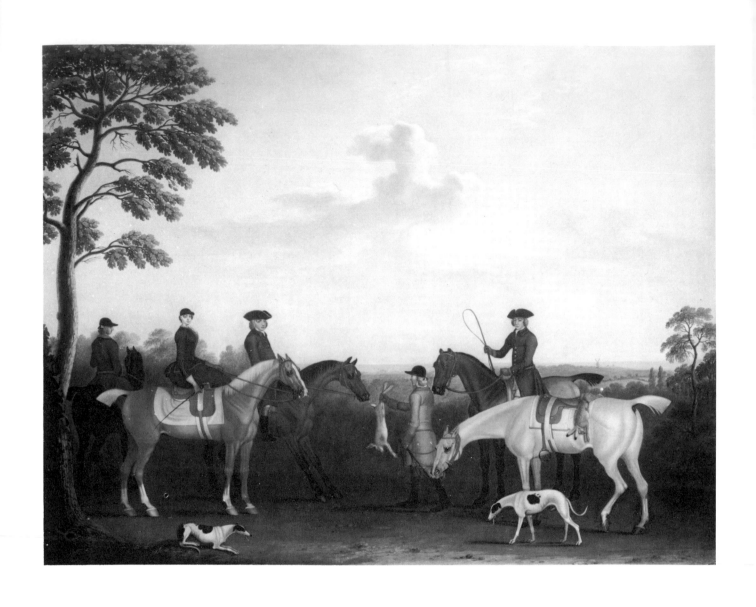

27
James Seymour
A coursing scene

25 Blank L
Canvas: 101.5 × 127
Prov: Presumably painted for 3rd Duke of Ancaster, by
descent
Lent by Earl of Ancaster

Blank, belonging to the Duke of Ancaster, a bay horse by
the Godolphin Arabian (see no.31) out of the Little
Hartley mare, was foaled in 1740; he was the grandsire of
Highflyer (see no.69).

†26 The chaise match L
Canvas: 106.7 × 167.7
Signed and dated: *J.Seymour/pinxit 1750*
Prov: Painted for 3rd Earl of March, by descent to the 8th
Marquess of Queensberry, sale 10 July 1897 (59); Sir
Walter Gilbey, sale Christie's 11 June 1915 (378);
W.M.Savell, sale Christie's 22 February 1924 (163);
London Art Market
Exh: Virginia Museum of Fine Arts, *Sport and the Horse*,
1960 (13); Virginia Museum of Fine Arts, *Painting in
England 1700–1850*, 1963 (310); Royal Academy, *Painting
in England 1700–1850*, 1964 (15); Yale, *Painting in England
1700 1850*, 1965 (163)
Engr: J.Bodger, 1789; J.Scott, *The Sporting Magazine*, 18,
1801, p.115
Lit: J.C.Whyte, *History of the British Turf*, I, 1840,
pp.473–6; W.Gilbey, *Animal Painters of England*, II, 1900,
pp.169–71; are the most important descriptions of this
much illustrated composition
Lent from the Collection of Mr and Mrs Paul Mellon,
Upperville, Virginia

The match was the result of a wager between the Duke of
Queensberry, Old Q, while Earl of March (1724–1810)
and the Earl of Eglinton on the one hand and Theobald
Taafe and Andrew Sprowle on the other for a thousand
guineas. It was stipulated that a four wheel carriage
carrying a man and drawn by four horses must be driven a
distance of 19 miles in one hour. This attempt to establish
a record involved long preparations both in selecting and
training the horses, and in designing the vehicle. A light
brake was designed by Wright of Long Acre and the
harness made of silk and whalebone with a total weight of
only two and a half hundredweight. A number of horses
were put into training so that if any of them went lame or
were 'got at' Lord March would be ready with a crack
team. The four horses who ran were Tawney, Roderick
Random, Chance, and Little Dan, the passenger in the
carriage was Lord March's groom, Thomas Wagstaff. At
about 7 o'clock in the morning of 29 August 1750 this
remarkable match was run via the Warren and Rubbing
Houses, through the ditch, to the right, three times round
a staked piece of ground of four miles and then back to the
starting point on Newmarket Heath. Their Lordships won
their wager, the actual time of the performance was
recorded as 53 minutes 27 seconds. The outcome of this
match at once raised Lord March to the position of
authority in racing matters which he retained for over

fifty years. Innumerable versions of this picture were
painted in commemoration of the event.

★27 A coursing scene
Canvas: 101 × 125.7
Private collection

Hare-hunting and coursing were by comparison with fox
and stag-hunting inexpensive and easy to organise.
Coursing was a most popular sport in the late seventeenth
and eighteenth centuries. Numerous coursing clubs were
set up from the middle of the eighteenth century and it
was only a hundred years later that the trial of dogs and
not the capture of game that became all important.
Seymour who was well known for his ability to show
details of manners and costume has here painted the
results of a successful chase.

28 Stag-hunting L
Canvas: 137.2 × 172
Lit: A.Noakes, James Seymour, *The British Racehorse*,
VII, 1955, p.192
Private collection

Seymour conveys the impression of movement in the
lively field here depicted. The details of the hunting
costumes of the two ladies in the foreground are especially
interesting.

29 Famous hunters of the Duke of York L
Canvas: 81.2 × 142.2
Exh: *English Conversation Pieces*, 1930 (41); Ackmerman,
1962 (3)
Lent by Her Majesty Queen Elizabeth, The Queen Mother

A detailed view of the inside of an eighteenth century
stable.

30 Two horses exercising on Newmarket Heath
Canvas: 29 × 62
Prov: Bequeathed by W.H.Forman, 1868, by descent
Lent by Major A.S.C.Browne, D.L.

After **David Morier** 1705?–1770

Portrait, military and sporting painter. Born at Berne,
Morier came to England in 1743. He was recorded as
'Limner' to the Duke of Cumberland with an annual
salary of £100 between 1752–64. He exhibited at the
Society of Artists 1760–8 and died in the Fleet Prison,
being buried at the expense of the Society of Artists of
which he was a member.

31 The Godolphin Arabian
Canvas: 63 × 76
Inscribed: *The Godolphin Arabian.*
*ESTEEM'D | one of the best | Foreign Horses | ever brought |
into England. | Appearing so | both from the | Country he came |*

from & from the | Performance of | his Posterity. | They being Excellent | both as Racers | and Stallions & | Hitting with most | other Pedigrees, | and mending y^e | Imperfections of | their shape. | He was the Sire | Among others of | y^e following Cattle. | Blank, Bajazet, | Babram, Slugg, | Dormouse, Regulus, | Cade.-Lath, | Whitenose, Dismal. | And y^e Grandsire of | y^c best Horses of the | present Time as Bandy, | Mercury, | Dutchess, | Amelia, L^d. Onslow's | Victorious and Cato. S^ir C. Sidley's Martin. | L^d: Eglintown's Whitefoot, | L^d. March's Dandy Cade, | M^r. Fen:^ks Byewell Tom | Matcham & Trajan. | And is allowed to have refresh'd the English Blood more than any | Foreign Horse ever yet imported. | He died at Hogmogog in 1754 | The Original Picture, taken at the Hills by D:Murrier. Painter to H:R:H. the Duke Cumberland.
Lent by the Marquess of Cholmondeley

A brown bay of about 15 hands the Godolphin Arabian was amongst the steady flow of imported Eastern stallions. Said to have been foaled in 1724 it was suspected that he had been stolen and taken to France; from there he was brought to England by 1730 by Mr Edward Coke who gave him to Mr Roger Williams, Master of the St. James's Street Coffee House who appeared also to have been a blood-stock dealer. Williams immediately disposed of him to the 2nd Earl of Godolphin who placed him at his stud at Babraham, Cambridgeshire, where the horse remained until his death in 1753.

His early life-history was serialised in novelette form by Eugène Sue in *La Presse* about 1825. The mutual attachment between the Godolphin Arabian and Grimalkin, the stable cat, adds a further air of legend and romance to the unknown origins of this famous horse who contributed greatly to the creation of the English thoroughbred. The standard likeness of the Godolphin Arabian. Stubbs' portrait of him, painted for the Turf Gallery after 1790 was taken from the same composition; 'From an original by a French artist, now in the possession of Lord Francis Godolphin Osborne, at his seat at Gogmagog Hills' (*The Sportsman's Repository; comprising a series of highly-finished engravings . . . executed in the line manner* by John Scott, 1820, p.4).
(Sir Mordaunt Miller, *The British Racehorse*, XIV, no.2, 1962, pp.188–91; R.Longrigg, *The History of Horse Racing*, 1972, pp.60–1.)

Charles Philips 1708–1747

Painter of portraits and conversation pieces. Son of a portrait painter. Patronised by Frederick, Prince of Wales.

32 William Draper of Beswick Hall 1736
Canvas: 122 × 111.8
Engr: Mezzotint by J.Faber junior
Lit: W.S.Dixon, *Hunting in the Olden Days*, 1912, pp.88–91
Lent by Sir Ian Macdonald of Sleat, Bt.

Squire Draper (1666?–1746) of East Beswick Hall, Yorkshire, painted in 1736 when the sitter was aged 66.

William Draper was King's Huntsman for the East Riding, the insignia of the office were a long drab coat down to the heels, a leather strap round the waist and a rusty hunting cap. He hunted the Holderness country, originally to protect the lambs from foxes. First Master of the Holderness Hunt he was a great lover of fox-hunting which he took up in 1726; he bred, fed and hunted a fine pack of hounds and maintained a good stud of horses. A hospitable and friendly man, he died suddenly on his return from visiting a neighbour to whom he had been giving advice about forming a pack of hounds. His daughter, appropriately named Diana, assisted her father in the field.

Thomas Smith d.1767

Known as Smith of Derby where he was born and chiefly lived. A self-taught painter he became a well known landscape artist many of whose works were engraved. He also turned his hand to sporting subjects. He exhibited at the Society of Artists and Free Society between 1760–67. The father of the distinguished mezzotint engraver John Raphael Smith.

33 Dainty Davie L
Canvas: 44 × 58.5
Signed and dated: *T.Smith 1758*
Lent by the Trustees of the Raby Settled Estate

Dainty Davie is held by a groom, a river beyond.

Allan Ramsay 1713–1784

Portrait painter. Born in Edinburgh, the eldest son of the poet of the same name. After a short training in Edinburgh, and in London under Hysing he went to Italy 1736–8, studying with Imperiale and Solimena. On his return he established a busy practice in London. He employed the drapery painter Joseph van Aken (d.1749). Governor of the Foundling Hospital. Competition from Reynolds who arrived in London 1753 encouraged Ramsay to make a second visit to Italy 1754–7. He returned with a finer and more graceful style. Appointed Principal Painter by George III in 1761 after which his time much taken up with countless replicas of his official portraits of George III and Queen Charlotte. Vice-President Society of Artists 1766. Early in the 1770s Ramsay began to acquire fame as a writer and his reputation as a painter gradually declined. He was a friend of Johnson.

***34 James 5th Earl of Wemyss 1750 L**
Canvas: 76.2 × 61
Lent by the Queen's Body Guard for Scotland, Royal Company of Archers

James 5th Earl of Wemyss (1699–1756)

34
Allan Ramsay
James, 5th Earl of Wemyss

Sir George Chalmers *d.*1791

Portrait painter. Born in Edinburgh, he inherited a title without a fortune. Studied firstly with Ramsay and later at Rome. He exhibited at the Royal Academy 1775–90. He lived for a few years at Hull and had moved to London by 1784.

35 William St.Clair of Rosslyn L

Canvas: 223.6 × 155

Prov: The Honourable Company of Edinburgh Golfers, 1833

Exh: Grafton Gallery, *Scottish Old Masters* 1895; Royal Academy, *Scottish Art*, 1939 (48)

Lit: R.A.Hay, *Genealogie of the Sainteclaires of Rosslyn*, Edinburgh 1835, pp.ii–iii

Lent by the Queen's Body Guard for Scotland, Royal Company of Archers

William St.Clair of Rosslyn (*d.*1778), as Captain of the Honourable Company of Edinburgh Golfers, aged 71, in the act of driving off the links.

William St. Clair married Cordelia, daughter of Sir George Wishart of Cliftonhall, by whom he had three sons and five daughters, all of whom died young, except his daughter Sarah.

A well known figure in his day he was vividly described by Sir Walter Scott: 'The last Rosslyn (for he was uniformly known by his patrimonial designation, and would probably have deemed it an insult in any who might have termed him Mr Sinclair) was a man considerably above six feet, with dark grey locks, a form upright, but gracefully so, thin-flanked and broad shouldered, built, it would seem, for the business of the war or chace, a noble eye of chastened pride and undoubted authority, and features handsome and striking in their general effect, though somewhat harsh and exaggerated when considered in detail. His complexion was dark and grizzled, and as we schoolboys, who crowded to see him perform feats of strength and skill in the old Scottish games of golf and archery, used to think and say amongst ourselves, the whole figure resembled the famous founder of the Douglas race, pointed out, it is pretended, to the Scottish monarch on a conquered field of battle, as the man whose arm had achieved the victory, by the expressive words, *Sholto Dhuglas,* – "behold the dark grey man." In all the manly sports which require strength and dexterity, Rosslyn was unrivalled; but his particular delight was in archery.' (*Prose Works* Vol. III, p.369).

Golf was played in Scotland as early as 1457. In 1744 the City of Edinburgh voted to the Company of Golfers a Silver Cup to be played for annually. The course of the Honourable Company is Muirfield.

Sir Joshua Reynolds, P.R.A. 1723–1792

Portrait painter. Born at Plympton, Devonshire. Pupil of Thomas Hudson 1740–3. Painted portraits in London and Devon 1744–9. Studied in Italy 1749–52. Returned to London and soon became the most distinguished and fashionable portrait painter with a wide and brilliant circle of acquaintance. Member of the Society of Artists. Became first President of the Royal Academy, Knighted 1769. Awarded Hon. DCL of Oxford 1773. Travelled in the Netherlands 1781 and 1783. Although appointed principal painter to George III in 1784, the King and Queen who disliked him placed their patronage elsewhere. His attempts at history painting in the 1780s illustrate limitations not apparent in his best portraits. His use of fugitive colours and unstable mediums have led to the decay of many of his works.

36 Francis, Marquess of Tavistock

Canvas: 124.5 × 99

Inscribed with sitter's name and date 1759

Exh: National Gallery of Scotland, Edinburgh, *Paintings from the Collection of the Duke of Bedford*, 1950 (48); Royal Academy, *Paintings and Silver From Woburn Abbey*, 1950. (84) pl.IX; Portland Art Museum, USA. January/February 1961 (20); Vancouver Art Gallery, Canada. February 1961 (20); M.H.de Young Memorial Museum, California, USA. March/April, 1961 (20)

Lit: C.R.Leslie & T.Taylor, *Life and Times of Sir Joshua Reynolds*, 1865, I, pp.269–270. A.Graves & W.V.Cronin, *Sir Joshua Reynolds PRA* 1899, III p.955 and IV, p.232. Sir W.Armstrong, *Sir Joshua Reynolds*, 1900, p.232. E.K.Waterhouse, *Reynolds*, 1941, p.53

Lent by the Trustees of the Bedford Estates

Francis, Marquess of Tavistock (1739–1767), son of the 4th and father of the 5th Duke of Bedford, married Lady Elizabeth Keppel. He wears the costume of the Dunstable Hunt – a silver-grey coat with a blue turnover collar. Whilst hunting at Dunstable he met with the accident from which he died.

Thomas Butler *fl.*1750–1755

Bookseller and stationer in Pall Mall who turned – with assistants – to the production of sporting prints and paintings. He published a series of engravings entitled *Portraitures of Horses* in 1754. He issued a prospectus announcing that 'He and his assistants, one of which takes views and paints Landskip and figures as well as most, propose to go to several parts of the Kingdom to take Horses and Dogs, Living and Dead Game, Views of Hunts etc., in order to compose sporting pieces for curious furniture in a more elegant and newer taste than has been yet. Specimens of the Landskips and other performances may be seen at my house. Any Nobleman's or Gentleman's own fancy will be punctually observed and their commands strictly observed by applying or

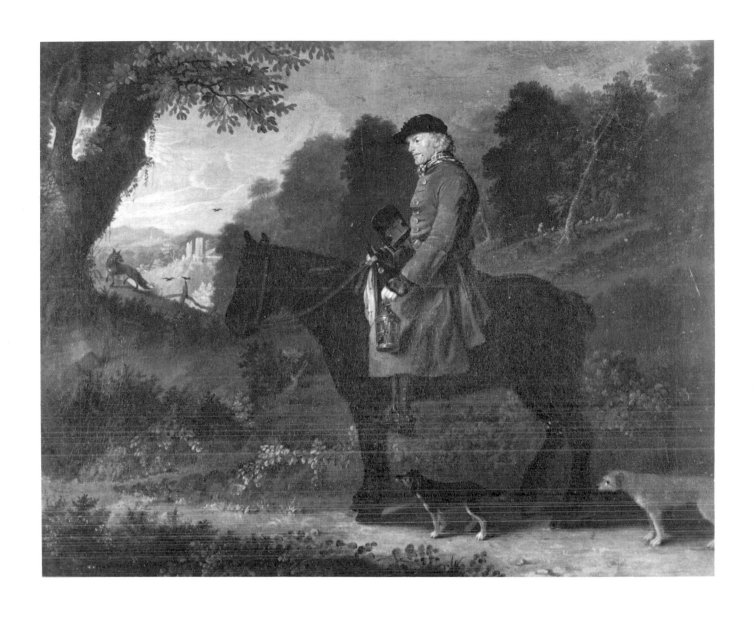

39
Nathan Drake
The earth stopper

directing as above. Will be at Newmarket this meeting and continue in the country adjacent until after the Second Meeting, and the painting of the beautiful Foreign Horse taken by Captain Rodney, Lord Northumberland's, also the more eminent Stallions will be finished this summer, with many other Curiosities in the Sporting way.' (W.T.Whitley, *Artists and their friends in England*, I, 1928, pp.78–9.)

37 Ireland beating England, Newmarket 1750
Canvas: 66 × 104
Private collection

Nathan Drake *fl*.1751–1783

Portrait and landscape painter, born at York in which city and at Lincoln he practised. Exhibited at the Society of Artists 1771–83. Probably a relation of Nathaniel Drake, artists' colourman of the White Hart, Long Acre.

38 William Tufnell with his hounds
Canvas: 99 × 132
Signed: with monogram and dated 1769
Prov: Painted for William Tufnell of Nun Monkton Priory, Yorkshire, by descent
Lit: *Connoisseur Yearbook* 1958
Lent by John Jolliffe Tufnell Esq.

William Tufnell and his huntsman at Nun Monkton Priory, Yorkshire. William Tufnell (d.1797), third son of Samuel, took the surname of Jolliffe pursuant to the terms of his grandfather Sir William Jolliffe. He inherited Nun Monkton from a maternal uncle in 1748.

*39 The earth stopper 1769
Canvas: 76 × 96.5
Prov: Painted for William Tufnell of Nun Monkton Priory, Yorkshire, by descent
Exh: Dorchester House, *Country Life Exhibition*, 1937
Lit: *Country Life*, September 1942
Lent by John Jolliffe Tufnell Esq.

40 The bailiff 1769
Canvas: 76 × 96.5
Prov: Painted for William Tufnell of Nun Monkton Priory, Yorkshire, by descent
Exh: Dorchester House, *Country Life Exhibition*, 1937 (326)
Lent by John Jolliffe Tufnell Esq.

George Stubbs, A.R.A. 1724–1806

Portrait and animal painter, engraver. Born in Liverpool. After a very short training made a living as a portrait painter in the north of England 1744–58. Visited Italy 1754. Published the *Anatomy of the Horse*, 1766. Established in London 1760 as a painter of portraits, animal, sporting and country subjects. Became the most influential and important English painter in this genre. 1773 President of the Society of Artists. 1780 A.R.A. Began painting in enamels in 1770s. Started a large series of portraits of horses for the *Turf Review*, 1790. Scraped a number of spectacularly fine mezzotints.

†*41 The Grosvenor Hunt L
Canvas: 150 × 242.5
Signed and dated: *Geo. Stubbs p.*/1762
Prov: Painted for Richard, First Earl Grosvenor, by descent
Exh: Liverpool Art Club, 1881 (94); Vokins, 1885 (26); Grosvenor Gallery, 1890 (46); Whitechapel, *George Stubbs*, 1957 (2); Agnew, *Stubbs in the 1760s*, 1970 (3)
Lit: J.Young, *A Catalogue of the Pictures at Grosvenor House*, 1821, no.2; Whitechapel Exhibition Catalogue, 1957, gives lit. up to B.Taylor, *Stubbs*, 1971, p.206
Lent by the Trustees of Anne, Duchess of Westminster's Settled Life Fund

Added to Ozias Humphrey's manuscript Life of Stubbs (Picton Library, Liverpool) is a note in another hand stating that 'in 1760, . . . he went to Eaton Hall, Cheshire, seat of Lord Grosvenor, . . . where he remained many months and among other tasks executed a very large Hunting-Piece in which were portraits of Lord Grosvenor on honest John . . . his brother Mr G., Sir Roger Moston, Mr Bell Loyd and appropriate Servants together with the scenery of the Country from the saloon of Eaton Hall. Every object in the Picture was painted from nature and very successfully executed.' Lord Grosvenor appears at the right of the tree. The huntsman on the left is blowing a French horn.

*42 Huntsmen setting out from Southill, Bedfordshire
Canvas: 61 × 105.5
Prov: Painted for George, Fourth Viscount Torrington; Colonel E.F.Hall (1929)
Exh: Whitechapel, *George Stubbs*, 1957 (4)
Lit: W.Shaw Sparrow, *A Book of Sporting Painters*, 1931, p.16
Private collection

Probably the picture referred to in Ozias Humphrey's manuscript Life of Stubbs (Picton Library, Liverpool) as having been painted for Lord Torrington – a hunting scene with the village of Southill in the background.

†43 Gimcrack L
Canvas: 96.5 × 186.7
Prov: Admiral Hon.H.J.Rous, bequeathed to the Jockey Club, 1877
Exh: *Sporting Pictures* 1931 (18); Royal Academy, *British Art*, 1934 (403)
Lit: W.Gilbey, *Stubbs*, 1898, p.132; B.Taylor, *Stubbs*, 1971, p.207
Lent by the Stewards of the Jockey Club

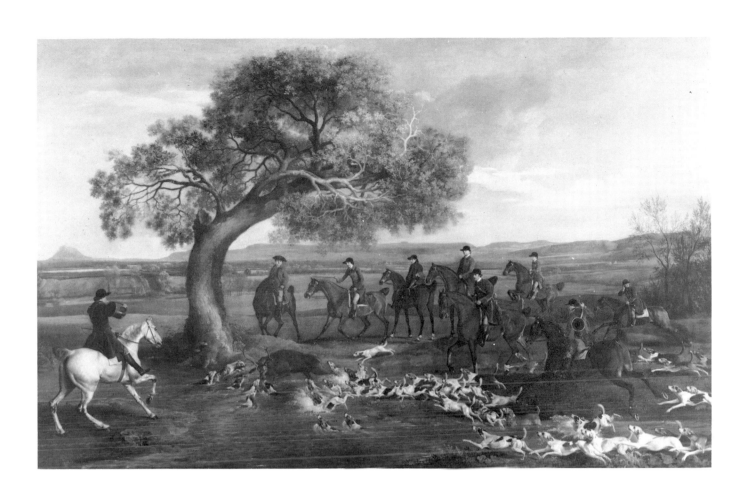

41
George Stubbs
Grosvenor Hunt (detail)

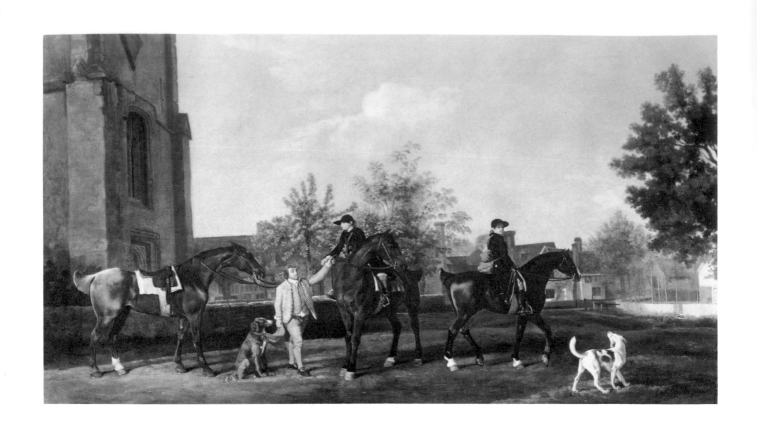

42
George Stubbs
Huntsmen setting out from Southill, Bedfordshire

Beside a rubbing down house, Gimcrack is being held by a groom while a stable boy rubs him down, the approaching jockey wears the colours of Lord Bolingbroke. In the distance at the right is a stretch of Newmarket Heath where four horses are racing–Gimcrack is in the lead. An unusually small dark grey colt of just over 14 hands, Gimcrack was foaled in 1760, a grandson of the Godolphin Arabian (no.31) by Cripple out of a mare by Grisewoods Partner and bred by Mr Gideon Elliott of Hampshire. He was subsequently owned by Mr Wildman, Lord Bolingbroke, Count Lauraguais, Sir Charles Bunbury and Lord Grosvenor. He gave the Gimcrack Club and Gimcrack Stakes at York their name, and also the Gimcrack Club, New York.

He ran first at Epsom in May 1764 and won 27 out of his 35 starts; he last raced in 1771. Through his son Medley he was important to the development of the American thoroughbred.

Lady Sarah Bunbury's description of him as 'the sweetest little horse that ever was; . . . he is delightful' reflects the charm for which he was noted. (R.Longrigg, The History of Horse Racing, 1972, pp.85, 87).

44 Eclipse L
Canvas. 100.5 × 132
Prov: Lady Sybil Grant, bequeathed to the Jockey Club
Engr: Burke
Lent by the Stewards of the Jockey Club

Held by a groom, Eclipse stands in front of a rubbing down house; a jockey wearing the colours of Colonel O'Kelly approaches him.

The most famous racehorse of the English Turf, by Marske out of Spiletta, Eclipse was foaled during the great eclipse of 1 April 1764 at the stud of the Duke of Cumberland. At first he displayed no remarkable characteristics except bad temper and he was bought by William Wildman for £75 at the sale of the Cumberland Stud in 1765.

He first ran as a five year old on 3 May 1769 at Epsom in a race of four-mile heats, winning easily at 4 to 1 on. For the second heat, an Irish gambler, Dennis O'Kelly, made a wager that he would place all the horses, pronouncing as he did so the most famous phrase in racing history: 'Eclipse first, and the rest nowhere'. Ridden by John Oakley, who had only to sit, Eclipse galloped away at the three-mile post and outdistanced the rest of the field – the distance post was usually 240 yards short of the winning post and a distanced horse was unplaced.

Dennis O'Kelly (1720–87) a lively character who had started his London life as a sedan chair carrier, was, after various vicissitudes and betting losses, thrown into the Fleet prison for debt. There he met, and subsequently married, Charlotte Hayes, one of the best known brothel keepers in fashionable London; they were both released from prison by the amnesty that followed the death of George II in 1760, and went back to their former walks of life. With the profits from her 'Cloister', Charlotte Hayes bought a house and training stable, Clay Hill near Banstead, Surrey. From there O'Kelly having made his famous bet, subsequently bought a half-share in Eclipse for 650 guineas.

Eclipse had a short career of wins and walk-overs ending in October 1770, but he was useless for betting purposes since no one would lay against him. O'Kelly bought the remaining half-share in Eclipse from Wildman for 1,100 guineas and took him to stud at Clay Hill, a matchless horse, never having been whipped, spurred or headed. In stud fees alone he earned some £25,000. By covering Herod's and Highflyer's daughters, Eclipse who sired three Derby winners, founded with Herod the most important male line.

A big horse for his time, Eclipse measured at least 15.2. After his death in February 1789 he was dissected by Charles Vial de Saint Bel who published An Essay on the Geometrical Proportions of Eclipse, 1791, in which he stated that it was worthy of notice 'that the heart weighed fourteen pounds'. His skeleton which belongs to the Royal College of Veterinary Surgeons is now on loan to the Natural History Museum.
(T.A.Cook, Eclipse and O'Kelly, 1907; R.Longrigg, The History of Horse Racing, 1972, pp.77–85; Henry Blyth, The Hight Tide of Pleasure, 1970, pp.111–134.)

*45 Gimcrack 1770
Canvas: 84 × 110.5
Prov: The Earl of Rosebery
Lent by Lord Irwin

As Gimcrack grew older he faded in colour to an almost chalky white. Here he is already lighter in shade than in no.43, painted some five years earlier.

46 Phillis, a Pointer of Lord Clermonts
Canvas: 101.5 × 127
Signed, dated and inscribed: Geo. Stubbs: 1772 Phillis, a Pointer of Lord Clermonts
Prov: Lord Forteviot; Henry Hutchinson; W.R.Rees Davies, Bt. 1951
Engr: B.Green, 1772
Lit: Leeds Art Calendar no.16, p.3; Leeds City Art Gallery Catalogue, Artists born before 1800, 1954, p.75
Lent by the Leeds City Art Galleries

47 Mares and foals 1773
Panel: 82.5 × 101.5
Prov: Painted for Richard, 1st Earl Grosvenor; by family descent
Exh: British Empire Exhibition, Wembley, 1924 (V.20); Agnew, Stubbs in the 1760s, 1970 (8)
Lit: W.Shaw Sparrow, George Stubbs and Ben Marshall, 1929, p.6; B.Taylor, Stubbs, 1971, p.207; C-A.Parker, Mr Stubbs the Horse Painter, 1971, p.64
Lent by the Trustees of Anne, Duchess of Westminster's Settled Life Fund

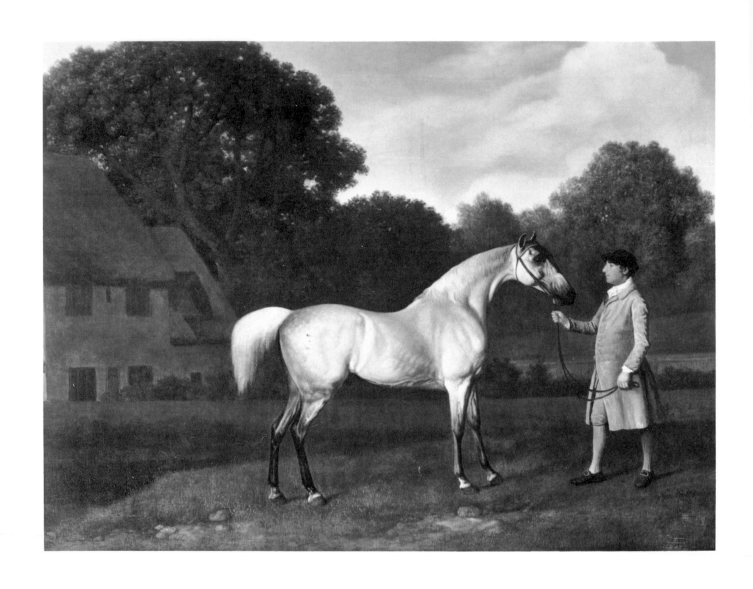

45
George Stubbs
Gimcrack

Stubbs began to paint compositions of mares and foals in a landscape in the early 1760s, they form a most inventive and impressive contribution to animal painting and reflect the high pitch of interest reached by English horsebreeders at this period.

Lord Grosvenor was one of Stubbs' early patrons (see no.41) for whom the artist painted what may possibly be the first composition of this type some ten years earlier. The landscape here represented may be a part of the Eaton Hall Estate or Lord Grosvenor's stud farm at Oxcroft near Newmarket.

48 John and Sophia Musters out riding at Colwick Hall

Panel: 96.5 × 128
Signed and dated: *Geo: Stubbs pinxit 1777*
Prov: Painted for John Musters, by descent
Exh: Royal Academy, *European Masters of the 18th Century*, 1954 (103); Whitechapel, *George Stubbs*, 1957 (8)
Lit: H.Wilberforce Bell, *Country Life*, 26 September 1936; B.Taylor, *Stubbs*, 1971, p.211; C-A.Parker, *Mr Stubbs the Horse Painter*, 1971, p.95
Lent by Major R.P.Chaworth-Musters

John Musters of Colwick (1753–1827), High Sheriff of Nottinghamshire 1777, married in 1775 Sophia, daughter of James Modyford Heywood. John Musters bought his famous pack of hounds from Lord Robert Manners Sutton in 1775; he brought them to Colwick Park and he and his son hunted for 35 seasons establishing the South Nottinghamshire country. The son John Musters became the husband of Byron's distant relative Mary Chaworth – who rejected the poet's proposal of marriage.

Viewed from below the sitters are boldly silhouetted against the sky; the architectural symmetry of the house serves to emphasise the movement of the animals. Some years after the portrait was painted the elder Musters, perhaps on account of his wife's infidelity, had both figures painted out and two walking grooms added by another hand. The picture was restored to its original appearance in the 1930s.

49 Two horses with groom in Grosvenor livery L

Panel: 81.2 × 99
Signed and dated: *Geo. Stubbs pinxit 1778*
Prov: The Earl of Caernavon, sale Christie's, 3 June 1918; Sir Edward Hulton
Exh: Walker Art Gallery, 1951 (32); Tate Gallery 1955/56; Whitechapel Art Gallery, *George Stubbs*, 1957 (24); Frank Partridge & Sons Ltd., Exhibition of *English Sporting Paintings*, Autumn 1960
Private collection

Two horses at the edge of a lake, with a groom dressed in the Grosvenor livery of yellow with black boots and a hat with white edging. The groom holds a sieve preparatory to feeding the horses; at his feet a large dog.

50 Sir Sidney Medows 1778 L

Panel: 82.5 × 101.6
Prov: Presumably acquired by George IV c.1818
Exh: Royal Academy, *King's Pictures*, 1946 (481)
Lit: O.Millar, *The Later Georgian Pictures in the Collection of Her Majesty The Queen*, 1969, no.1113
Lent by Her Majesty The Queen

Sir Sidney Medows (1701–92) riding on a white horse in a hilly landscape. He succeeded his father as Knight Marshal in 1758 and was appointed Deputy Ranger of Richmond Park in 1761. He was a famous horseman who worked regularly in his riding house for two or three hours a day until shortly before his death.

51 Ringwood—a foxhound 1792 L

Canvas: 100 × 126
Prov: Painted for the 1st Baron Yarborough, by descent
Exh: Walker Art Gallery, *Stubbs*, 1951; Roland Ward, *Foxhunting Exhibition*, 1953; Aldeburgh and Victoria & Albert Museum, *The Prints of George Stubbs*, 1969 (34); Lincoln Usher Art Gallery, 1973
Lit: B.Taylor, *Stubbs*, 1931, p.214; C-A.Parker, *Mr Stubbs The Horse Painter*, 1971, p.100
Lent by the Earl of Yarborough

Painted for Charles Pelham (1749–1823), an important patron of Stubbs, this accomplished and celebrated picture noble in form and classic in simplicity has every claim to be considered Stubbs' greatest dog portrait.
Under the 'Young' Tom Smith, huntsman to the Brocklesby from 1761–1816, the pack secured a reputation second to none. Ringwood sired by Neptune out of Vestal was born in 1788 (G.E.Collins, *History of the Brocklesby Hounds*, 1902, pp.19,20,253; Earl Bathurst, *Supplement to the Foxhound Kennel Stud Book*, 1928, p.106).

52 Baronet with Sam Chifney L

Canvas: 100.5 × 125
Engr: G.T.Stubbs, 1794
Lit: C-A.Parker, *Mr Stubbs the Horse Painter*, 1971, pp.142–6
Lent by Lord Irwin

The celebrated jockey Sam Chifney the Elder (c.1750–1807) riding the Prince of Wales' Baronet. Baronet foaled in 1785, by Vertumnus out of Penultima, was bought in 1789 by the Prince of Wales and always ridden by Chifney. He won the Oaklands Stakes at Ascot in 1791. In the advertisement for the *Turf Review*, for which this composition was painted, it was stated that 'Mr Stubbs had taken great pains to give the character and style of riding of this celebrated jockey' and described it as 'singular . . . the horse's legs are all off the ground. That moment when raised by the motion of muscular strength, a bold attempt, and as well perfected . . .' (F.Siltzer, *The Story of British Sporting Prints*, 1925, pp.256–7).
Chifney was involved in the Escape scandal at Newmarket in 1791, he had won easily for the Prince of Wales on

Escape in two races, persuaded the Prince not to bet on him in a third which he lost having said the horse was not fit, and on the following day he won on Escape against heavy odds. The Stewards of the Jockey Club thereupon told the Prince that if Chifney rode his horses again 'no gentleman would start against him'. The Prince left the turf in a huff but stood by Chifney loyally giving him a pension. (R.Longrigg, *The History of Horse Racing*, 1972, pp.93–4).

Thomas Gainsborough, R.A. 1727–1788

Portrait and landscape painter. Born at Sudbury, Suffolk. Studied at the St. Martin's Lane Academy under Gravelot and later under Hayman. Returned to Suffolk where he practised as a portrait painter, and also painted landscapes, until 1759 when he sought a more fashionable clientele at Bath. Member of the Society of Artists. Foundation Member of the Royal Academy where he exhibited portraits, landscapes and fancy pictures until a disagreement about hanging in 1784. In 1774 he settled in London and was much patronised by George III, Queen Charlotte and the Prince of Wales. For his landscapes and scenes with animals, Gainsborough discarded convention and devoted himself to the study of nature.

53 Lambe Barry L
Canvas: 33 × 30.5
Prov: Christie's 30 May 1829 (111) bt. Johnson; London Art Market 1919; Hon. Annie Cunliffe-Lister; Christie's 28 November 1930 (153); Capt. N.Colville, sale Sotheby 9 June 1955 (166)
Lit: E.K.Waterhouse, *Gainsborough*, 1958, no.40
Private collection

Lambe Barry (1704–68) in hunting costume, holding a whip. Painted about 1750.

54 A sportsman with a gun and two dogs
Canvas: 76 × 65
Prov: Christie's 6 May 1927 (125)
Lit: E.K.Waterhouse, *Gainsborough*, 1958, no.759
Private collection

Painted in the mid 1750s.

Sawrey Gilpin, R.A. 1733–1807

Painter of animals, sporting and historical pictures in which animals were involved. Became a pupil of Samuel Scott, the marine painter in 1749. He went to Newmarket about 1758 to further his knowledge of the horse and of animal anatomy. One of his earliest patrons was William, Duke of Cumberland. Gilpin painted a number of pictures for Colonel Thornton, and for Samuel Whitbread (1758–1815) M.P. who became a kind friend as well as a patron. Exhibited at the Society of Artists 1762–83;

became the Society's President 1774; exhibited at the Royal Academy 1786–1807. Worked in collaboration with portrait and landscape painters. Produced a number of important and influential animal and sporting pictures.

55 Portrait of a horse L
Canvas: 78.7 × 91.4
Signed: *S.Gilpin*
Lit: O.Millar, *The Later Georgian Pictures in the Collection of Her Majesty The Queen*, 1969, no.821
Lent by Her Majesty The Queen

A chestnut horse standing in a glade, held by a groom in livery. Painted in the early 1760s.

†56 Cypron with her brood 1764 L
Canvas: 91.5 × 157.5
Prov: Probably painted for Sir William St. Quintin
Private collection

Under a large oak tree stands Cypron, foaled in 1750, lying down behind her the yearling filly got by Regulus and at her feet Sejanus, her tenth foal, Thais and the St. Quintin mare; and her colt Senlis. On the far right held by a groom is Cypron's most famous son King Herod, foaled 1758.
Both Gilpin and Stubbs (see nos.47 & 61) painted groups of mares and foals during the 1760s, producing some of the most sensitive and poetical animal portraits ever depicted.

57 Favourite hunters of Francis Noel Clarke Mundy 1776
Canvas: 68.5 × 81.2
Private collection

For Francis Noel Clarke Mundy see no.66.

58 John Parkhurst of Catesby Abbey, Northamptonshire 1785
Canvas: 127 × 165
Prov: Walter Gilbey; Christie's 30 May 1947 (41)
Exh: Probably Royal Academy 1794 (227)
Engr: F. Babbage
Lit: W.Shaw Sparrow, *A Book of Sporting Painters*, 1931, p.33; W.Gilbey, *Animal Painters of England*, I, 1900, pp.195–6
Lent by Marcus Wickham-Boynton Esq., D.L.

John Parkhurst was known as 'handsome Jack'. He was a friend of Colonel Thornton (see no.80) whose wild and extravagant exploits he joined while his fortune permitted. He married Mary, widow of Sir Griffith Boynton.
The picture Gilpin exhibited at the Royal Academy in 1794 was 'A gentleman on horseback bringing up lag hounds to the cover. The portrait by Mr Reinagle'. The sitter has been identified as Mr Parkhurst.

59 The death of the fox
Canvas: 67 × 91.5
Exh: *Allendale Exhibition of Sporting Painters* 1931;
Virginia Museum of Fine Arts, Richmond, USA 1960
Engr: J.Ross; J.Scott
Lit: T.Thornton, *Sporting Tour in France*, II, 1806, p.228;
P.Egan, *Sporting Anecdotes*, 1832; W.Shaw Sparrow, *A Book of Sporting Painters*, 1931, p.38; C.H.Collins Baker, *British Painting*, 1933, p.146; S.Walker, *Sporting Art*, 1942, pp.75–6
Lent by S.C.Whitbread Esq.

A celebrated composition of which there are three versions. The first was painted for Colonel Thornton (see no.80) who commissioned the picture after winning a wager from some of his fox-hunting friends – that he would annually find a fox near his house at Thornville Royal that would run twenty miles. After the first year the bet was cancelled for the fox at Thornville ran twenty-three miles. The picture was painted in commemoration. The first production of its kind, Gilpin broke from the Sartorius tradition showing a novelty of conception in the movement of the hounds.
By Thornton's own account 'the dogs . . . were represented as large as life, and some of them were actually killed and fastened down in the position in which they appear to enable the artist to give the greater perfection to his work; as it was impossible to place living dogs in those positions for a sufficient length of time'.

60 A bay horse L
Canvas: 83 × 109.8
Inscribed on an old stretcher: *C.R.de Berenger, 65, Pall Mall, 26 Jan 1811. Gilpin*
Lent by S.C. Whitbread Esq.

Sawrey Gilpin and William Marlow 1740–1813

Marlow studied as a landscape painter under Samuel Scott. Exhibited at the Society of Artists 1762–90. He travelled in France and Italy 1765–8 and exhibited landscapes, including moonlight views of England, France and Italy at the Royal Academy until 1807.

***61 The Duke of Cumberland visiting his stud** L
Canvas: 106 × 139.7
Prov: 3rd Earl of Albermarle; Christie's 24 February 1883 (264); bt. by Queen Victoria
Exh: Presumably Society of Artists, 1771 (44), Royal Academy, *King's Pictures*, 1946 (494); Royal Academy, *The First Hundred Years*, 1951 (7); Virginia Museum of Fine Arts, *Sport and the Horse*, 1960 (31)
Lit: O.Millar, *The Later Georgian Pictures in the Collection of Her Majesty The Queen*, 1969, no.826
Lent by Her Majesty The Queen

A view of the Long Walk with Windsor Castle in the distance, showing the Duke of Cumberland wearing a green coat with the Star of the Garter, inspecting his mares and foals. The landscape is by Marlow and the horses from the Duke's stud by Gilpin.

Sawrey Gilpin and George Barret, R.A. 1732–1784

Barret was a landscape painter, born in Dublin where he was patronised by Burke. He came to London in 1762. Exhibited at the Society of Artists 1764–82, one of the founder members of the Royal Academy where he exhibited 1769–82. Highly esteemed in his own day, his landscapes were fresh and spirited; he was a skilful draughtsman.

62 Colonel Thornton with his pointers Juno and Pluto 1770 L
Canvas: 112 × 160
Lit: *The Sportsman's Repository; comprising a series of highly-finished engravings, representing the horse and the dog, . . . by John Scott*, 1820, pp.121–2
Lent by Winchester House Property Co. Ltd.

The Spanish pointer, introduced into England about 1730, was found to be too easily tired and became slow at the end of a day's work. In order to overcome its lack of perseverance it was crossed with the foxhound. The celebrated sportsman Colonel Thornton (see no.80) brought the improved dog prominently to the public notice. He contrived to get big prices for some of his dogs and obtained a reputation for them as being the best in England.
Pluto was famous in his day as a deer-hound running many long and successful chases after outlying deer. It is recorded that Pluto and Juno kept their point for over an hour and a quarter while Gilpin was drawing their portraits.

Sawrey Gilpin, Johann Zoffany and Joseph Farrington, R.A. 1747–1821

For biographies of Gilpin and Zoffany, see p.54 and p.57.

Farington was a landscape painter and diarist, a pupil of Richard Wilson. In 1773 he went to Houghton to make drawings of the pictures which were sold to the Empress Catherine of Russia. His drawings of views taken on many tours in England, Scotland and France were published in book form. Closely associated with every proceeding in the Royal Academy and artistic circles of London whose activity he recorded in his diary, Farington won high respect, though known as the 'Dictator of the Academy'. He exhibited at the Royal Academy from 1778–1813.

63 Henry Styleman and his first wife
Canvas: 182.2 × 259
Prov: Henry Styleman m. 2nd Miss L'Estrange, whose name he assumed; Estrange family of Hunstanton Hall;

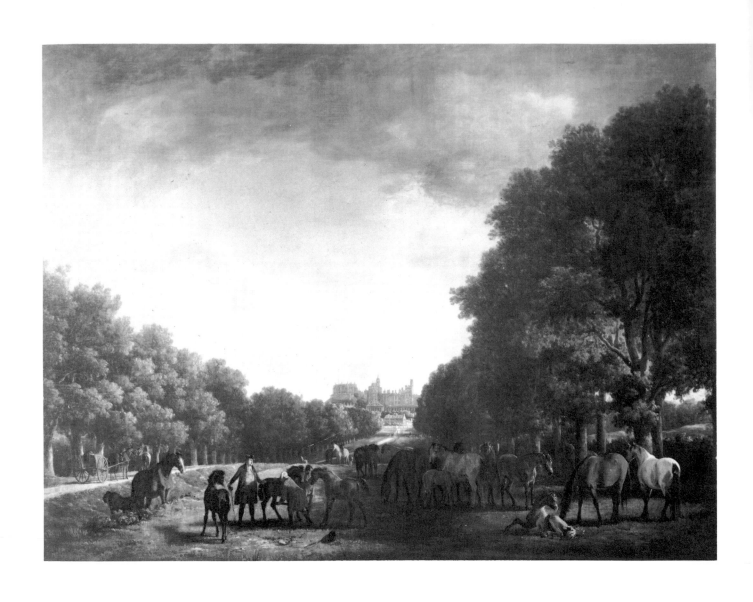

61
Gilpin and Marlow
The Duke of Cumberland visiting his stud

London Art Market, bt. 1951
Exh: Society of Artists 1783 (95); Royal Academy
British Art, 1934 (366); Norwich, *Portraits in the
Landscape Park*, 1948
Lent by Lady Thompson

Henry Styleman (1755–1819) stands holding his hat. His
first wife Mary Gregg wearing scarlet rests her arm on
the head of a bay horse, over whose neck a dark horse
thrusts his head. Behind, a groom, in front, a spaniel and
a pointer.
The catalogue of the Society of Artists states the figures
by Mr Zoffany, the landscape by Mr Farington. Gilpin is
known to have sought the collaboration of other artists
for several of his portraits and landscapes, including
Marlow (see no.61), Cosway, Walton and Wheatley.

Sawrey Gilpin and Johann Zoffany

For biographies see p.54 and below.

64 William Coates of Pasture House, Northallerton L
Canvas: 149.8 × 124.4
Private collection

William Coates (1714–1788) and his wife Anne.

Johann Zoffany, R.A. 1733–1810

Painter of portraits, genre and history pictures. Born at
Frankfurt. Trained at Rome under Masucci and Mengs.
Worked for the Elector of Trier 1759–60. Came to
England 1760. After some months of difficulty became
known as a painter of portraits and, through Garrick, of
conversation pieces. Nominated to the Royal Academy
by George III, by whom patronised. Sent by Queen
Charlotte to Florence 1772, to paint the Tribuna of the
Uffizi. Patronised by Maria Theresa who made him
Baron of the Holy Roman Empire. Returned to England
1779. In India 1783–9 where he painted portraits and
scenes of Anglo-Indian life. Exhibited at the Royal
Academy 1770–1800.

***65 A view in Hampton Garden with Mr & Mrs David
Garrick taking tea**
Canvas: 99.7 × 125
Prov: Painted for Garrick, sale Christie's 23 June 1823
(53); Lord Durham, by descent
Exh: Newcastle 1887 (853); Newcastle, *N.E.Coast*,
1929 (843); *Conversation Pieces*, 1930 (151); Royal
Academy, *British Art*, 1934 (248)
Lit: V.Manners & G.C.Williamson, *John Zoffany*, 1920,
pp.142–3, 194; G.C.Williamson, *Conversation Pieces*,
1931, p.20
Lent by Lord Lambton

At tea in the grounds of Garrick's villa at Hampton

overlooking the Thames. Mr Bowden sits to the left,
Mrs Garrick at the tea table with David Garrick on the
right; behind them stands Charles Hart Garrick's butler.
Garrick's brother George is fishing.
David Garrick (1717–79) the celebrated actor was an
early patron of Zoffany. His wife Eva Maria Violetti
(1724–1824) the reputed daughter of a Viennese named
Viegel, came to London as the guest of the Earl and
Countess of Burlington in 1746. She married Garrick in
1749. The man seated to the left is a Mr Bowden. Charles
Hart was a trusted servant of Garrick.
The picture was presumably painted in the early 1760s
and hung in Garrick's dining parlour. (*A Descriptive
Inventory of the Household Furniture and Fixtures . . .
belonging to the Dwelling house of the late David Garrick Esq.,
deceased . . . taken this 18th day of February 1779, and the
five following days* no.27, in which the sitters are identified.
(MS. Victoria and Albert Museum)).

Joseph Wright of Derby 1734–1797

Portrait and landscape painter. Born in Derby. Came to
London in 1751 to study under Hudson. Exhibited at the
Society of Artists portraits with candle and lamplight
effects, often of scientific interest. Visited Italy 1773–5,
where he saw Vesuvius in eruption. Returned to Derby
in 1779 and became involved with the literary and
scientific circles of the Midlands. Wright's moonlit
landscapes, scenes of volcanic eruption and artificially lit
subject pieces reflect his absorbing fascination with the
effects of light.

66 Francis Noel Clarke Mundy of Markeaton 1762
Canvas: 127 × 101.5
Prov: Mundy Collection; Rev Clark-Maxwell Sale
Christie's 15 May 1936 (21)
Exh: Derby 1934 (147)
Lit: Benedict Nicolson, *Joseph Wright of Derby*, 1968,
cat.110
Private collection

One of six portraits of members of the Markeaton Hunt,
painted for Francis Mundy about 1762. Mundy wears the
uniform of the hunt–navy blue coat, red waistcoat,
yellow breeches. The hound turns to sniff the severed
brush of a fox.

Francis Noel Clarke Mundy (1739–1815) J.P., High
Sheriff Co. Derby 1772; the Mundy family had been
established at Markeaton for over two hundred years and
were amongst the most prominent of Derbyshire families.
A man of literary tastes who enjoyed the life of a poet and
sportsman, Francis Mundy gravitated to the Lichfield
circle. Encouraged by Erasmus Darwin and Anna Seward,
he published anonymously a volume of his poems,
Needwood Forest in 1776 (see no.67).

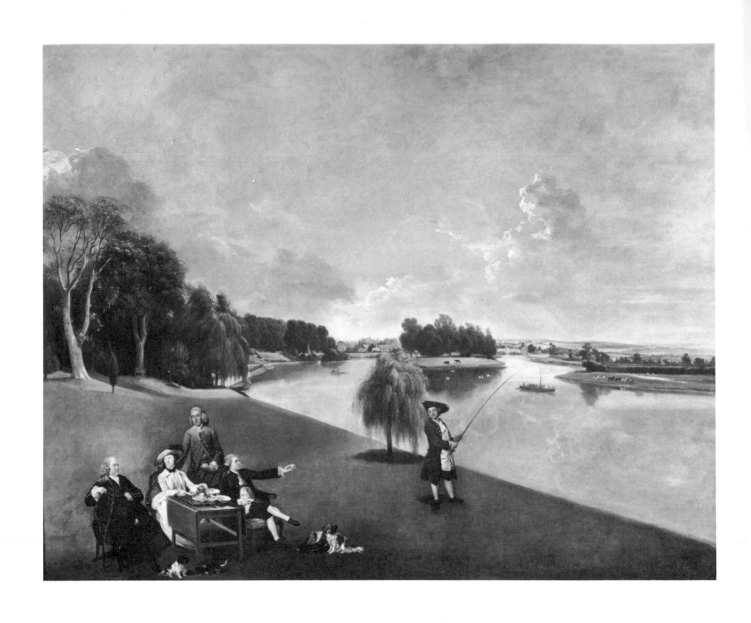

65
Johann Zoffany
A view in Hampton Garden with Mr & Mrs David Garrick
taking tea

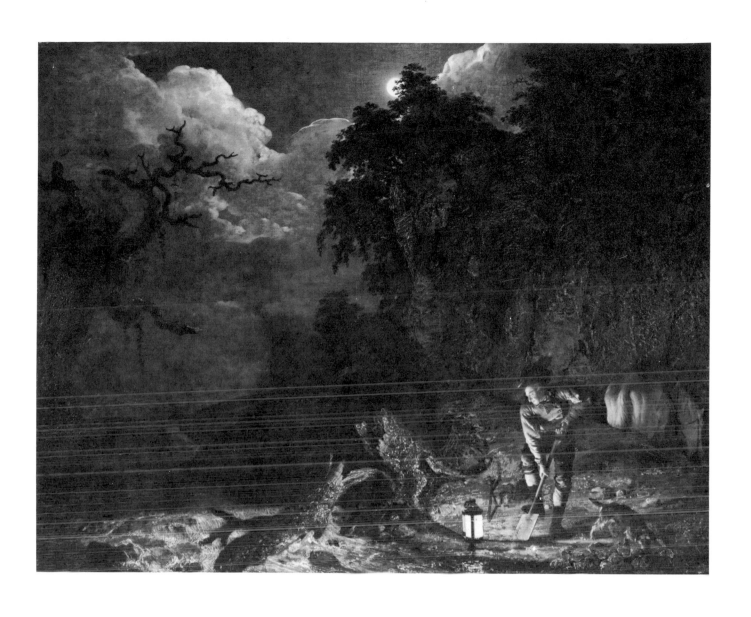

67
Joseph Wright of Derby
The earthstopper on the banks of the Derwent

***67 The earthstopper on the banks of the Derwent**
Canvas: 96.5 × 120.6
Signed and dated: *J. Wright pinxit/1773*
Prov: Philip, 2nd Earl of Hardwicke; Christie's, 17 March 1950 (123), Benedict Nicolson
Exh: S.A. 1773 (372); Tate Gallery 1958 (14)
Lit: B.Nicolson, *Joseph Wright of Derby*, 1968, Cat. 242
Lent by Derby Museums and Art Gallery

On a frosty moonlit night, the earthstopper is working to block the fox-holes to prevent the foxes taking refuge in them during the following day's hunt. He is accompanied by his dog and waiting horse. This lantern-lit scene is doubtless inspired by the same source as Francis Mundy's (see no.66) poem *Needwood Forest*:
'. . . Whilst, as the silver moon-beams rise . . .
His lantern gleaming down the glade,
One, like a sexton with his spade,
Comes from their caverns to exclude
The mid-night prowlers of the wood . . .'
A footnote refers the reader from the word sexton to 'Earth-stopper', and in a subsequent (1808) edition names him as Manuel 'the Forest earth-stopper in the hunting days of the author'. (Nicolson, *op.cit.*, p.97).

Francis Sartorius 1735–1804

Animal and sporting painter. Son of John Sartorius. Much esteemed for his portraits of horses. Exhibited at the Society of Artists and Free Society 1773–91, and at the Royal Academy 1775–90.

68 The Fermor Brothers
Canvas: 89 × 150
Signed and dated: *F.Sartorius 1764*
Prov: W.C.Cartwright, by descent
Lit: W.Gilbey, *Animal Painters of England*, II, 1900, pp.127–8
Lent by Miss Cartwright

William and Henry Fermor with a friend hunting in Aynho Park attended by three hunt servants in green liveries, they are pursuing a hare closely followed by a pack of harriers. Aynho House and Church are in the background.
William and Henry Fermor are probably the sons of William Fermor (*b.*1703) second son of William Lord Lempster and Sophia, sixth daughter of the Duke of Leeds.

Thomas Beach 1738–1806

Portrait painter. Became a pupil of Reynolds in 1760 and subsequently established himself at Bath. From there he sent 1772–83 portraits for exhibition at the Society of Artists, of which he became Vice-President in 1780. He had a wide practice and was well known in the west country. By 1785, he had moved to London and exhibited at the Royal Academy until 1797.

69 Richard Tattersall with Highflyer in the background
Canvas: 125 × 98.3
Prov: Presumably painted for the sitter
Lit: R.Longrigg, *The History of Horse Racing*, 1972, pp.70, 86
Private collection

Richard Tattersall (1724–95) 'Old Tatt', was the son of a north country yeoman. As founder of Tattersalls in 1766 he became head of the world's first and greatest company of bloodstock auctioneers. He was the proprietor of an estate at which he entertained the Prince of Wales. His most proud possession was Highflyer a champion racehorse of his time, whose portrait hangs on the wall behind 'Old Tatt'. On a table lies his stud book and over it firmly held down by a determined hand is a sheet of paper with the words 'Highflyer not to be sold'.
Herod's most important son Highflyer foaled 1774 was bred by Sir Charles Bunbury at Barton. After a triumphant turf career for Lord Bolingbroke, in which he was never beaten, he became under Tattersall a stallion almost as important as Eclipse. Tattersall named his house Highflyer Hall and it is said that the horse's stud fees financed its rebuilding; the horse's name and portrait were engraved on his table glass and on his silver. When Highflyer died in 1793 his tombstone read: 'Here lieth the perfect and beautiful symmetry of the much lamented Highflyer, by whom and his wonderful offspring the celebrated Tattersall acquired a noble fortune, but was not ashamed to acknowledge it'.
The picture represented in the background is after John Boultbee's portrait of Highflyer showing Highflyer Hall, near Ely in the distance. This portrait of Tattersall or the other version of it with the dome and ionic capitals of the 'Fox' fountain (now at Newmarket) was exhibited at the Royal Academy in 1787 (101).

John Hamilton Mortimer, A.R.A. 1741–1779

History and portrait painter. Born at Eastbourne. Came to London about 1758 to study under Hudson; also drew at the St. Martin's Lane Academy and the Duke of Richmond's Gallery. President of the Society of Artists 1774. A.R.A. 1779. Early regarded with much promise which a dissolute life curtailed, though redeemed for a few years after his marriage in 1775. Mortimer was an enthusiastic cricketer and sportsman.

***70 Broughton and Stevenson, 'The Set-to'**
Canvas: 63.5 × 76.2
Engr: Mezzotint by J.Young
Private collection

By 1742 boxing matches took place frequently, they were patronised by the nobility and tolerated by the magistrates. Both contestants here represented were well known pugilists. John Broughton (1705–1789) pugilist and yeoman of the guard was the foremost boxer of his day.

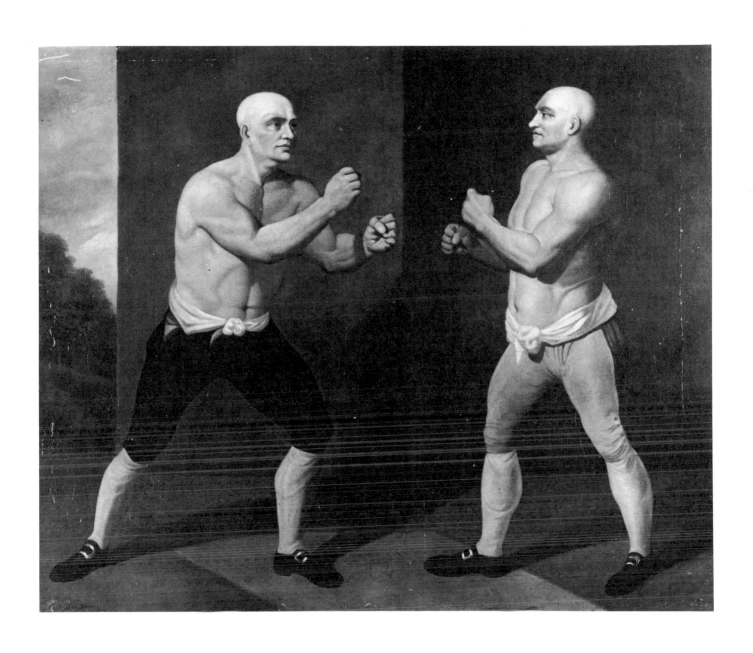

70
John Hamilton Mortimer
Broughton and Stevenson, 'The Set-to'

5 foot 11 inches tall he weighed about 14 stone; he had a good eye and was able to discover the weakness of his adversary and to cover himself. His favourite blows were straight.

Broughton's New Amphitheatre in the Oxford Road was one of the most famous of its time; part of the expenses of building it were raised by subscription. It opened on 13 March 1743. (*The Sporting Magazine*, 1793, pp.81–2.).

David Allan 1744–1796

Portrait and history painter, born near Edinburgh. Studied first at the Foulis Academy at Glasgow; in Italy from 1764–77. After a short time in London he returned to Edinburgh where he had considerable patronage as a portrait painter. Drew and engraved a number of scenes of country and cottage life which were admired for their expression and character. Exhibited a few pictures at the Royal Academy 1771–99.

71 The Fourth Duke of Atholl and family 1780
Canvas: 91.5 × 101.5
Prov: Painted for the sitter; by descent
Lit: T. Crouther Gordon, *David Allan of Alloa, 1744–1796*, 1951, pp.31–2
Lent by the Duke of Atholl

John Murray 4th Duke of Atholl (1755–1830) married 1774 Jane (1754–90) eldest daughter of Charles 9th Baron Cathcart and niece of Sir William Hamilton.
This conversation piece of the Duke with his first wife, their three eldest children, and Alexander Crerar the gamekeeper was painted after Allan's return to Scotland from Italy. Writing to his friend and patron Sir William Hamilton in Naples in November 1780, Allan reported, 'I got employment in the small portrait way and the Duchess of Athole was so good as to call me to the Highlands to paint their family in a group, which I did. That pure air improved my health and has introduced that kind of painting, and has the prospect of being well employed in this way. The Duchess is most amiable and quite like the heavenly disposition of the late Lady C(athcart), has three children, two girls and a charming boy. I painted them on the green, with the Duke returning from the hunting in the Highland dress, his gun under one arm and in the other a heath cock which he holds out to the little marquis who is running to take it. The Duchess with the others sitting on a bank looking on, and in the distance Athole House with a view of the country, which please very well and figures about two-feet high'.

John Boultbee c.1745–1812

John Boultbee was born at Stordon Grange, Leicestershire; his twin brother Thomas was also a painter, principally of portraits although he exhibited three sporting paintings. In 1776 the brothers, living at 338 Oxford Street, London, both exhibited for the first time paintings (landscapes) at the Royal Academy. John Boultbee's main interest does not clearly emerge until 1783, when he exhibited, from Derby, the portrait of the stallion Penscroso, the property of the Leicestershire farmer T. W. Coke. Boultbee's work from this point consists of fairly straightforward horse and cattle painting. In 1785 he painted the famous horse Highflyer for Richard Tattersall, and from that date became a recognised horse painter, in a style deeply influenced by Stubbs but of a more pedestrian nature. In 1788, while resident near the heart of the Quorn country in Loughborough, he exhibited a hunting subject at the Royal Academy; he later painted several pictures of incidents on the hunting field, distinguished by a curious, yet attractive, naivity. Near Loughborough, at Dishley Grange, lived Robert Bakewell, the pioneering stockbreeder whose experiments in the selective breeding of certain strains produced the celebrated Leicestershire Longwool sheep, and the modern Shire heavy horse. Boultbee painstakingly recorded for Bakewell many of these improvements in a series of paintings of great documentary interest. His portrait of Bakewell is in the Leicester Art Gallery. George III was an admirer of Boultbee's work for Bakewell, but a commission to paint stock at Windsor does not appear to have come to anything, perhaps due to the artist's failing health. His sporting pictures are less well-known than the paintings of stock, but they possess at their best an engaging clumsiness that gives his work a sturdy individuality despite the obvious debts to Stubbs.

72 Portrait of Mufti, with jockey up
Canvas: 69.3 × 89
Signed
Lent by the Duke of Bedford

73 Portrait of Dragon with the jockey Stevens and a trainer on a course
Canvas: 69.9 × 90.2
Signed
Lent by the Duke of Bedford

74 Portrait of Windsor, a black hack, in a landscape
Canvas: 69.8 × 88.8
Signed
Lent by the Duke of Bedford

75 Colonel Rawlinson on his horse
Canvas: 66 × 91.5
Lent by Major R. P. Hedley Dent

Colonel Rawlinson of Ancoats Hall, Lancashire is portrayed on his horse Magnet in Knowsley Park. This painting has been attributed to several artists.

James Northcote, R.A. 1746–1831

History and portrait painter. Pupil of Reynolds 1771. Visited Italy and Flanders 1770–80. Set up in London where he painted history pictures, animals and portraits. *Published Life of Sir Joshua Reynolds*, 1813.

76 Grouse shooting in the Forest of Bowland 1802 L
Canvas: 145.5 × 217
Prov: Painted for Thomas Lister Parker of Browsholme, by descent
Exh: Royal Academy 1803 (145)
Engr: George Dawe, 1804
Lit: T.L.Parker, *Description of Browsholme Hall*, 1815, p.9; S.Gwynn, *Memorials of an Eighteenth Century Painter*, 1898, p.277
Lent by Col Robert Parker of Browsholme Hall in the Forest of Bowland

William Assheton (1758–1833) of Downham and Cuerdale, Lancashire, High Sheriff of Lancaster 1792, and the Reverend T.H.Dixon Hoste (1779–1805) of Godwick Hall, Norfolk, Fellow of Trinity College, Cambridge.
Thomas Lister Parker (1779–1858) F.S.A., F.R.S. of Browsholme for whom the picture was painted, was hereditary Bowbearer of the Forest of Bowland and Trumpeter to the Queen. He succeeded to the Browsholme estates in 1797. His historical and antiquarian tastes led him into the circles of intellectual families in the north; he was an intimate friend of Charles Towneley and Dr Whitaker. In London he became the friend and patron of West, Turner, Northcote and Romney. Returning to Browsholme after a tour of the continent in 1800–1, Thomas Lister Parker had lavish alterations made to the Hall under the superintendance of Sir Jeffrey Wyattville. He hung his large collection of portraits and sporting pictures by Northcote in his dining-room. (T.D.Whitaker, *History of Whalley*, I, 1872, pp.337–8.)

Francis Wheatley, R.A. 1747–1801

Portrait, landscape and genre painter. Trained at Shipley's drawing school. A friend of Mortimer who influenced him. In Ireland 1779–83 where he painted a number of large group portraits, and landscapes in oil and watercolour. Returned to London and developed genre of sentimental realism, painting many small pictures for engraving – best known are *The Cries of London*, begun 1795. His portraits of country gentlemen and sportsmen were commended for their good likenesses. Executed large historical pictures for Boydell, R.A. 1791. Exhibited at the Royal Academy 1778–1801.

★77 The return from shooting
Canvas: 156.2 × 209.5
Signed and dated: *F.W.Pinxt. 1788*
Prov: Painted for the 2nd Duke of Newcastle, by descent
Exh: Royal Academy 1789 (17); National Portrait 1867 (649); Royal Academy 1879 (14); on loan to Nottingham Museum Art Gallery 1929; Royal Academy *British Art* 1934 (376)
Engr: F.Bartolozzi and S.Alken 1792; without the Star on the Duke's breast 1803
Lit: *Clumber Catalogue* 1923, p.56, no.134; M.Webster, *Francis Wheatley*, 1970, pp.109, 137
Lent by the Trustees of the Seventh Duke of Newcastle, Deceased

Henry Fiennes Pelham-Clinton, 2nd Duke of Newcastle (1720–94), riding a chestnut horse wears a grey coat with the Star of the Garter; behind him is Colonel Litchfield; William Mansell the gamekeeper bends down to couple two Clumber spaniels; Day the underkeeper is putting game into a sack; at the far right is Rowlands the Duke's valet, with a shooting pony. Clumber House since destroyed, is seen in the distance.
Henry Clinton was a well-known and enthusiastic sportsman. On a visit to France probably at some time during the 1760s he received as a gift from the duc de Noailles several couples of 'cock-springers'. They were brought home to Clumber, after which they were named and placed under the management of William Mansell. They were used to work in front of the gun to flush game.

Philip Reinagle, R.A. 1749–1833

Animal and landscape painter. Studied at the Royal Academy Schools 1769. First employed as an assistant to Ramsay, after 1785 he turned to landscape and animal painting. Was well known for his hunting pictures and portraits of dogs. Exhibited at the Royal Academy 1773–1827.

78 Water spaniel
Canvas: 62.2 × 75.2
Exh: Royal Academy, 1805 (144)
Lent by the Viscount Wimborne

79 Carrom Abbey Hunt L
Canvas: 91.5 × 122
Lent by the Viscount Bearsted

Philip Reinagle and John Russell, R.A. 1744–1806

Portrait painter in pastel and oil. A pupil of Francis Cotes. Appointed Crayon Painter to the King and the Prince of Wales. Interested in astronomical studies. Exhibited at the Society of Artists 1768 and at the Royal Academy 1769–1806.

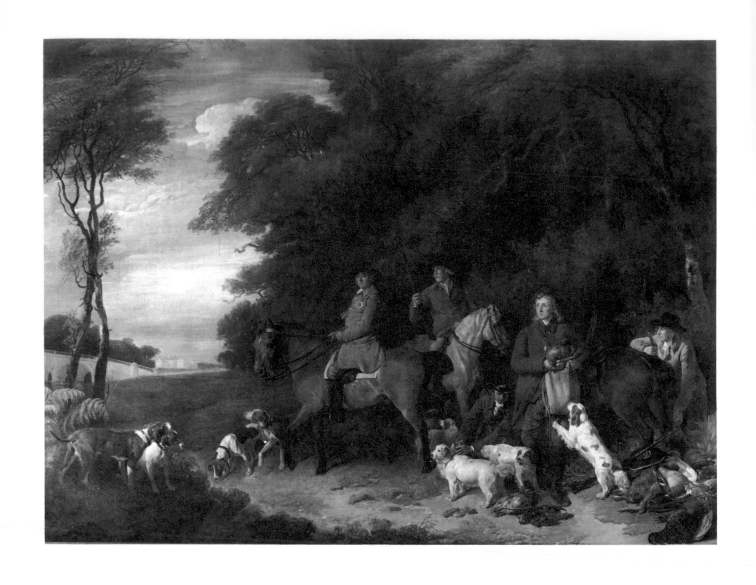

77
Francis Wheatley
The return from shooting

80 Colonel Thornton
Canvas: 61 × 45.5
Signed on reverse: Russell (and) P.Reinagle pinxit
Thornville Royal 1792
Prov: Mr Fleming of Barochan, by descent; bequeathed
by Miss Catherine Fleming, 1863 to her cousin W.C.
Stewart Hamilton (1831–1876) 5th of Craichlaw House
Exh: Glasgow 1911
Lit: J.Gladstone of Capenoch, 'The Barochan Falconry
Heirlooms', *Transactions of the Dumfriesshire and
Galloway . . . Antiquarian Society*, XXXVI
Private collection

Colonel Thomas Thornton (c.1755–1823) the most
celebrated sporting figure of the late eighteenth and early
nineteenth centuries, was a liberal patron of sporting art.
He came into an immense fortune at the age of 22,
devoting the remainder of his life to sport. He was above
all else passionately fond of hawking, in 1771 together
with the Earl of Orford, he founded the Falconry Club of
Great Britain.
In 1789, Colonel Thornton – he had gained this title by
joining the West York Militia – bought from the Duke of
York, Allerton Maulevrer, which he renamed Thornville
Royal. It is said that the £110,000 he paid for the estate
was won by gambling. There he set up his famous
sporting establishment, where every sporting activity was
carried out on the most magnificent scale. His hounds
were renowned, he was a familiar figure on the Turf as
both owner and rider, he was an excellent shot and a
good fisherman.
The first to investigate the sporting possibilities of the
Scottish Highlands he went on a sporting tour in the early
1780s, which he recorded with detail in *A Tour of the
Highlands*, 1784; George Garrard (see p.69)
accompanied him as artist on this tour. In 1802 he went on
a sporting tour of France taking with him his fourteen-
barrelled gun (now in the Musée d'Armes, Liège). He
received a brace of wolves as a present and proposed
letting them loose in Yorkshire in order to hunt them,
but was forced to desist. His tour, with splendid
illustrations after an English artist Bryant and a French
artist Lucas who accompanied him, was published as
A Sporting Tour in France, 1806.
Finding that the crops hindered hawking from Thornville
Royal he built a house on the Wolds near Baythorpe
where hunting, hawking, coursing by day and sumptuous
banquets by night entertained the guests on a splendid
scale. In 1805 he sold his Yorkshire establishments and
moved to Spye Park in Wiltshire and was able to indulge
his favourite sport of falconry on Salisbury Plain. The
procession which accompanied the king of sport was truly
regal: huntsman, falconers, grooms, keepers, kennelmen,
horses, hounds; wagons with red-deer, roebuck, fallow-
deer, Russian wild boar, cormorants, terriers and
greyhounds. A wagon was filled with hunting weapons
and others contained wine from the renowned cellars of
Thornville Royal. About 1815 the Colonel gave up
hawking and retired to France where he died.

Now a rare sport, falconry was at the height of its
popularity at the end of the sixteenth century in England.
Its long history and importance are reflected in the Game
Laws from Norman times. The first blow to hawking
was the invention of the fowling piece, which made the
killing of game more sure, and the second the enclosures
of land which meant that large tracts were no longer
available. The antipathy of falconers to sportsmen with
guns is expressed by their toast: 'A health to all that shot
and missed'. (W.Gilbey, *Animal Painters of England*, I,
1900, pp.211–4).

Samuel Alken 1756–1815

Son of Sefferin Alken, a carver and gilder, born in London.
Alken started his artistic career as an architectural and
decorative draughtsman, and became an accomplished
engraver of landscape and sporting subjects. He was the
father of Henry Alken (1785–1851), the best known of a
family of sporting artists many of whose works are
inextricably tangled. (W.Shaw Sparrow, *Henry Alken*,
1927, pp.45–50.)
From the mid 1780s Samuel appears to have devoted
himself to sporting subjects in oil, water colour and
engraving. Attractively and accurately drawn, his scenes
of hunting and shooting are characteristic reflections of
the mode of the participants.

81 Partridge shooting
Canvas: 87 × 124
Signed: S Alken
Prov: Walter Stone Collection (7a); bequeathed by Miss
Mary Stone, 1944
Exh: Delft, 1940–50, *Merry Old England* (13); National
Gallery, 1945; *Walker Art Gallery Acquisitions 1945–55*
(87), Whitechapel 1950, *English Sporting Pictures* (20)
Lit: Walker Art Gallery Picture Book No.5, 1949,
Twenty Sporting Pictures (16)
Lent by the Walker Art Gallery, Liverpool

Early in the nineteenth century shooting was still usually
practised behind pointers, but in Norfolk driving the
birds into fields of turnips or other roots and walking
them up was common. The dogs, setters and a pointer
are working in the foreground amidst such typical cover,
while in the distant corn field can be discerned birds
seeking cover in the high stubble left by the scythe.

***82 Pheasant shooting**
Canvas: 87 × 124
Signed: S.Alken
Prov: Walter Stone Collection (73); bequeathed by Miss
Mary Stone, 1944
Exh: National Gallery, 1945, *Walker Art Gallery
Acquisitions 1945–1955* (88); Bluecoat School, Liverpool,
1953, *Walter Stone Collection* (2).
Lit: Walker Art Gallery Picture Book No.5, 1949,
Twenty Sporting Pictures (17)

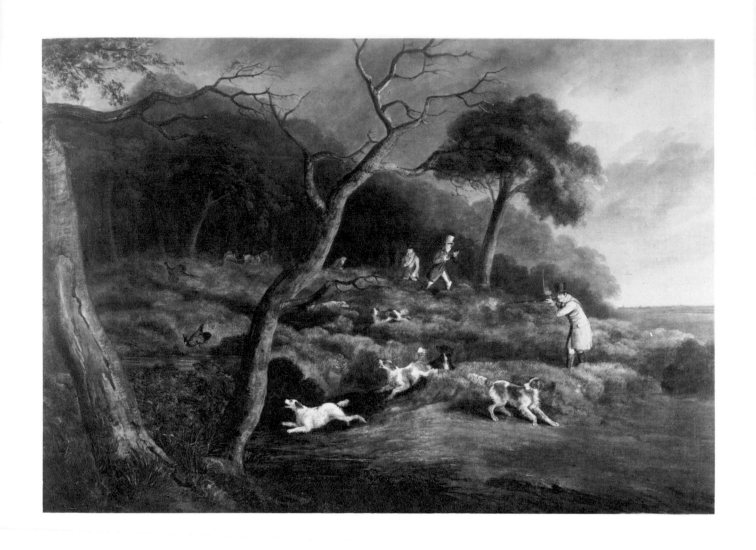

82
Samuel Alken
Pheasant shooting

Lent by the Walker Art Gallery, Liverpool

This lively scene shows a pheasant flushed out by the dogs, over whom a shot has been fired. It falls to the ground, while another flies towards the safety of the copse.

83 Hunters at cover-side – Fly and Dash
Canvas: 46 × 61
Signed: *S.Alken*
Prov: bt. Fores about 1911
Engr: J.Pollard, 1822
Lit: W.Shaw Sparrow, *Henry Alken*, 1927, pp.52–3
Private collection

Fly and Dash, a chestnut and a bay horse, favourite hunters of Colonel Thornton. (See no.80).

84 Coursing
Canvas: 44.5 × 63.5
Private collection

85 Coursing
Canvas: 49.5 × 63.5
Private collection

Sir Henry Raeburn, R.A. 1756–1823

Portrait painter, born near Edinburgh. First apprenticed to Gilliland, a silversmith, Raeburn began to paint miniatures and about 1775 with the encouragement of the leading Scottish portrait painter David Martin, branched out into oils. After his marriage to Ann Edgar, widow of James Leslie, he came to London and proceeded on the advice of Reynolds to study in Italy. He returned to Edinburgh in 1787 and quickly gained a wide practice and pre-eminence. In 1812 he became President of the Society of Artists in Scotland; R.A. 1814. He exhibited at the Royal Academy 1792–1823. Knighted by George IV in 1822 and appointed His Majesty's Limner for Scotland 1823.

86 The Reverend Robert Walker, D.D., skating on Duddingston Loch 1784 L
Canvas: 73.6 × 61
Prov: Presented by the painter to Mrs Walker after the death of the sitter in 1808; by descent to Miss Beatrix Scott; Christie's 6 March 1914 (89); Miss Lucy Hume, sale Christie's 25 Feb. 1949 (80) bt. for the National Gallery of Scotland
Lent by the National Gallery of Scotland

Robert Walker (1755–1808), born at Monkton, Ayrshire, son of William Walker, later minister of the Scots Church, Rotterdam. He was licensed by the Presbytery of Edinburgh, 24 April 1770; ordained to Cramond 1776; presented by George III, translated and admitted to Canongate Kirk, Edinburgh, 19 August 1784; died 30 June 1808. In addition to more devotional publications he was the author of the account of 'Kolf, a

Dutch game' (*Statistical Account of Scotland*, xvi), with which his residence in Holland had made him familiar. Dr Walker joined the Skating Society in 1784.

*87 Dr Nathaniel Spens 1791 L
Canvas: 237.5 × 147.3
Prov: Painted for the Royal Company of Archers
Exh: Edinburgh R.S.A. 1863 (193); Edinburgh *Raeburn* 1876 (157) and 1884 (219); Royal Academy, *Old Masters*, 1877 (268); Edinburgh, *Loan*, 1901 (147); Royal Academy, *British Art*, 1934 (446); Royal Academy, *Scottish Art*, 1939 (118)
Engr: J.Beugo 1796
Lit: Armstrong, *Raeburn*, 1901, pp.63, 73, 76, 90, 112; Mackay, *Scottish School*, 1906, p.43; Caw, *Scottish Painting*, 1908, p.73
Lent by the Queen's Body Guard for Scotland, Royal Company of Archers

Nathaniel Spens (1728–1815), M.D., President of the Royal College of Physicians of Edinburgh (1794–6), was a prominent member of the Royal Company of Archers, of which he became President in 1809. He stands full-length in Archer's uniform. This masterly portrait shows the degree of insight and skill that Raeburn attained early in his career.

John Hoppner, R.A. 1758–1810

Portrait painter, studied at the Royal Academy. Brought to the notice of George III who assisted him as a youth; by 1785 Hoppner was working for the Royal family. Exhibited portraits at the Royal Academy from 1780–1809.

88 Portrait of Richard Humphreys
Canvas: 61 × 76.2
Private collection

John Nost Sartorius 1759–after 1824

Animal painter, son of Francis and grandson of John Sartorius. A prolific painter of animal and sporting subjects, particularly well known for his lively depictions of the Quorn and Belvoir Hunts. Exhibited at the Society of Artists and Free Society 1776–83 and at the Royal Academy 1781–1824.

89 Newmarket Races 1810
Canvas: 53.5 × 76
Lent by the Earl of Jersey

90 Hunting scene 1825
Canvas: 91.5 × 66 (including frame)
Lent by the Kintore Trust

A pair to no.89.

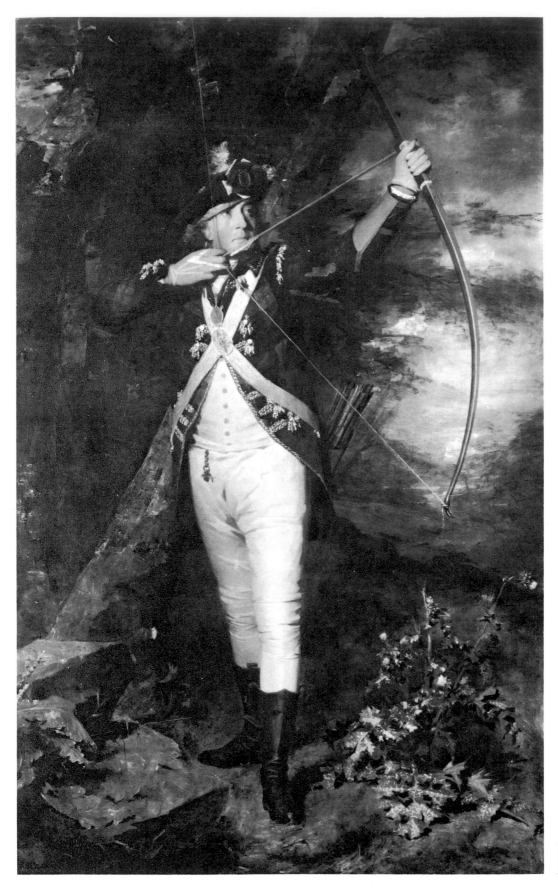

87
Sir Henry Raeburn
Dr Nathaniel Spens

91 Hunting scene 1825
Canvas: 91.5 × 66 (including frame)
Lent by the Kintore Trust

92 A match on Beacon Course Newmarket
Canvas: 32.1 × 182.8
Private collection

George Garrard, A.R.A. 1760–1826

Painter of animals, sporting life and landscapes. After 1795 began to practice as a modeller exhibiting many portrait busts, some models and reliefs of animals. A pupil, and son-in-law, of Sawrey Gilpin, he also studied at the Royal Academy, where he exhibited regularly 1781–1826. Garrard accompanied Colonel Thornton on his sporting tour in Scotland about 1786 as artist. He was much commended for his ability to paint animals in landscape scenes adapted to sport.

★93 Racehorse with jockey up L
Canvas: 85 × 108
Signed and dated: *G.Garrard/1786*
Prov: The Duke of Hamilton, sale Hamilton Palace Collection 8 July 1882 (1100), bt. Milligan; by descent, Christie's 18 November 1960 (103)
Exh: Possibly Royal Academy 1786 (424); Virginia Museum of Fine Arts, *Painting in England 1700–1850*, 1963 (343); Royal Academy, *Painting in England 1700–1850*, 1964 (290); Yale, *Painting in England 1700–1850*, 1965 (95)
Lit: A.Bury, *The British Racehorse*, XVII, no 2, 1965, p.171; S.H.Pavière, *A Dictionary of Sporting Painters*, 1965, pl.17
Lent from the Collection of Mr and Mrs Paul Mellon, Upperville, Virginia

94 Greyhounds in a landscape L
Canvas: 76.2 × 101.5
Inscribed: *Greyhounds watching a terrier London 1789*
Prov: Sotheby 29 January 1925 (69)
Lent by Peter Johnson Esq.

George Morland 1763–1804

Animal and landscape painter. Son of Henry Robert Morland by whom taught. Studied at the Royal Academy schools. Exhibited at the Royal Academy 1773–1804. In spite of prolific output, his dissipated existence made him a prey to unscrupulous dealers. Spent much of his life fleeing, not always successfully, from his creditors.

95 Ferreting 1792
Canvas: 28.5 × 37.5
Prov: Bequeathed by W.H.Forman 1868; by descent
Exh: Hatton Gallery, Newcastle upon Tyne, *Festival Exhibition* 1951 (27); Arts Council, *George Morland* 1954 (21)
Lent by Major A.S.C.Browne, D.L.

★96 Going into cover
Canvas: 51 × 66
Private collection

97 Hunting scenes
Canvas: 22.9 × 27.9
Lent by the Earl of Bradford, T.D., J.P.

1st. Hacking to the meet	4th. The chase
2nd. Drawing cover	5th. The kill
3rd. Breaking cover	6th. Hacking home

A set of six small sketches of lively hunting scenes representing episodes in a winter day's sport.

Thomas Gooch *exh.*1778–1802

A painter of animals – principally dogs and horses, sometimes including portraits of their owners. Possibly a pupil of Sawrey Gilpin from whose address he sent his first exhibited pictures at the Society of Artists. Retired from London at the turn of the century, sending the last of over 80 pictures to the Royal Academy from Lyndhurst, Kent. His work was warmly praised the *Old Sporting Magazine* but is now largely unidentified.

98 The life of a race-horse, in a series of six different stages L
Canvas: 30.5 × 45.5
Exh: Probably Royal Academy, 1783 (239)
Engr: By T.Gooch 1792 with an essay by Dr Hawkesworth 'tending to excite a benevolent conduct towards the Brute Creation'
Lit: W.Shaw Sparrow, *A Book of Sporting Painters*, 1931, Ill, opp .pp.32, 36, 37; B.Taylor, *Stubbs*, 1971, p.28
Lent by the Viscount Bearsted

1st. The foal with the mare	4th. As a hunter
2nd. The colt breaking	5th. As a post horse
3rd. The time of running	6th. His death

An early example of the treatment of animals in human terms which became popular in the nineteenth century. The series of engravings had considerable influence with philanthropists. Gooch may have painted more than one such series.

William Webb *c.*1780–*c.*1845

Originally a clock-maker, Webb first painted at Tamworth in Staffordshire, but later moved to Melton Mowbray, where he died. He exhibited seven times at the Royal Academy and once at the British Institution; he painted lions and other animals as well as sporting subjects. His most famous painting, which became well known through engravings, was a portrait of John Mytton, Squire of Halston.

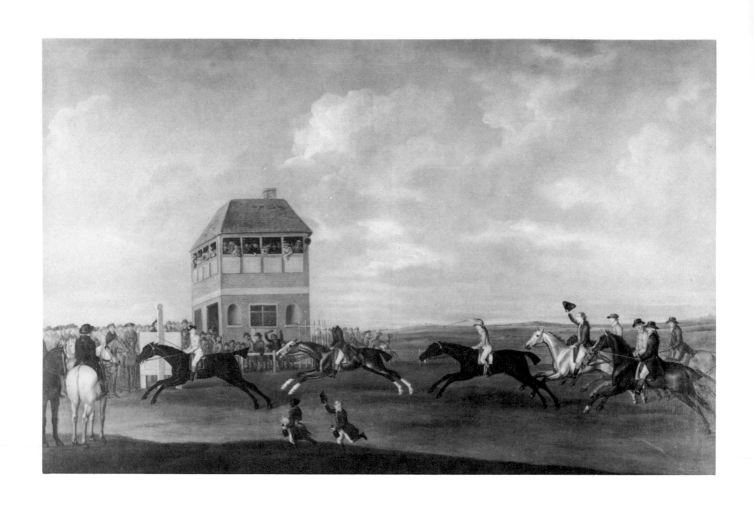

92
John Nost Sartorius
A match on Beacon Course, Newmarket

93
George Garrard
Racehorse with jockey up

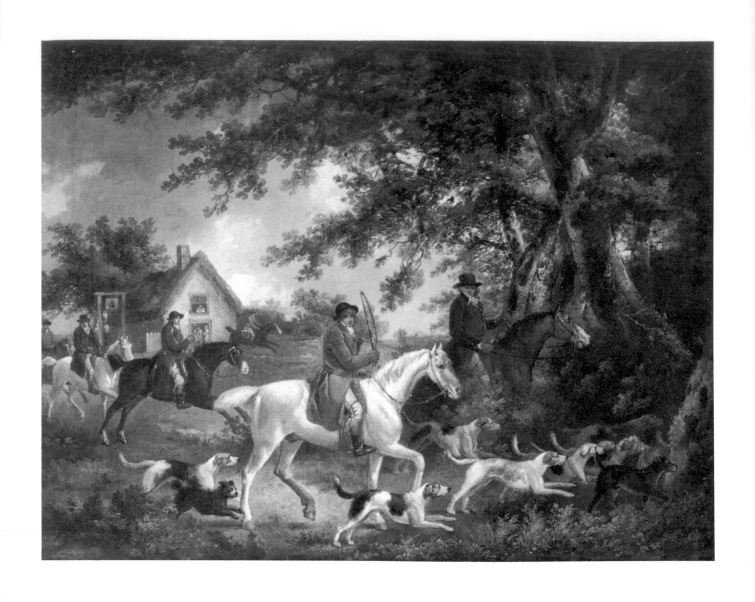

96
George Morland
Going into cover

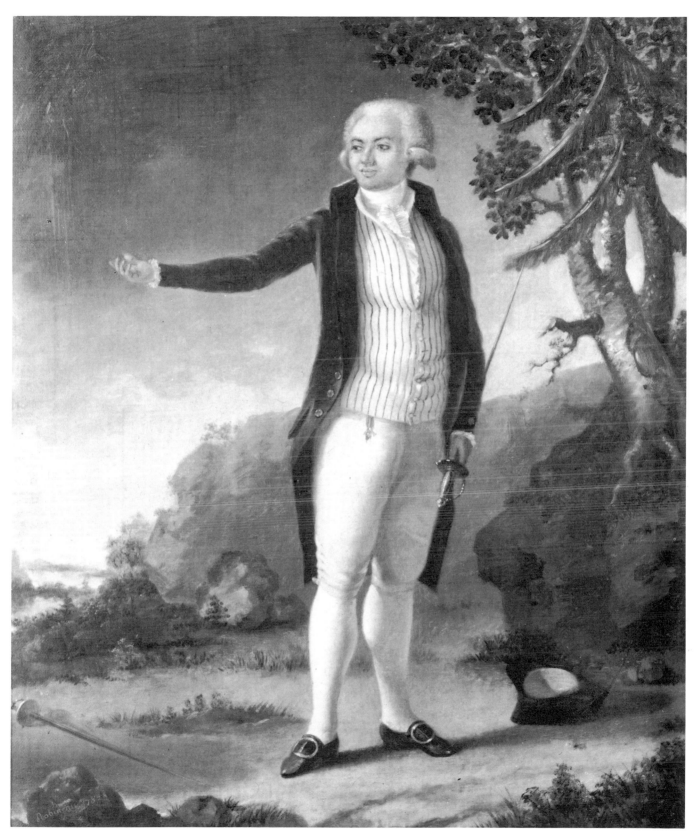

100
Charles Jean Robineau
The Chevalier de Saint-George

99 Shooting in Freeby Wood
Canvas: 89 × 111.8
Private collection

Charles Jean Robineau fl.1780–1806

Portrait painter and musical composer. He practised in
Paris and came to London during the 1780s, exhibiting at
the Royal Academy in 1785 and 1788. In 1806 he was
inspector of a drawing school for the French government.

★100 The Chevalier de Saint-George L
Canvas: 61.3 × 51.1
Signed and dated: *Robineau 1787*
Prov: Probably painted for George IV
Lit: O.Millar, *The Later Georgian Pictures in the Collection
of Her Majesty The Queen*, 1969, no.1049
Lent by Her Majesty The Queen

A creole and a celebrated swordsman, athlete and amateur
musician, he stands full-length in a landscape holding a
sword, his hat and another sword, belonging to a disarmed
adversary, and lying on the ground beside him.
Apparently a favourite with the Prince of Wales, he took
part in fencing contests before him.

Luke Clennell 1781–1840

Born 8 April 1781 at Ulgham, near Morpeth,
Northumberland. He was apprenticed to Thomas Bewick
at the age of 16, and executed some of the designs of
Robert Johnson for the second volume of Bewick's *Birds*
published in 1804. He settled in London in the same year,
and practised as an engraver until 1812, when he was
elected an associate of the Watercolour Society. Also in
1812 he exhibited for the first time at the Royal Academy.
In 1814 he collaborated with Ben Marshall on a portrait of
the famous sportsman and bookbinder, Thomas Gosden.
In 1816 Clennell won the British Institution's prize for his
sketch of *The Decisive Charge of the Life Guards at Waterloo*,
and the success of this, and of another painting of the
battle, led to a commission to paint a large picture
commemorating the meeting of the allied sovereigns at
the Guildhall Banquet. In 1817 the strains of this
commission led to his insanity and his career ended,
although he lived on until 9 February 1840, when he died
in a Newcastle Asylum.

★101 Sportsmen regaling
Canvas: 114 × 152.4
Prov: H.S.Goodhart-Rendel
Exh: British Institution 1813; Laing Art Gallery,
Newcastle on Tyne, *Luke Clennell*, 1951; Ackermanns,
London, *Annual Exhibition of Sporting Paintings*, 1963
Lent by Arthur Ackermann and Son Ltd.

Clennell's genre subjects included studies of fishermen and
fairground scenes, but his first exhibited picture at the
Royal Academy was *Foxhunters regaling after the Chase*.
This painting, of the same kind, captures the simple
pleasures of a halt for refreshment at an inn in the depths of
the countryside. The bulky riders are mounted on small
but sturdy ponies, ideally suited for the rigours of a day's
cross-country shooting. Such shooting scenes provide a
record of the minor pleasures of the English yeoman
farmer before the organised battues, with an army of
beaters and huge bags, of the Victorian era. What such
genre scenes as this do not record are the effects of the
severe game laws of a period in which the preservation of
game for organised shooting allowed the widespread use
of mantraps and spring guns laid to maim poachers.

102 Duck shooting
Canvas: 55.2 × 44.5
Private collection

John Ferneley 1782–1860

John Ferneley was born at Thrussington, Leicestershire on
18 May 1782. He was apprenticed to his father, a master
wheelwright, until he was twenty. There seems little
reason to doubt the romantic story of the young Ferneley
using the foreboards of waggons brought in for repair as
supports for paintings of hunting incidents, for by the
1780s Leicestershire, as a result of enclosures, had become
almost entirely grassland and the best hunting country in
England where foxhunting took place six days a week.
The famous Billesdon Coplow to Enderby run of 24
February 1800, in which a fox ran 28 miles before evading
a field of 200 riders, led Ferneley to produce the first of his
'scurries', an innovation in canvas size with which his
name will always be associated. These long and narrow
rectangular pictures (see nos.104 and 106) graphically
record the variety of thrills and spills that make for a
memorable run. The painting was brought to the
attention of the Duke of Rutland, who arranged for
Ferneley to go to London in 1801 as an apprentice to Ben
Marshall for a fee of £200. Ferneley stayed with Marshall
for three years, and studied in the Royal Academy schools.
From 1804 he travelled fairly extensively, visiting Dover to
paint the Leicestershire Militia, Lincolnshire, and Ireland
(where he stayed for about a year in 1808). In 1814 he
settled in Melton Mowbray where, apart from annual
visits to London for the summer season and occasional
trips to execute commissions in Hampshire, Scotland and
the North of England, he remained until his death on 3
June 1860.

Nimrod (C.J.Apperly), writing of Melton Mowbray in
the *Quarterly Review* of 1830, estimated that the average
sportsman hunting from the town maintained a stable of
ten horses, costing at least 200 guineas each and 1,000
guineas to keep in stables, and judged the income the town
received from these sportsmen to be £50,000 a year.

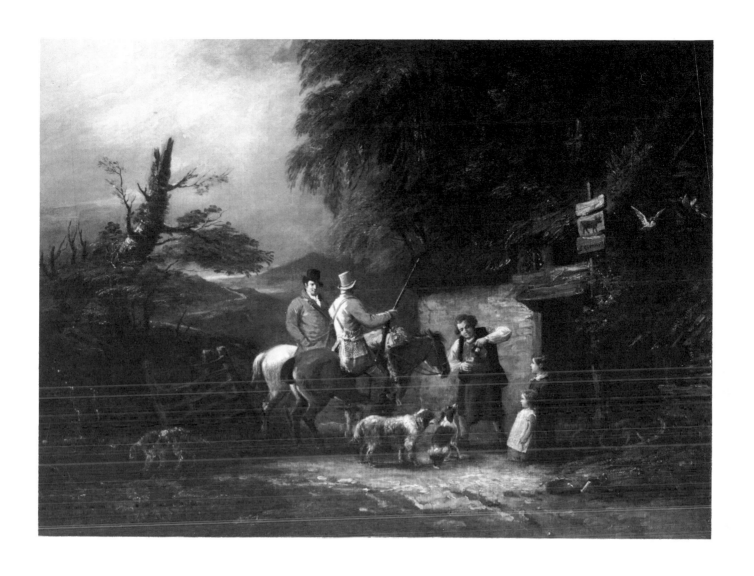

Luke Clennell
Sportsmen regaling

These sportsmen were Ferneley's patrons. His transactions with them have survived in his account books; his fees remained constant throughout his career, being ten guineas for a horse portrait, seven for a cow, and 30 to 60 guineas for larger compositions, depending on the numbers depicted. His paintings possess a sparkle, a glossy vivacity and elegance, that recall the work of Sir Thomas Lawrence, and he displays a remarkable gift for capturing vivid likenesses of both horse and rider.

(Guy Paget, *The Melton Mowbray of John Ferneley 1782–1860*, Leicester 1931; Colin D.B.Ellis, *Leicestershire and the Quorn Hunt*, Leicester 1951; catalogue of the exhibition *John Ferneley 1782–1860*, Leicester Museum and Art Gallery 1960.)

*103 John, Henry and Francis Grant at Melton
Canvas: 132 × 195.5
Signed and dated: *J.Ferneley/Melton Mowbray 1823*
Prov: By descent in the Grant family until acquired by Leicester Museum and Art Gallery, 1967
Exh: Leicester Museum and Art Gallery, *John Ferneley 1782–1860*, 1960 (13)
Lent by Leicestershire Museums and Art Galleries

Sir Francis Grant, P.R.A. (1803–1878; p.110) is seen here with his two brothers, all wearing the immaculate outfit of the fashionable 'Meltonians' of the Regency, who prided themselves on the cut of their coats, and the high gloss of their boots, which were cleaned with a mixture of boot blacking and champagne. On the left can be seen the tower of Melton Mowbray church, and behind Sir Francis stands a dead tree, a favourite compositional motif in Ferneley's work.

104 Sketch for 'The Quorn at Quenby 1823'
Canvas, laid on board: 45.7 × 96.5
Prov: Charles Ferneley; purchased by Leicester Museum and Art Gallery from Miss Margaret A.Geden, 1936
Exh: Het Prinsenhof, Delft, *Engelse Jachtschilderijen*, 1949–50 (23); Whitechapel Art Gallery, *Sporting Pictures*, 1950 (36); Leicester Museum and Art Gallery, *Leicestershire Hunting Pictures*, 1951 (9); Leicester Museum and Art Gallery, *John Ferneley 1782–1860*, 1960 (15)
Lent by Leicestershire Museums and Art Galleries

A sketch for *The Quorn at Quenby, 1823*, a large picture (190.5 × 391cms) in the possession of Sir Richard Bellingham Graham of Norton Conyers (see Sparrow *op cit* pp.191–2, repr, facing p.192, and Paget *op cit* pp.54–5, repr. in colour facing p.54). Ownership of this picture was decided by lottery in 1825, 42 shares of five guineas each having been subscribed. The winner was Sir Bellingham Graham, Master of the Quorn at the time the picture was painted. He is prominently featured in the sketch, below the tree on the left, riding his favourite horse 'Baron'. Subscriptions were invited for an engraving of the finished picture by C.Turner, but owing to insufficient support this project was not carried out.

105 Lord Cardigan's mares and foals
Canvas: 160 × 254 (including frame)
Lent by Edmund Brudenell Esq.

James Thomas, Lord Brudenell, later 7th Earl of Cardigan, was as a young man an ardent Meltonian, and perhaps acquired on the hunting field the qualities of reckless physical courage which were to distinguish him in the Charge of the Light Brigade during the Crimean War. He was also a great patron of Ferneley, and the family seat of Deene Park contains one of the largest collections of the artist's works regularly open to the public. The two entries for Brudenell pictures in Ferneley's account books for 1830 and 1844 do not refer to the present picture, which dates from 1823.

106 Run at Croxton Park 1824
Canvas: 61 × 122
Lent by the Kintore Trust

Ferneley's account books are unfortunately missing for the year 1824, but Anthony Adrian, 7th Earl of Kintore was one of the artist's constant patrons and a devoted sportsman. In August 1824 Ferneley stayed with him at Keith Hall, Aberdeenshire, in order to make notes for his large picture *Meet of the Keith Hall Foxhounds*, and this painting of Croxton probably commemorates the 7th Earl's earlier successful season in the shires.

107 Run near Melton Mowbray 1824
Canvas: 167.5 × 78.8 (including frame)
Lent by the Kintore Trust

Another example of Ferneley's work for the 7th Earl of Kintore.

*108 John Henry Bouclitch, Lord Kintore's keeper, shooting roebuck at Keith Hall 1824
Canvas: 68.6 × 99.1
Lent by the Kintore Trust

While staying at Keith Hall in August 1824, Ferneley greatly enjoyed the opportunities for field sports. In a letter home, he wrote: 'I killed 2 brace of Grouse in Good Stile . . . we kild 8 Roes one I kild myself . . . this I consider the pleasantest days sport I ever had . . . yesterday whent a fishing today I am getting ready for work'. Despite such attractive diversions, the artist succeeded here in capturing brilliantly the character of the old man, for forty-five years the Head Keeper of the Estate of Kintore. The 7th Earl was keenly interested in possessing such likenesses of humbler devotees of sport; in 1844 he wrote to Ferneley thanking him for a portrait of George Marriot, a Melton draper whose blue coat, metal buttons, and superb horses were renowned on the hunting field. The present picture appears as no.270 in Ferneley's account book, and he charged £10.10.0 for it.

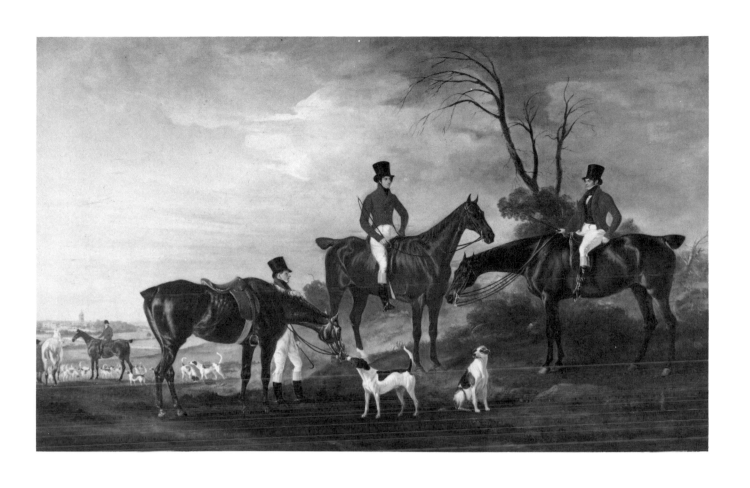

103
John Ferneley
John, Henry and Francis Grant at Melton

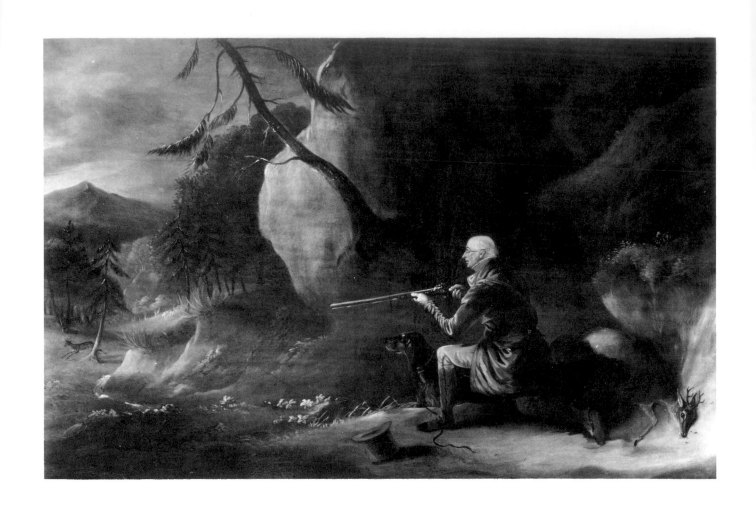

108
John Ferneley
*John Henry Bouclitch, Lord Kintore's Keeper, shooting
roebuck at Keith Hall*

109 Sir Francis Mackenzie, 5th Baronet of Gairlock L
Canvas: 104.1 × 147.3
Signed and dated: *J. Ferneley, Melton Mowbray 1829*
Private collection

In a classified list of the best performers at Melton between 1820 and 1830, with the formality of a University Honours list, Sir Francis is accorded a third class. Ferneley charged £31.10.0 for this picture, no.275 in his account book, where it is described as 'Sir Francis Mackenzie, Portrait of himself, Two Horses and Mackenzie Esq'.

110 The Favourite Greyhound of the Rev. Francis Best, Vicar of South Dalton, near Beverley 1833 L
Canvas: 101.5 × 83.8
Private collection

Ferneley's account books record his work for November 1833: 'The Rev T. Best, South Dalton . . . Portraits of Four Greyhounds in a Group. £21.0.0'. Their names were Treasure, Gabrielle, Butterfly, and Harpy. The present picture would appear to have been painted at about the same time.

111 Silver firs at Osberton L
Canvas: 223 × 155
Signed and dated: *J. Ferneley/Melton Mowbray 1835*
Lit: Paget *op cit* p.44, repr. facing p.45 (the date is incorrectly given as 1826)
Private collection

This shooting picture includes portraits of Sir William Milner and his son-in-law, G.S. Foljambe, with their Clumber spaniels, in a wood of silver firs, the treatment of which may perhaps in part be influenced by the artist after whom Ferneley had named his son — Claude Lorrain.

112 The Cur, winner of the Brighton Stakes L
Canvas: 96.5 × 124.5
Signed and dated: *Melton Mowbray, 1848*
Prov: Baroness Stuart Stevenson of Perth
Exh: Royal Academy 1849
Private collection

In 1848 The Cur won the Brighton Stakes, the Cambridgeshire, and the Cesarewitch. This portrait was painted for W. Crawford Esq, who paid £10.10.0 (account book no.600). Racing portraits of this kind feature increasingly in the later years of Ferneley's career.

113 Carriages outside Apsley House
Canvas: 127 × 214.5
Lent by the Earl of Bradford

Every year Ferneley used to visit London during the summer season, where he painted horse portraits for his patrons, but even in London he remained devoted to open-air settings, particularly Rotten Row and the fashionable end of Hyde Park. The Marble Arch, the Achilles Statue, and the Serpentine Bridge all feature in the backgrounds of his London pictures. The present painting is an especially successful example of Ferneley's ability to capture the elegance and glitter of smart London equipages.

†114 John E. Ferneley and his favourite hunter
Canvas: 99 × 124.5
Private collection

Paget (*op cit*) claims that Ferneley signed some of his pictures *John E. Ferneley* or *J. E. Ferneley*, but no second name appears either in the Parish Register, his will, or on his tombstone. Like so many sporting artists his children inherited his gifts to a more limited extent. His sons, John Ferneley junior 'of York', Claude Loraine Ferneley, and his daughter Sarah, were all painters, and assisted him at times with his work. Sarah married the portrait painter Henry Johnson, whose portrait of his father-in-law is in the National Portrait Gallery.
It is possible that the present painting, which probably dates from the 1840s is a collaboration between the artist and one of his sons, or son-in-law.

Charles Towne 1763–1840

Born in Wigan, Towne gained some knowledge of landscape painting from the Lancashire painter John Rathbone, and a training in coachpainting from Robert Latham, the Liverpool coachbuilder. At the age of 17 he set up as a japanner and decorative painter in Liverpool, and exhibited a landscape at the 2nd exhibition of the Liverpool Society for Promoting Painting and Design in 1787. He also copied Stubbs' *Harvesters* and *Reapers* which were exhibited there. By the 1790s he emerged as an experienced animal painter, and he settled in Manchester for a few years, later moving to London in the early 1800s. In London, Towne met De Loutherbourg and Morland, whose romanticised rural subjects are echoed in his own early work, although his style developed a more delicate and aethereal quality. He returned to Liverpool in 1810/11, and became Vice-President of the new Academy of Artists in 1812. He exhibited there until 1825. He died on 6 January 1840. He should not be confused with Charles Towne of London, a painter of similar subjects (1781–1854). There is an extremely perceptive essay on Towne in W. Shaw Sparrow *op cit* 1931.

(Exhibition catalogue *Charles Towne* Walker Art Gallery, Liverpool 1971–2.)

★115 Gentleman returning from shooting
Panel: 30.5 × 38.3
Signed: *C. T.*
Prov: Walter Stone Bequest 1944 (Inv.no.2341)
Lent by the Walker Art Gallery, Liverpool

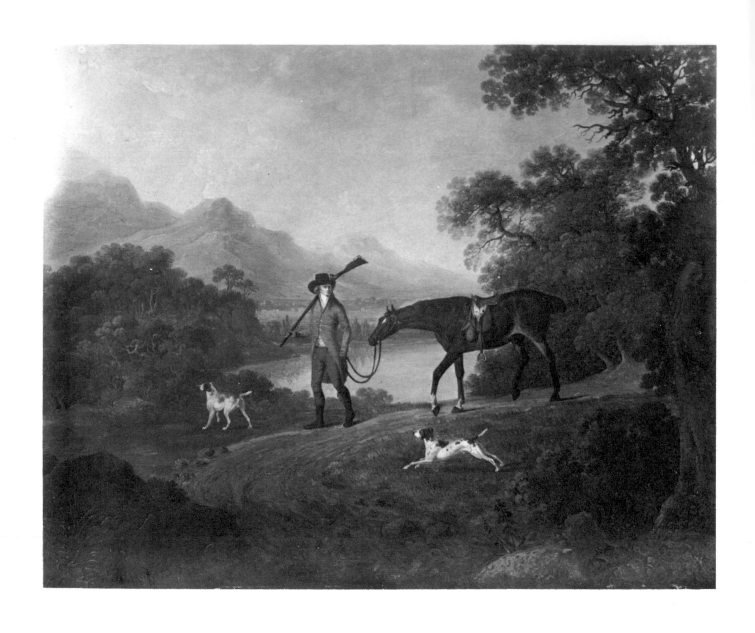

115
Charles Towne
Gentleman returning from shooting

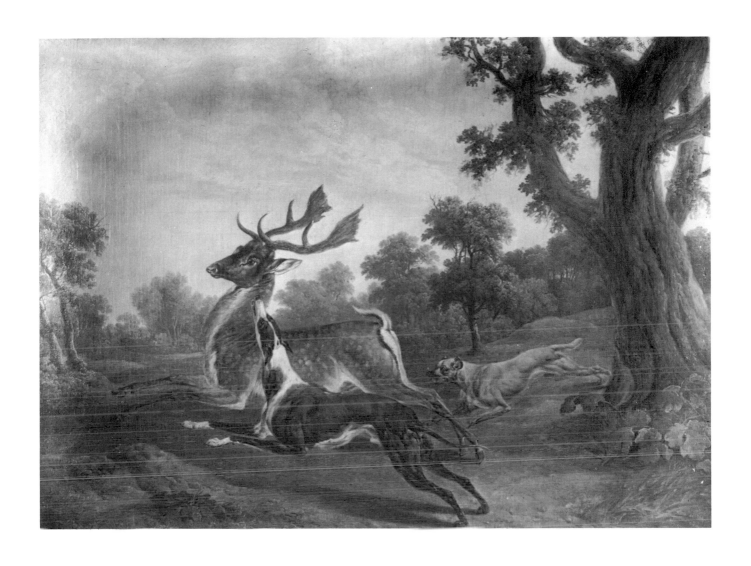

120
Charles Towne
Mischief in a park

A typical shooting subject of the 1790s; a successful blend of the solid realistic manner of Stubbs with the romantic and theatrically composed landscapes of De Loutherbourg.

116 Equestrian portrait of John Yates L
Canvas: 99 × 21.9
Signed with initials: *C.T.*
Lent by Roy Miles Fine Paintings, London

The painting dates from 1794, the year of Towne's move to Manchester. Among his chief patrons at this time were the Yates family, and this portrait shows John Yates of Barton, brother of the first Lady Peel, the mother of Sir Robert Peel. He is riding Mr Clifton's horse Ninety-Three, the winner of the 1793 St. Leger, and he is wearing the Old Windsor Hunt dress, a yellow waistcoat, a long blue coat with a red collar, riding boots with very wide tops, and a tall dark hat with a narrow curly brim. The horse wears a running martingale. Shaw Sparrow *(op cit)* notes that 'the high key of colour used in this painting may have been suggested by acquaintance with the work of Jean Pillement (1728–1808). The picture possesses the curious blend of naivity and sophistication, particularly in the sombre glazes of the landscape, characteristic of the artist's work at this time, when he is moving towards the exact miniature technique of his later work'.

117 Gentleman on a white mare
Panel: 80.5 × 66
Signed and dated (partially illegible): *Charles Towne/1799*
Lent by the Walker Art Gallery, Liverpool

Possibly the picture exhibited at the Royal Academy in 1799, sent from a London address, called *Portrait of a Gentleman and trotting mare*.

118 Gentleman on a black shooting pony talking to an attendant
Canvas: 61.4 × 77.5
Signed: *C.T.* (in monogram)
Prov: Walter Stone Bequest 1944
Lent by the Walker Art Gallery, Liverpool

Towne used this monogram at least as early as 1796, when he made copies of classical landscapes by Richard Wilson for Henry Blundell of Ince. This painting may, however, date from the early 1800s.

119 Fishing *c.*1810
Panel: 33 × 38.1
Prov: Hutchinson collection
Lent by Lady Thompson

★120 Mischief in a park
Canvas: 49.5 × 67.3
Signed: *C.T.* (in monogram)
Prov: Walter Stone Bequest 1944
Lent by the Walker Art Gallery, Liverpool

Probably the picture exhibited at the Liverpool Academy in 1812 as *Fallow Deer and dogs: 'But alas he flies in vain'*. It is one of Towne's occasional essays in the grand manner, with wild animals at bay, imitative of the great hunting pictures of seventeenth century Flemish painters. Towne also painted a picture entitled *Tiger growling over her prey*, which suggests that he was still influenced by Stubbs, although the heightened romanticism in the present picture is perhaps more reflective of James Ward.

121 Going out 1816
Canvas: 45.7 × 63.5
Private collection

122 Kate, the champion trotter
Canvas: 48.2 × 61
Signed and dated: *1824*
Prov: Commissioned by Mr John Kaye of Summerhays, Manchester (the owner of Kate); bought by the present owner from the Leger Gallery 1951
Lent by Lady Thompson

123 An intruder
Canvas: 61.2 × 71.5
Signed and dated: *C.Towne 1829*
Lent by the Walker Art Gallery, Liverpool

Painted for Henry Harrison of Mostyn, Aigburth.

John Cordrey 1765–1825

An early painter of coaching. The great detail shown in his pictures suggests that Cordrey may have worked as a designer of carriages.

124 Full cry
Canvas: 61 × 86.5
Private collection

125 The Duke of Bedford's coach
Panel: 46.5 × 74
Prov: bt. 1907
Lent by the Trustees of the Bedford Estates

Jacques-Laurent Agasse 1767–1849

Born in Geneva of a bourgeois family, Agasse first studied at the Ecole de Dessin. His father sent him to Paris in about 1785 to study under David, and Agasse must have been one of that artist's earliest pupils. In Paris, Agasse became interested in natural history, and studied veterinary medicine, osteology, and dissection techniques. He returned to Geneva in the summer of 1788. Lord Rivers, travelling in Switzerland in 1790, met Agasse and took him to London, where during his short visit he was attracted by the work of George Morland. In 1800 he returned to live permanently in London, sharing

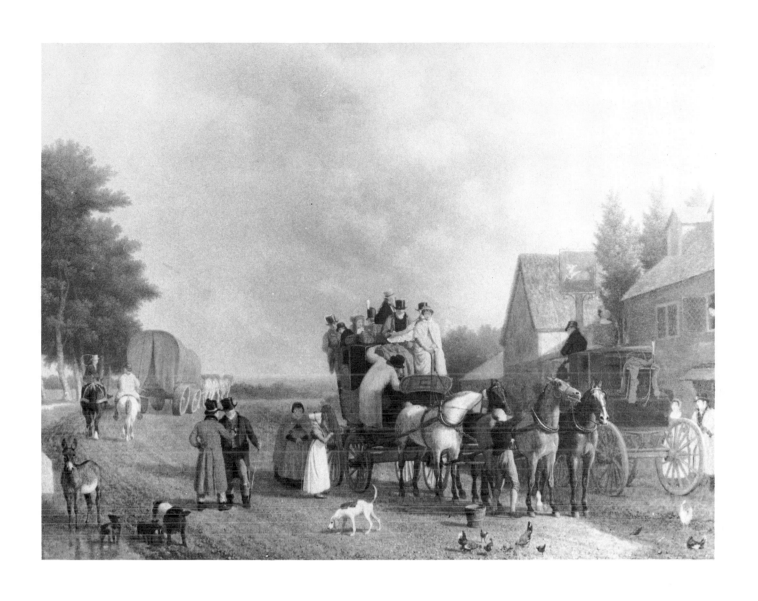

127
Jacques–Laurent Agasse
The last stage on the Portsmouth Road

accommodation with another Swiss artist, A.E.Chalon. During his first decade in England, Agasse achieved considerable success with sporting scenes in the manner of Stubbs, and paintings of exotic animals. He also essayed historical subjects, among which are *Romulus and Remus* (1810), *Androcles and the Lion* (1811), and *Alexander subduing Bucephalus* (1812). He became a close friend of Edward Cross, proprietor of the famous menagerie in Exeter Change, which before the foundation of the Royal Zoological Society in 1826 was the only place in London where foreign animals could be publicly seen. Agasse painted elephants, lions and panthers at the menagerie, and in 1827 secured a royal commission from George IV to paint the first giraffe to be introduced into Britain. In 1828 his principal patron, Lord Rivers, died and Agasse's fortunes declined. He exhibited at the Royal Academy for the last time in 1845, and died four years later.

126 Lord Rivers coursing

Canvas: 73.7 × 61
Lent by the Trustees of the Lane Fox Settlement

Agasse shows here his patron, Lord Rivers, coursing. The principle of coursing is the hunting of hare by greyhounds, solely by means of sight. The sport has a long history, the first known set of rules being drawn up by Thomas, Duke of Norfolk during the reign of Queen Elizabeth I. The first coursing club was established at Swaffham in 1776.

★127 The last stage on the Portsmouth Road 1832

Canvas: 72.4 × 91.4
Private collection

The seventy-two mile long Portsmouth Road was not one of the crack coach routes of England. In *The Portsmouth Road* by C.G.Harper, 1895, the detailed reminiscences of Sam Carter, an old coachman are quoted, 'the night coaches used to do the distance in about 12 hours, and the day coaches in 9 hours, but the mails were 10 hours upon the road. . . .We only changed (horses) once between Portsmouth and Godalming and that was at Petersfield, but the stages were terribly long, and we afterwards used to get another team at Liphook'.

Benjamin Marshall 1768–1835

Born 8 November 1768 in Leicestershire, Marshall worked there as a schoolmaster; in 1791 he moved to London where he trained briefly with the portrait painter Lemuel Francis Abbott. By 1801, when he first exhibited at the Royal Academy, he was established as one of the leading sporting artists. Between 1812 and 1825 he lived in Norfolk, near Newmarket; as he said to his pupil Abraham Cooper, 'the second animal in creation is a fine horse, and at Newmarket I can study him in the greatest grandeur, beauty and variety'. In 1819 he sustained serious injuries in a mail-coach accident, which impaired his abilities as an artist, and he turned to sporting

journalism, using the pseudonyms 'Observator' and 'Breeder of Cocktails'. He returned to London in 1825, and ten years later, on 24 July, he died.

(W.Shaw Sparrow, *George Stubbs and Ben Marshall*, 1936; Exhibition catalogue, *Ben Marshall*, Leicester Art Gallery, 1967.)

★128 Portrait of Daniel Lambert 1806

Canvas: 76.2 × 62.8
Prov: S.J.Pegg Esq., who presented it to Leicester Art Gallery in 1919
Exh: Royal Academy, 1807 (667); Leicester Art Gallery, *Ben Marshall*, 1967 (4); Brighton Art Gallery, *Vanity*, 1972
Lit: Lionel Lambourne, 'Notes on British Art', *Apollo*, XXX, 1968
Lent by Leicestershire Museums and Art Galleries

Marshall was a close personal friend of Daniel Lambert, the celebrated Leicester fat man, after whom he named a son born on 5 January 1807, who was baptised Lambert Marshall at Marylebone Parish Church on 23 June, but subsequently died on 12 November 1807. This event took place shortly after Daniel Lambert's successful six months stay in London from April to September 1806, when he exhibited himself at 53 Piccadilly for a fee of a shilling a head. Lambert's wit and charm made this exhibition a pleasant social event rather than a vulgar peep-show, and it was probably during this stay that the present picture was painted, in what appears to be the artist's studio. A pile of unframed canvasses rests against the wall, the upper one portraying a fighting cock. On the left a classical medallion is partly shown, depicting two of the three Graces, thus wittily making the visual pun that Daniel Lambert, that 'prodigy of nature', according to his tombstone, represents the third Grace. Such classical allusions are occasionally to be found in Marshall's work, and may have found their origin in his early years as a schoolmaster. Daniel Lambert died 21 June 1809 and, still wishing to commemorate his friend, Marshall named his next son, born 13 November 1809, Lambert. In later years, Lambert was to follow with less success his father's career as a sporting artist.

129 Lord Sondes and his brothers with their hounds in Rockingham Park L

Canvas: 44.8 × 216
Signed and dated: 1815
Prov: Painted for Lord Sondes, and thence by family descent
Exh: Virginia Museum of Fine Arts, *Sport and the Horse*, 1960 (38); Leicester Art Gallery, *Ben Marshall*, 1967 (9)
Lent by Commander L.M.M.Saunders Watson

This picture shows Lewis, 3rd Lord Sondes, and his brothers John, later 4th Lord Sondes, and Henry and Richard Watson. Guy Paget (*Sporting Pictures of England* 1965) comments adversely on the 'rag-bag' quality of the pack, but praises the veracity with which Marshall has

128
Benjamin Marshall
Portrait of Daniel Lambert

depicted them, each hound being an individual portrait. The artist used his favourite pictorial device of raising the foreground, not as has been suggested to avoid the tedium of painting each individual paw, but to place the animals visually more firmly on the ground. It has been suggested that these are the Pytchley Hounds, but Lord Sondes did not become Master of the Pytchley until some time later. In ambitious large compositions like this, Marshall liked to experiment, achieving greater richness of colour and texture by first painting in the ground, allowing the paint to dry, and then rubbing with a pumice stone and water on certain areas, which he finally repainted. This technique produced the thick impasto which can be seen here particularly clearly on the tree trunks, and is the antithesis of the brilliantly applied thin paint of his more spontaneous early manner. Opinions vary sharply as to the success of these later paintings.

130 George, 5th Duke of Gordon, on Tiny, with hounds and grooms c.1815 L

Canvas: 106 × 125
Signed lower right: *B.Marshall p*ᵗ
Prov: Elizabeth, Duchess of Gordon, and thereafter in the Brodie family by descent until 1962; bought by Mr Mellon from Agnews 1962
Exh: Royal Academy, 1964–5, *Painting in England 1700–1750* (298)
Lent from the collection of Mr and Mrs Paul Mellon. Upperville, Virginia.

The 5th Duke of Gordon founded the Gordon Highlanders and commanded this regiment in Spain, Corsica, Ireland and Holland from 1795 to 1799. He commanded a division in the Walcherev Expedition of 1809, being created a full General in 1827. He was MP for Eye, and succeeded to the dukedom in 1827. He married Elizabeth Brodie in 1813, and died in 1836. The horse's name of Tiny was ironical, as he stood seventeen hands high. The background in this picture suggests Goodwood, Sussex.

131 Mameluke on Newmarket Heath 1828 L

Canvas: 68.5 × 91.5
Signed and dated
Exh: Leicester, *Ben Marshall*, 1967 (17)
Private collection

Mameluke was a bay horse foaled in 1824 by Partisan out of Miss Sophia by Stanford. His dam was a half-sister to Charlotte, winner of the 1,000 guineas, and their dam was Sophia, a half-sister to Champion, winner of the Derby and the St. Leger. Mameluke was bred by Mr Elwes, and sold to the Earl of Jersey, for whom he won the Derby in 1827. On the strength of this win he was bought for £4,000 by John Gulley, prizefighter, MP for Pontefract, and a member of the notorious 'Danebury Confederacy' whose story has been so vividly told by Henry Bly in his biography of Crockford. Gulley, whose portrait was painted by Marshall, won the Oatlands Stakes with

Mameluke in 1828, and the horse after winning several races in 1829, was sold to Mr Theobald, who transferred him to his stud in Stockwell. Marshall painted at least four versions of this picture, with varied backgrounds. The distant glimpse of Newmarket racecourse in this repetition gives an additional attraction.

†132 Zinganee held by Sam Chifney junior, with the owner Mr W.Chifney, at Newmarket L

Canvas: 103 × 125
Prov: The 5th Earl of Rosebery
Lent by Lord Irwin

Zinganee, a bay colt by Tramp out of Folly, was foaled in 1825 and bred by the Marquess of Exeter, who sold him to Mr Chifney in 1827. He won the Newmarket Stakes in 1828, the Craven Stakes and the Oatland Stakes at Ascot in 1829, after which he was sold to Lord Chesterfield for whom he won the Ascot Gold Cup. The following year Zinganee was sold to Mr Delme Radcliffe, and later to George IV. This picture was painted possibly in 1829 after his victory in the Craven Stakes. Sam Chifney junior (1786–1855) was described by 'Sylvanus' as 'out-and-out the beau ideal of a jockey when in his prime, and for elegance of seat, perfection of hand, judgment of pace, and power in his saddle, was excelled by no man who ever sat in one'. He won races with his famous last second 'Chifney rush', but he was extremely unscrupulous, blatantly stopping the favourite Manuella in the 1812 Derby. He won the Derby in 1818 and 1820. Marshall, in his capacity as a sporting journalist, wrote of Zinganee's running in the Gold Cup at Ascot in 1829: 'eight out of the nine came well away . . . then came the body with Green Mantle at their head, all the way on the bottom of the course a most slaughtering pace, and Bobadilla still ahead at least fifty yards; and from Zinganee, who was last, and Mameluke, last but one, fifty yards more till the rising of the hill; when they began to close a little, with no change of places. As Zinganee came up, Wheatley (on Mameluke) advanced. If Chifney (on Zinganee) took a pull, Wheatley did the same . . . opposite to the Betting Stand Chifney and Wheatley, as if by signal, called upon their horses . . . Zinganee the best horse in England; Mameluke second . .'.

133 Fighting cock

Canvas: 66 × 50.8
Private collection

Marshall painted gamecocks on several occasions. His recorded pictures were *A Game Cock* and *A Trimmed Cock* exhibited at the Royal Academy in 1812; *The Cock in Feather* and *The Trained Cock* published as prints engraved by C.Turner in 1812, and also known as *Peace* and *War* in the second smaller state of the engraving; *Two Game Cocks: Black Breasted Dark Red and Streaky Breasted Red Dun*; and the present example *Fighting Cock*, perhaps the most attractive, showing the cock strutting proudly round a farmyard, surrounded by his hens. He would seem to have been drawn to the drama of the sport, and may have

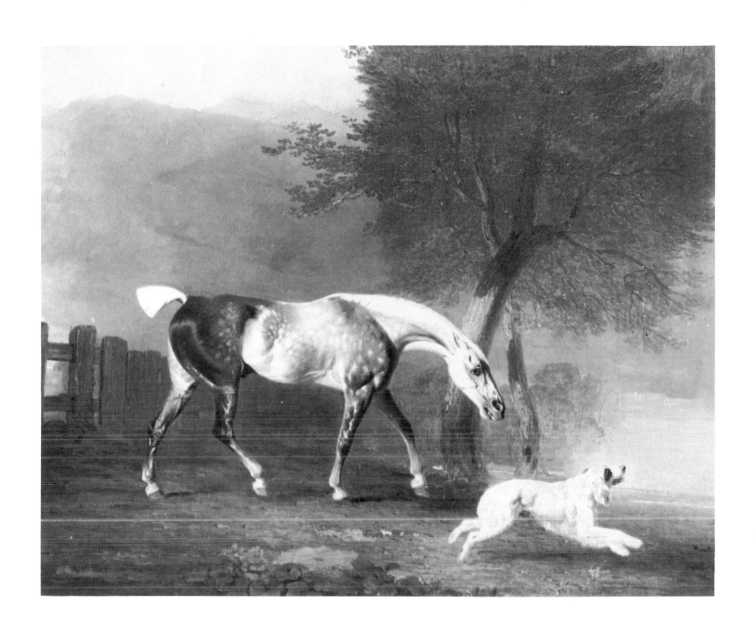

134
Benjamin Marshall
A grey horse called Badger, and a dog

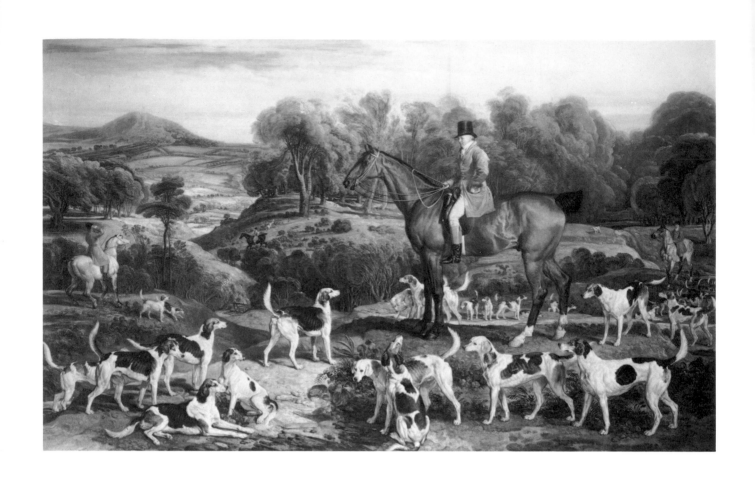

140
James Ward
Ralph Lambton and his hounds

visited the Royal Cockpit built by Henry VIII in St. James's Field (Birdcage Walk) with his friend, Daniel Lambert. He could also have visited the pits in Cambridge and Newmarket. A surviving cockpit today is the Denbigh Cockpit now re-erected at St.Fagan's Welsh Folk Museum, Cardiff. The Museum publish an excellent small booklet about this dramatic building, and the popularity of the sport in Wales.

*134 A grey horse called Badger, and a dog c.1802
Canvas: 81.2 × 99
Signed
Exh: Virginia Museum of Fine Arts, *Sport and the Horse*, 1960 (37)
Lent by the Earl of Jersey

135 Yellow Hammer c.1800 L
Canvas: 71.1 × 91.4
Private collection

James Ward, R.A. 1769–1859

Born in London, he was trained as an engraver with John Raphael Smith and then with his elder brother William Ward. In the later 1780s he turned to painting, encouraged by George Morland. In 1794 he was appointed Painter and Engraver in Mezzotint to the Prince of Wales. During the 1790s he became well-known as a painter of animals, particularly cattle, and in 1800 was commissioned by the Agricultural Society to paint a series of 200 pictures illustrating the typical British breeds of cattle, pigs and sheep, a project which was never completed. Ward was a prolific artist, and after 1800 was financially successful, especially through commissions for portraits of bloodstock. Between 1823 and 1826 he produced a series of 24 lithographs of famous horses, perhaps in emulation of Stubbs's *Turf Gallery*. But Ward was ambitious in other branches of painting, and essayed landscape, portraits, religious and historical subjects, often on a very large scale. He exhibited these regularly at the Royal Academy, and held his own one-man shows. He was elected ARA in 1807, RA in 1811, and in 1815 won the 1,000 guinea prize at the British Institution for his sketch of *The Triumph of the Duke of Wellington* (now in the Chelsea Royal Hospital). In the 1820s his income began to decline, and by 1847 he was obliged to apply to the Royal Academy for financial assistance, which was granted in the form of a pension.

(J.Frankau, *William Ward ARA, James Ward RA*, 1904; C.R.Grundy, *James Ward RA*, 1909; exhibition catalogue, *James Ward*, Arts Council 1960.)

136 Rev.T.Levett and his favourite dogs cockshooting L
Canvas: 71.1 × 91.4
Exh: Royal Academy, 1811 (489)
Lit: C.R.Grundy *op cit* no.686
Lent by Edward Speelman Ltd.

Ward's friendship with the Rev.Theophilus Levett and his family was of a particularly close nature. For him Ward painted *The Deer Stealer* (now in the Tate Gallery), a picture with which Levett was so delighted that he raised the fee from 500 to 600 guineas, the highest sum Ward ever received for a private commission.

137 John Levett hunting in the park at Wychnor 1817 L
Canvas: 102 × 127
Private collection

Painted for the Levett family, for whom he painted several pictures besides the present example (see cat.136). In 1821 he borrowed money from the Levetts in order to take the lease on B.R.Haydon's studio.

138 Hambletonian's famous race against Diamond at Newmarket 1819
Canvas: 101 × 190
Private collection

George Stubbs, in his 76th year, painted Sir Henry Vane-Tempest's Hambletonian, a descendant of Herod and Eclipse and winner of the 1795 St. Leger, beating Mr Cookson's Diamond by a short head in a four mile match at Newmarket. It is difficult to establish why Ward should attempt a quarter of a century later to paint the same subject, unless in conscious rivalry of his great predecessor's achievement.

139 Portrait of Mr Cozens 1827
Canvas: 60.4 × 76.2
Signed and dated
Lit: D.Livingstone-Learmonth *The Horse in Art* 1958, pl.48
Private collection

The rider, Mr Cozens, sits heavily in the saddle of a horse which is a magnificent example of a weight-carrying hunter of massive proportions. The horse has a cropped tail, which must have distressed the artist, who in later life was to publish a pamphlet *The Folly and Crime of Docking Horses*. This early shot in the campaign against the practice of cropping horses' tails later found another champion in Anna Sewell, authoress of *Black Beauty*.

*140 Ralph Lambton and his hounds
Canvas: 137 × 213
Lent by the Duke of Northumberland

The Lambton family were famous huntsmen, in fact this sitter's father William is reputed to have been the first

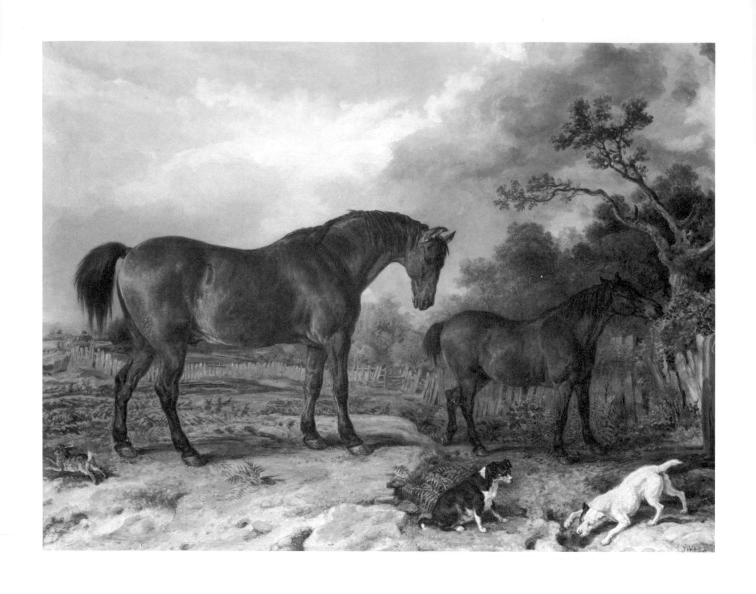

141
James Ward
Reformer, Blucher, Tory and Crib

Meltonian, retiring from the Quorndon Club in 1790. Ralph himself was a famous Master, and John Ferneley painted him and the Sedgefield Hunt, with its famous pack of hounds, on several occasions in the early 1830s. The present picture, although broadly and vigorously painted, clearly shows how by 1828 Ward had departed from the Rubenesque phase of the 1800s and 1810s to find a true individuality, in which landscape and riders form a harmonious and relaxed composition in a more English style. This painting may be that exhibited at the Royal Academy in 1820 (337) as *Foxhunting: calling the hounds out of cover – Portraits of Ralph Lambton Esq, his horse Undertaker, and hounds.*

★141 Reformer, Blucher, Tory and Crib L

Canvas: 71.2 × 91.5
Signed and dated: *JWD* (monogram) *RA 1835*
Prov: Rowland Alston and thence by descent until 1970; bt. Mr Mellon from Gooden and Fox 1970.
Exh: Royal Academy 1836 (37)
Lent from the collection of Mr and Mrs Paul Mellon, Upperville, Virginia

Rowland Alston (1782–1865) was MP for Hertfordshire from 1835 to 1841.

W. Bromley *fl.c.*1850

142 Portrait of George Parr c.1850

Canvas: 59.7 × 44.5
Lent by the Marylebone Cricket Club

George Parr (1826–1891), 'the Lion of the North', was, in succession to Fuller Pilch, the first batsman in England. One of the greatest of all Nottinghamshire cricketers, he lived all his life in his native village of Radcliffe-on-Trent. He succeeded William Clarke as captain of both Nottinghamshire and the All-England XI, he also captained the strong England team which toured Australia in 1863–4. His career in first-class cricket lasted from 1844 to 1871.

143 John Wisden c.1850

Canvas: 59.6 × 44.5
Lent by the Marylebone Cricket Club

John Wisden (1826–1884) played for Sussex and the All-England XI, and for some years, although quite small (5 foot 4½ inches), was a fast round-arm bowler. In 1850, playing for the North against the South, he became the first bowler to clean bowl all ten wickets in an innings of a major match. He is best remembered for founding 'Wisden's Cricketers' Almanack' which first appeared in 1864, and remains the major work of reference on the game.

144 Alfred Mynn c.1840

Canvas: 59.7 × 44.5
Lit: Sir Pelham Warner *Lord's 1787–1945*, 1946; P.Morrah *Alfred Mynn and the Cricketers of his time*, 1963
Lent by the Marylebone Cricket Club

Alfred Mynn (1807–1861) was the popular, giant fast bowler of the mid-nineteenth century. Six feet one inch tall, and weighing between eighteen and twenty stone, he played for Kent, the All-England XI, and the Gentlemen. *Scores and Biographies*, compiled by Arthur Haygarth, records of him that 'his delivery was noble, walking majestically up to the crease . . . his bowling was very fast and ripping, round armed and of a good length . . . it was always considered one of the sights of cricket to see Mynn advance and deliver the ball'.

Henry Bernard Chalon 1771–1849

H.B.Chalon was born in London of a Dutch family, and should not be confused with his contemporaries, the Swiss-born brothers J.J.Chalon, the landscape painter, and A.E.Chalon, the fashionable portrait painter. H.B.Chalon studied at the Royal Academy, where he first exhibited in 1792; he exhibited there for 45 years a total of 193 works. In 1796 he married a sister of James Ward. In 1795 he was appointed animal painter to HRH the Duchess of York, and in 1804 dedicated to her his book *Studies from Nature*, published in collaboration with J.C.Nattes. This work, a study of the muscular system of the horse with anatomical tables, and in his paintings his use of colour and compositional devices, show clearly how Chalon, more than any of his contemporaries, was influenced by the work of George Stubbs. Chalon also published *Chalon's Drawing Book of Animals and Birds of Every Description*, one of the many attractive primers of soft ground etching which enabled amateurs to copy and produce work of some ability that after the passage of time can easily be confused with the original models. Chalon was frequently patronised by the Royal Family, and eventually was appointed animal painter to William IV. In 1846 he met with a severe accident, and died on 15 August 1849.

145 Tom Oldacre, huntsman to the Berkeley

Canvas: 71.7 × 91.5
Signed and dated: *H.B.Chalon pinx/ 1800*
Prov: Walter Stone Esq; bequeathed to Walker Art Gallery, Liverpool by Miss Mary Stone 1944
Lent by the Walker Art Gallery, Liverpool

The famous huntsman Thomas Oldacre was painted on at least three occasions by Ben Marshall, and also by John Nost Sartorius and Abraham Cooper. Oldacre was huntsman to the Earl of Berkeley, and hunted for 32 years over a wide area between Berkeley Castle and Middlesex. In the present painting he is wearing a long full-skirted coat in deep yellow Berkeley livery, and still carries the traditional twist bugle horn.

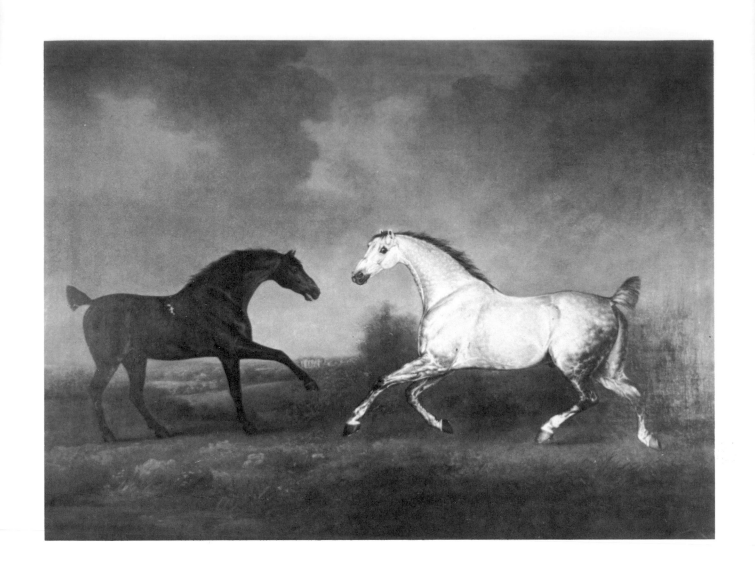

146
Henry Bernard Chalon
A pair of carriage horses at grass with a distant view of
Burton Agnes Hall, Yorkshire

★146 A pair of carriage horses at grass with a distant view of Burton Agnes Hall, Yorkshire 1805
Canvas: 109 × 150
Exh: possibly Royal Academy 1806 (76 or 186)
Lent by Marcus Wickham-Boynton Esq., D.L.

The composition of the two horses recalls Stubbs in its counterpoint of shape and contour, and is enhanced by the charming view of the late Elizabethan mansion of Burton Agnes.

147 Bay horse with groom on Newmarket Heath
Canvas: 84 × 112
Signed and dated: *Newmarket 1807*
Exh: Royal Academy 1808 (69)
Private collection

The Prince of Wales's bay racehorse Sir David, by Trumpator, with the jockey Sam Chifney junior, and a trainer on a pony, on Newmarket Heath. Nearby is the rubbing down house which so often features in the work of Stubbs, and indeed the whole composition, with its classical calm and balance, shows the extent of Stubbs's influence on Chalon.

★148 Unkennelling the Royal hounds on Ascot Heath
Canvas: 103.5 × 149.5
Signed and dated: *H.B.Chalon. pinxit 1817*
Prov: painted for George IV
Exh: Royal Academy 1817 (348)
Lit: O.Millar, *The later Georgian Pictures in the Collection of Her Majesty The Queen*, 1969, no.702
Lent by Her Majesty The Queen

In 1818 Chalon was paid £100 by the Prince of Wales for this picture. A group of picked hounds are being unkennelled, and surround the Huntsman of the Royal or King's Hunt, George Sharpe, who is mounted on his favourite hunter Flamingo in front of three whippers-in.

149 The Warwickshire Beagles 1813
Canvas: 122 × 183
Private collection

Charles Henry Schwanfelder 1774–1837

Of German ancestry, Schwanfelder was born in Leeds, where he was to live all his life. He painted in Yorkshire, Wales, Scotland and the Lake District, but rarely visited London. He exhibited at the Royal Academy between 1809 and 1835 and was Animal Painter to George IV between 1817 and 1821. He painted portraits, landscapes, and still-life of game as well as sporting subjects.

150 Portrait of a hound, Ringwood
Canvas: 69.8 × 86.4
Lent by the Trustees of the Lane Fox Settlement

151 Three hounds and a terrier
Canvas: 57.2 × 75
Lent by the Trustees of the Lane Fox Settlement

152 Botsam Fly
Canvas: 68.5 × 88.9
Lent by the Trustees of the Lane Fox Settlement

Richard Ramsay Reinagle, R.A. 1775–1862

Portrait and animal painter, son of Philip Reinagle. Exhibited at the Royal Academy 1778–1857. Studied in Italy, in 1796 he was in Rome, and later in Holland. A prolific painter he was an accurate draughtsman, paying careful attention to anatomical truth. He was also a landscape painter of talent.

★153 The 6th Duke of Devonshire shooting in the park at Chatsworth with his gamekeeper Mr Burgoyne, and Mr Beaumont
Canvas: 109 × 139.5
Signed and dated: *R.R.Reinagle 1812*
Prov: Painted for the sitter, by descent
Lent by the Trustees of the Chatsworth Settlement (Devonshire Collection)

William Spencer, 6th Duke of Devonshire (1790–1858), Lord Lieutenant and *Custos Rotulorum* of Derbyshire, High Steward of Derby.

Henry Alken 1785–1841

Painter of sporting and animal subjects, Henry Alken was the most famous of a family of four generations of artists. Studied under his father Samuel, and with a miniaturist named Beaumont. His foxhunting compositions are best known and he was also a prolific painter, draughtsman and etcher of British and Foreign sports, manners and customs. A keen sportsman, he used the pseudonym of Ben Tally Ho.

154 Hunting recollections
Canvas: 23 × 30.5
Prov: Fores 1911
Engr: Alken 1829
Lit: W.Shaw Sparrow, *Henry Alken*, 1927, pp.36–7
Private collection

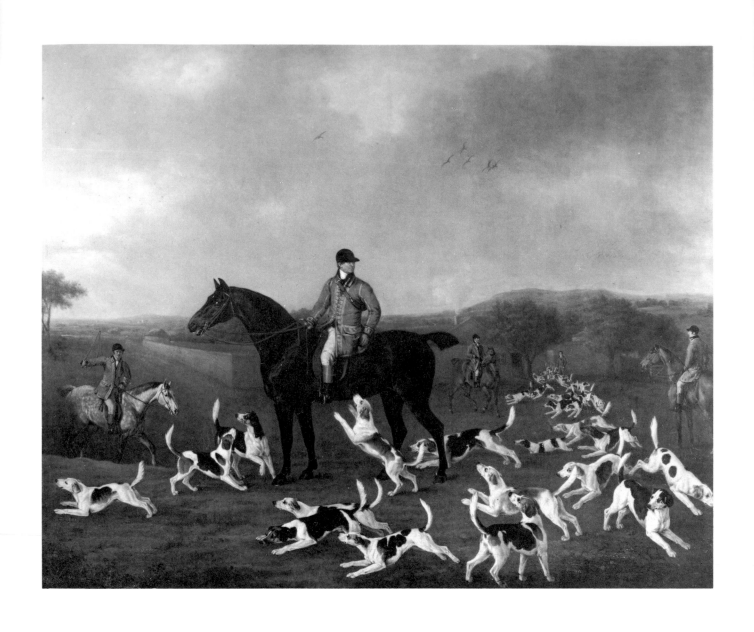

148
Henry Bernard Chalon
Unkennelling the Royal Hounds on Ascot Heath

153
Richard Ramsay Reinagle
The 6th Duke of Devonshire shooting in the park at
Chatsworth with his gamekeeper Mr Burgoyne, and Mr
Beaumont

I 'Ware horse! D–n these hot horses! They are seldom
 worth more than a bunch of dog's meat after a ten
 minutes' burst!'
II 'So much for your pepper! Now I want it you turn
 out a top!'
III 'Push on sharp at it, my Lord, there's the h—ll of a
 ditch on the farther side.'
IV 'There, I knew how 'twould be – that 'ere Lord
 hasn't half enough devil in him!'
V 'Essex to Wit.'
VI By the Lord Harry, my chestnut horse can almost
 fly!'

Abraham Cooper 1787–1868

Cooper was born on 8 September 1787, the son of a
Holborn tobacconist. From the age of 13 to 22 he worked
as groom and rider at Astley's Theatre, where his uncle
was manager. Astley's was a great attraction of nineteenth
century London, and combined a proscenium stage with a
circus ring. According to Shaw Sparrow, in 1809 Cooper
refused his uncle's order to ride for John Kemble at Covent
Garden, and left Astley's. He had been a keen draughtsman
as a boy, and he went to work for Ben Marshall for three
years. He completely assimilated Marshall's style, and
their works are very similar, but unlike Marshall, Cooper
frequently exhibited at the Royal Academy, where he
showed 332 works between 1812 and 1868. Cooper was
elected an RA in 1820, and in 1822 tried to get financial
assistance from the RA for his friend William Blake.

★155 **Plenipotentiary, winner of the Derby in 1834** L
Canvas: 73.6 × 105.4
Lent by the Stewards of the Jockey Club

Plenipotentiary – known on the racecourse as 'Plenipo' –
was a big horse who always carried a lot of flesh. He was
once described by a jockey as 'that great bullock cantering
by my side'. Cooper has cleverly suggested here something
of his great muscle and girth. He started a short priced
favourite for the Derby, which he won in a canter by two
lengths, but was doped before the St. Leger in which he
finished last. The 1830s and 1840s were years of
considerable corruption on the turf, culminating in
Running Rein's Derby of 1844 in which the disqualified
winner was a four year old, who in running broke the leg
of a six year old, in which the favourite was a victim of foul
riding and the second favourite of both doping and
pulling. These abuses were exposed by Lord George
Bentinck, whose personality dominates this period in the
history of the turf. He introduced paddock parades,
number boards, and the use of a flag for starting, which
eliminated many dubious practices. He was not, however,
without his own tricks, as the story behind no.156 shows.

156 **Elis and his van**
Canvas: 96.5 × 128.3
Exh: Royal Academy, 1836
Lent by the Duke of Portland, K.G.

The scene is Doncaster, just before the St. Leger of 1836.
The great three year old of 1836 was Bay Middleton, but
in his absence Lord George Bentinck's horse Elis was hotly
fancied for the St. Leger, and very short odds were quoted
by the Ring. Bentinck, enraged, threatened to scratch the
horse, and left him at Goodwood (where he had been
racing) until it was obvious that he would not have time to
walk to Doncaster by road, a fifteen day journey.
Rumours that he was a non-runner became a certainty
when he was seen still in his stable at home a week before
the race. The trick worked – the odds lengthened,
Bentinck placed his bets most advantageously, and put
the rest of his plan into operation. The plan had been
suggested to him by John Doe, standing with the pony to
the right of this picture. He had been trainer to a Mr
Territt, who in 1816 sent his horse Sovereign from
Worcestershire to Newmarket on a bullock cart. Bentinck
developed this idea by having the London coachbuilder
Herring, construct an enormous waggon to be drawn by
six horses. The waggon was backed up to a high bank, and
Elis and his travelling companion The Drummer were led
in. This amazing vehicle travelled to Doncaster at eighty
miles a day, and Elis reached the course fresh and fit in
two-and-a-half days, having had an exercise gallop en
route at Lichfield. He won the race with ease from the
favourite Scroggins. In this painting, which Cooper
showed with great success at the Royal Academy in 1836,
John Day rides Elis in Lord Lichfield's colours, and The
Drummer is being led out of the van on the left. The
innovation of travelling vans inaugurated a revolution in
the training and engagement of racehorses.

Anonymous

157 **Portrait of Tom Cribb, Champion of England,
 holding the 85 guinea silver cup, presented to him
 after his last great fight with Molyneux at Thistleton
 Gap on September 28th 1811**
Canvas: 24.7 × 20.3
Private collection

This portrait has previously been thought to be of Tom
Molyneux, the first Negro boxer, but it is clearly not him,
but his famous opponent Tom Cribb (1781–1848) the
legendary Champion of England from 1809 to 1822.
Cribb's distinctive features can be studied in an
illustration to Pierce Egan's 'Tom and Jerry', showing the
Champion in his parlour in the 'Union Arms', standing
and retailing to customers his former exploits, while
holding the same distinctive cup, the base of which is in
the form of Hercules supporting the bowl, on which in
relief are depicted some of Cribb's most famous fights.
Cribb was presented with this cup, which he valued above

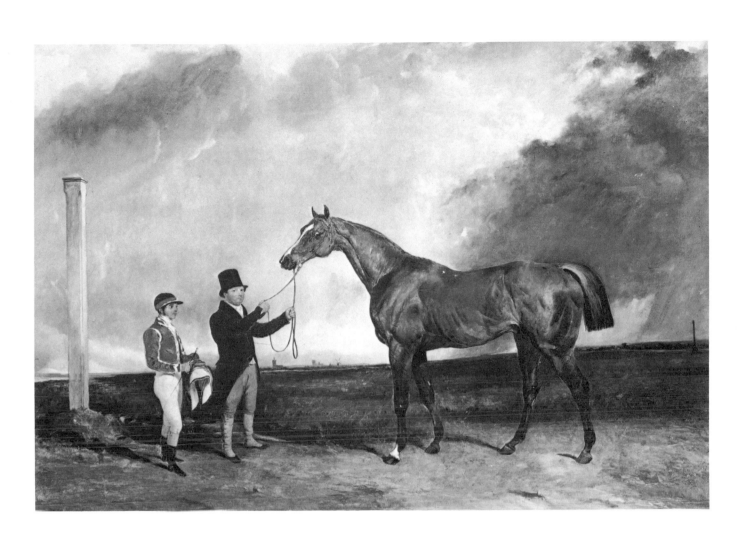

155
Abraham Cooper
Plenipotentiary, winner of the Derby in 1834

159
Edmund Bristowe
Greyhounds, the property of W. Adams

all his other trophies, at a dinner given on 11th December, 1811 at 'Bob's Chop House' in Holborn. The proprietor 'Bob' Gregson had raised a subscription list for the cup at an earlier celebratory 'milling grubbing match' to use the picturesque slang of the time. Henning (op cit) Chapter VII provides an amusing account of the event, and also describes Cribb's later life as a publican, when his 'Parlour' became a fashionable place of resort for such men as Hazlitt, Thomas Moore and Lord Byron, a great admirer of the fighter whom he mentions several times in his poems.

Cribb was, in his lifetime, a national hero. To use George Borrow's words, he was 'Champion of England, and perhaps the best man in England'. His character portrayed contemporary national spirit – slow, sure and courageous, always at his best when 'milling on the retreat'.

Edmund Bristowe 1787–1876

Born at Windsor 1 April 1787, the son of a heraldic painter, he remained throughout his long and prolific career in his native town, becoming known as 'Bristowe of Windsor'. At an early age, he was patronised by the Duke of Clarence, later William IV, and was a friend of Landseer. He rarely exhibited, but found many opportunities for selling his work at Windsor and Eton, and painted many portraits of well-known characters in the town and school. Bristowe worked on a small scale with meticulous and careful detail, often painting on panels, and emulating the technique and manner of small Dutch seventeenth century cabinet pictures. He produced both horse and field sport paintings, but particularly specialised in shooting and coursing subjects. He ceased to paint in about 1847, but lived on to the age of 89, when he died on 12 February 1876.

158 William Sharpe on Cocky
Panel: 62.2 × 73.6
Signed and dated: *1816*
Lent by I. Hervey Stuart Black Esq.

Sharpe was huntsman to Charles Shard Esq, of Lovel Hill, Berkshire.

*159 Greyhounds, the property of W. Adams
Canvas: 19 × 24.8
Private collection

Two greyhounds, a dead hare, and a terrier, painted with the fastidious and delicate touch characteristic of the artist.

William Turner of Oxford 1789–1862

Born 12 November 1789 at Blackbourton in Oxfordshire. At the age of 15 he went to London and was apprenticed to John Varley, with whom he remained for seven years. In 1808, when he was 18, he became a member of the Watercolour Society, and for 55 years he contributed annually to their exhibitions. He returned to Oxford in 1811, remaining there until his death, except for periodical sketching trips to the Lake District, North Wales, Cornwall and Scotland. Between these tours, Turner taught Oxford undergraduates the art of watercolour painting, and his tranquil life ended on 7 August 1862.

160 Lincoln Horse Fair
Canvas: 36.8 × 62.8
Signed and dated: *W. H. Turner 1858*
Prov: G. Clothier sale, Christie's 29 November 1890 (90), bt. Volkins; Sir Walter Gilbey sale, Christie's 15 March 1910 (159), bt. Cusnick; acquired by Lord Bearsted by 1937
Exh: 39 Grosvenor Square, London, *British Country Life through the centuries* 1937 (258)
Lent by the National Trust (Bearsted Collection, Upton House)

In *Lavengro* and *The Romany Rye*, George Borrow describes on several occasions the excitement of the large horse fairs at Norwich, Horncastle and Lincoln, which played a vital role in an age so dependent on the horse. He writes in *Lavengro*: '... horse fairs are seldom dull. There was shouting and whooping, neighing and braying; there was galloping and trotting; fellows with highlows and white stockings, and with many a string dangling from the knees of their tight breeches, were running desperately, holding horses by the halter, and in some cases dragging them along; there were long-tailed steeds, and dock-tailed steeds of every degree and breed; there were droves of wild ponies, and long rows of sober cart-horses; there were donkeys, and even mules. . . .'

David Dalby of York 1790–1840

Little is known of David Dalby's life at York, beyond the incident described by Gilbey that several sportsmen united to guarantee a supply of twenty horses to be painted at the low price of three guineas a picture. Gilbey also states that Dalby moved from York to Leeds after producing a libellous caricature of the Sheriff.

161 Coming home from the horse fair
Canvas: 30.5 × 43.2
Private collection

Anonymous

162 Portrait of the boxer Daniel Mendoza
Canvas: 76.2 × 63.5
Private collection

Mendoza of Whitechapel (1764–1836), an ancestor of the actor Peter Sellers, was Champion of England, which meant world champion, from 1792 until 1795, when

'Gentleman' John Jackson held him by his long hair and knocked him out. The first Jewish champion, he left a lively autobiography which, unlike many later works by famous boxers, was written with great brio and spontaneity, and without the aid of a hack 'ghost'. His career, although chequered with imprisonment for debt, included the establishment of a number of boxing 'academies' for the aristocracy, who admired the courage and pluck so inherent in the pugilist. During this period of the French Revolution and the Napoleonic Wars, when class feeling ran so high, the lowest and the highest in the land patronised the ring, and the motto of the Pugilistic Club (founded in 1814), 'a fair ring and no favour and let the best man win', formed a real bond between the classes. Mendoza also appeared in an elaborate stage show that displayed the heroic styles of great fighters in an act 'performed before crowned heads and women, in which there is neither violence nor indelicacy that can offend the most delicate of their sex'. He fought his last fight at the age of 56. Improving on Broughton's original technique, Mendoza originated a new and more rapid style of boxing, introducing a controlled method of advancing and retreating by alternating from left foot and fist forward to right foot and fist forward, which, if rudimentary by the standards of today, at least represented the beginning of a systematic approach to moving around the ring, rather than standing still and trading blows.

James Pollard 1792–1867

The son of a topographical artist and engraver, James Pollard's childhood and most of his life was passed in his birthplace Islington and nearby Holloway, two areas of London closely associated with the great mail coach routes to the North of England. In 1807 when James was 15, his father wrote to his friend Thomas Bewick that he 'would like him to see James's pictures of horses after Ben Marshall, as I am trying to make him a painter in that line'. Pollard was to share Marshall's love of depicting animated throngs of horses and people, but to delineate them, not in a broad painterly fashion, but with the meticulous, sharply observed vision of the engraver. James continued to work for his father until his late twenties, and became a master of the aquatint process. In 1821 the course of his career was changed by a commission from the King's Printseller, Edward Orme, to paint a mail coach with horses and passengers as a signboard for an inn, which was first exhibited with great success in the window of a Bond Street shop. This led to both more commissions and the successful showing in the same year of his first painting at the Royal Academy – *North Country Mails at the Peacock, Islington*. In the next decade Pollard was to produce his finest paintings of mail and stage coaches, then at the height of their glory before their rapid decline with the onset of the railways. From 1830 to 1840 coaching pictures gave place increasingly to racing and steeplechase subjects, as well as some angling and cricket pictures. In 1840 his wife and younger daughter died, a blow which

stopped him painting for two years, and from which his talent was never wholly to recover. His pictures generally diminish in quality and size, and hunting scenes, and, increasingly, omnibuses, form the bulk of his work, marking the decline in popularity of coaching subjects. Fashions had changed, and as he wrote on the back of a drawing of an Islington omnibus: 'To justice see Jack bow . . . He's on no bed of roses now / And yet how strange the thing doth sound / For all that's done he gets a pound'. The total number of prints after Pollard's paintings is about 343, of which he himself engraved 146. The demands of the aquatint process are always present in his handling of the medium of oil paint.

(N.C.Selway *The Regency Road: the Coaching Prints of James Pollard* 1957; N.C.Selway *James Pollard 1792–1867* 1965; N.C.Selway *The Golden Age of Coaching and Sport* 1972.)

163 The Exeter Royal Mail on a country road L
Canvas: 76.2 × 101.5
Signed and dated: *J.Pollard 1820*
Prov: Captain Adney
Exh: Ackermann's 1963
Lit: N.C.Selway *James Pollard 1792–1867* 1965 (no.3)
Private collection

This is probably the picture that Pollard painted for Prince Esterhazy, the Austrian Ambassador, who had seen the painting commissioned by Edward Orme, the King's Bookseller, in his shop window in Bond Street, and wanted a similar picture for himself. In the early nineteenth century, the coach was virtually the sole means of transport, playing the combined roles of today's train, car, and aeroplane. This is shown by the fact that at Hounslow, the first stage out of London for the Exeter, as well as for the Bath, Oxford and Gloucester stages, 170 coaches passed through the town in 24 hours, and that one inn proprietor alone maintained more than 150 horses.

164 A mail coach in a flood 1825
Canvas: 50.8 × 76.2
Signed and dated
Prov: G.S.Martin, sold Sotheby's 23 February 1938 (26); Miss Angela Matta, sold Christie's 17 April 1964 (52)
Lit: N.C.Selway *James Pollard 1792–1867* 1965 (no.20, repro.); N.C.Selway *The Golden Age of Coaching and Sport* 1972 (no.15)
Lent by N.C.Selway Esq.

This is a subject Pollard painted at least three times, and one of them was engraved in 1827 by F. Rosenberg. This picture is a companion to *A mail coach in a drift of snow* (also collection of N.C.Selway Esq). Of a similar pair, exhibited at the Royal Academy in 1824 as *Incidents of mail coach travelling* (773 and 774), the *Sporting Magazine* commented: 'the idea is clever, but the tails of the horses should drop close to the buttocks which is always the case in going through water; some of the water should also

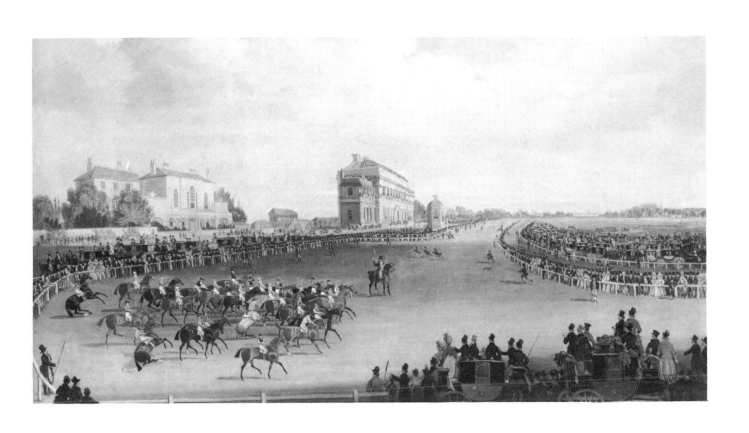

169
James Pollard
Doncaster Races, horses starting for the St. Leger

have been represented as dropping from the wheels during their circumvolution'. Criticism of such minor details gives a good idea of the general veracity and accuracy expected from, and achieved in, Pollard's work.

165 The Bath, Bristol and London mail coach by moonlight c.1825
Canvas: 50.8 × 76.2
Signed: *J.Pollard*
Prov: E.Leonard, New York
Exh: Ackermann's, *The Coaching Paintings of James Pollard*, 1963
Lit: N.C.Selway *op cit* 1957; N.C.Selway *op cit* 1965 (no. 19 repro.); N.C.Selway *op cit* 1972 (no.14)
Lent by N.C.Selway Esq.

The mail coach at night was once a familiar but always exciting spectacle, as all coaches, with the exception of two or three, left London at eight o'clock in the evening. For Hazlitt the spectacle never palled: 'some persons think the sublimest object in nature is a ship launched on the bosom of the ocean; but give me for my private satisfaction the mail coaches that pour down Piccadilly of an evening, tear up the pavement, and devour the way before them . . .'

166 The funeral of Tom Moody 1829
Canvas: 24.8 × 27.3
Signed and dated
Private collection

The funeral of the famous huntsman Tom Moody became a sporting legend. On his deathbed Moody made a last request that at his graveside 'three rattling view halloas' should be given. a request which was duly carried out. Pollard here depicts the cortege of the sportsman as it makes its way to the church. The coffin on which rests his cap and whip is carried by six huntsmen, flanked by hounds, while Moody's favourite horse, riderless, follows behind the bearer party. The event was also recorded by Dean Wolstenholme junior.

167 The start of the St. Leger 1830
Canvas: 49.5 × 75
Exh: Harrogate Festival, *Exhibition of Sporting Paintings*, 1968
Private collection

168 The finish of the St. Leger 1830
Canvas: 49.5 × 75
Exh: Harrogate Festival, *Exhibition of Sporting Paintings*, 1968
Private collection

***169 Doncaster Races: horses starting for the St. Leger** L
Canvas: 36.8 × 64.8
Signed and dated: *J.Pollard 1831*
Prov: R.Younger Esq; bt. by Mr Mellon from Arthur Ackermann and Son Ltd in 1965

Lit: N.C.Selway *op cit* 1965 (no.158, repro.); N.C.Selway *op cit* 1972 (no.186)
Lent from the collection of Mr and Mrs Paul Mellon, Upperville, Virginia

A companion piece to *Passing the Judge's stand* (also in the Mellon collection). Both were engraved by Smart and Hunt.
In 1776 a group of sportsmen subscribed to a new sweepstakes which two years later gained its name from the popular Lt-General Anthony St. Leger. The same year the venue moved to the new course on the Town Moor, with its large towering grandstand seen in the centre of the picture which had been erected at a cost of £2,637 by the architect John Carr. By the 1800s the race was recognised as a Classic. On the left can be seen a private grandstand, built in 1809, overlooking the paddock, which by 1830 had become a county school for the deaf and dumb, who watched the racing from their balcony.

170 The Cambridge Mail at the 'Falcon', Waltham Cross, on May Day
Canvas: 50.8 × 76.2
Signed and dated: *J.Pollard 1831*
Prov: E.J.Heward; Christie's 8 May 1936
Lit: N.C.Selway *op cit* 1972 (no.76)
Private collection

There were two main coaching routes to Cambridge, one via Buntingford and Royston, the other via Waltham Cross and Bishop's Stortford. The coachmen on these routes were colourful personalities, like Dick Vaughan 'hell-fire Dick' driver of the 'Cambridge Telegraph', and Joe Walton, driver of the 'Star of Cambridge', who had 'the temper of an emperor, and a tongue as fluent and free as a bargee'. His coach made the journey in five hours, only two hours longer than today's road journey if traffic is heavy.

***171 The painter, his son, and a friend, after a day's shooting, 1846**
Oil on board: 22.8 × 29.2
Signed and dated
Lit: N.C.Selway *op cit* 1972 (no.353, repro.)
Lent by N.C.Selway Esq.

Pollard found relaxation from his strenuous professional travels in the practice of field sports, enjoying both fishing on his favourite River Lea at Waltham Abbey, which he recorded in some charming angling pictures, and a day out shooting. He is seen here with his eighteen year old son James Robert Pollard, and a friend, counting the bag, mostly rabbits, after a day's sport.

172 Horses racing
Canvas: 25.4 × 35.5
Lent by the Duke of Portland, K.G.

171
James Pollard
The painter, his son, and a friend, after a day's shooting

Anonymous

173 Man on a horse with greyhounds
Canvas: 62.2 × 74.9
Private collection

Anonymous

174 Huntsman
Canvas: 53.3 × 43.2
Prov: Walter Stone Collection (65); bequeathed by Miss
Mary Stone
Lent by the Walker Art Gallery, Liverpool

J. Burford

Nothing is known of this artist

175 Cosmo beating Gimcrack at Newmarket
Canvas: 86.3 × 139.8
Private collection

John Frederick Herring 1795–1865

Herring was born in Surrey, but brought up in London.
The fastest mode of transport at any time possesses a
unique fascination for the young, and as a boy Herring
was absorbed by the glamour of the crack coaches of the
turnpike age, which he saw daily outside his father's
fringe-making shop in the main thoroughfare of Newgate
Street. According to Gilbey, Herring drew horses for his
own diversion from an early age, and had his first lessons
in drawing from a family friend, the driver of the London
to Woking coach. At 19 he went to Doncaster on a chance
whim after seeing the town advertised on the side of the
Royal Leeds Union coach. In Yorkshire he encountered a
coachpainter who was having difficulty transferring an
Alken equestrian sketch of the Duke of Wellington on to
the door of a new coach. Herring's successful intervention
gained him employment as a coachpainter, and he used
this contact to obtain employment as a professional driver,
one of the most coveted of all occupations, and which he
remained for five or six years. But his artistic activities
continued, and the steady production of inn signs, coach
doors and portraits of horses earned him the soubriquet
of the 'artistic coachman'. In 1818 his *Portrait of a dog* was
hung at the Royal Academy, and in 1821 a discerning
passenger, Frank Hawkesworth, persuaded him to become
a full-time artist. In 1830 he moved to Newmarket, and in
1833 to London, where he studied with Abraham Cooper.
His pictures had become immensely popular, and he
received commissions from George IV, William IV, and
later Queen Victoria. In the late 1840s his choice of subject
matter changed from straightforward horse portraits to
sentimental scenes of animal genre and detailed
descriptions of farmyards. He was sometimes aided by his

sons, John Frederick junior and Benjamin, whose style
resembled his, and Charles, whose more individual work
was also passed off by Herring as his own. He also
occasionally collaborated with Landseer and John Phillips.
His last years were passed at Meopham Park near
Tunbridge Wells, where he died on 23 September 1865.
Through the widely disseminated medium of prints, his
work was probably known by, and influenced, both
Manet and Degas.

(A.M.W. Stirling, *A Painter of Dreams, and other
biographical studies*, 1916.)

★176 The Duchess's ponies 1823 L
Canvas: 66 × 90.2
Signed and dated
Lent by the Executors of the late Lord Barnard

A pair of ponies are harnessed for a carriage, with the
initials E.D. (Elizabeth Darlington) on the harness, led by a
coachman in livery, in the stable yard at Raby Castle.
Somewhat surprisingly, relatively few paintings by
Herring of coaching scenes exist, despite his long
experience as a coachman. The details of the harness and
elaborate tails and manes in this early work, in the
otherwise broadly painted setting of the stables, prefigure
the tight and exact delineation of Herring's later manner.

★177 John Mytton Esq. of Halston, Salop
Canvas: 61 × 73.7
Dated: *1828*
Exh: Ackermann, *A centenary exhibition of the oil paintings
of J.F. Herring Sr.*, 1965 (22)
Lent by Arthur Ackermann and Son Ltd.

Squire Mytton (1796–1834) was, like Colonel Thomas
Thornton and Squire Osbaldeston, one of the greatest
eccentrics in a period rich in colourful characters. His
exploits were legendary in his own lifetime, and included
riding a bear round his dining room dressed in full hunting
kit, setting fire to his nightshirt to cure an attack of
hiccups (hideously burned he was carried out crying 'the
hiccups are gone, by God!'), duckshooting at night on the
ice clad only in a shirt, and driving his gig into a ditch for
the benefit of a passenger who had never had an accident
('What – never upset in a gig – what a damned slow fellow
you must have been all your life!'). When he died in the
King's Bench debtor's prison, having squandered a
fortune of £150,000, the churchbells of Shropshire tolled
his requiem. Mytton's life is narrated by Nimrod
(C.J. Apperley) in a biography of 1837, and by Edith
Sitwell in *English Eccentrics*.

178 Shooting at Six Mile Bottom 1832 L
Canvas: 47.2 × 63.5
Signed and dated
Private collection

176
John Frederick Herring
The Duchess's ponies

177
John Frederick Herring
 John Mytton Esq. of Halston, Salop

The two men in the foreground are shooting at a covey of partridges which have been driven from cover by two dogs. On the left a groom leans on a gate and holds his horse's reins.

179 Rubini, Whale and Beiram L
Canvas: 70 × 70
Lent by the Stewards of the Jockey Club

†180 Rubini before the start of the Goodwood Gold Cup 1833 L
Canvas: 100.4 × 100.4
Lent by the Stewards of the Jockey Club

181 Vespa, winner of the Oaks at Epsom 1833
Canvas: 54.6 × 75
Dated: *1836*
Private collection

For many years Herring painted nearly all the famous racehorses of his day, including 18 winners of the Derby and no less than 33 successive winners of the St. Leger. Over a hundred of these pictures were engraved, bringing him great popularity, for the public appreciated the documentary value of his work. This is a relatively early example of such a painting, before constant repetition had reduced his racehorse portraits to attractive but stylized ciphers. Herring finally tired of painting racehorses, and on 28 February 1848 wrote to his old friend Charles Spencer-Stanhope: 'I have quite given up painting simple portraits of horses unless allowed to make them into subjects'.

182 The Doncaster Gold Cup 1838 L
Canvas: 111.8 × 205.7
Signed and dated: *J.F.Herring 1839*
Private collection

The Earl of Chesterfield's three year old bay colt Don John, carrying 7 stone 3 pounds, is beating Beeswing, The Doctor, and Melbourne. Herring and Pollard collaborated in this large painting, Herring painting the horses in the immediate foreground, and Pollard the crowded stands and coaches with passengers and grooms at the rear, and the judges' box on the left. 'The Druid', a popular nineteenth century sporting journalist, claimed that Herring's racing scenes of this type were produced by using a sketchbook of ideal horses and jockeys with a few quick studies from life added to give convincing verisimilitude. Sir Niklaus Pevsner in *The Englishness of English Art* observed that 'where animal painting is at its best, where even the racing picture is at its best, there is no exciting action, but a curious stillness'. This seems to describe perfectly the highly exaggerated poses of the horses in this painting, which to modern eyes appear the opposite of the true movements of the running horses. But Eadweard Muybridge's pioneering photographs at San Paolo which so changed our mode of seeing were not taken until 1872, and for the Victorian sportsman wanting

an exact record of the scene as the horses reached the post, Herring's paintings provided a clear impression of the suspense and excitement of that moment in time rather than the true action of rapidly moving horses.

183 Steeplechase cracks c.1846 L
Canvas: 53.3 × 106.6
Lent by Her Majesty Queen Elizabeth, The Queen Mother

184 Mr More of Hermswell hunting
Canvas: 56.5 × 76.8
Prov: Walter Stone collection (20), bequeathed to the Walker Art Gallery, Liverpool by Miss Mary Stone 1944
Exh: *Walker Art Gallery Acquisitions 1945–55* 1955 (91)
Lent by the Walker Art Gallery, Liverpool

185 The London and Edinburgh Royal Mail
Canvas: 71.1 × 91.5
Private collection

Herring painted surprisingly few coaching subjects, but when he did his years of experience as a 'whip' gave his pictures a powerful force unusual in his work. The subject of this picture, the London and Edinburgh Royal Mail, may stand for a century of progress in road transport. In 1731 Blind Jack Metcalfe, who with Macadam and Telford was to so greatly improve the roads of eighteenth century England, walked from Harrogate to London quicker than a coach in which he had been offered a seat. By 1831 roads had so improved that the journey to Edinburgh from London by coach took only 44 hours, at the astonishing speed of just under ten miles an hour.

Dean Wolstenholme Jnr 1798–1882

Wolstenholme was born near Waltham Abbey, Essex, on 21 April 1798, the son of the sporting artist of the same name whose work is very similar in style. He showed early talent for both sport and painting, and trained as an engraver, the art of which was to occupy much of his time. He first exhibited at the Royal Academy in 1818, a portrait of a bulldog, and soon found a profitable line in painting teams of dray horses for Truman's and Barclay's Breweries, which led to many commissions for portraits of horses and hounds. He scored a popular success with his picture of the 'sporting' funeral of the famous huntsman Tom Moody, and a series of fox-hunting scenes. He also painted historical animal genre subjects, like *Queen Elizabeth I hunting*. Although ceasing to exhibit in 1859, he continued to paint until his death, especially pictures of pigeons, of which he was a well-known fancier.

186 Lord Glamis and his staghounds L
Canvas: 129.5 × 206
Prov. Commissioned by Lord Glamis, and thence by descent to the Hon. Francis Bowes-Lyon; sold Christie's 25 June 1948 (64), bt. Mr Wood; bought by Mr Mellon

from Nicholson, New York, 1959
Exh. Virginia Museum of Fine Arts, *Painting in England 1700–1850*, 1963 (340)
Lent from the collection of Mr and Mrs Paul Mellon, Upperville, Virginia

In the 1948 sale catalogue, this picture was described as 'Lord Glamis and his staghounds at St Paul's, Walden Bury, on his favourite hunter, with his brother-in-law and first whip J. V. Grinstead Esq'. This picture was engraved by S. W. Reynolds and published in 1823, and in the same year Wolstenholme exhibited at the Royal Academy (no.30) a 'portrait of Harlot, a favourite staghound with puppies, belonging to Lord Glamis'. The Dictionary of National Biography notes that in about 1830 Wolstenholme painted Lord Glamis at full-length in highland costume.

Sir Edwin Landseer, R.A. 1802–1873

Born in London, probably on 7 March 1802, the youngest son of a large family of artists, Landseer studied at B.R.Haydon's school and the Royal Academy, where he was called by Fuseli the 'little dog-boy'. A child prodigy, he first exhibited at the Royal Academy at the age of 13. Elected an ARA when he was 24, and RA in 1831, Landseer's growing melancholia, possibly caused by a thwarted relationship with Georgina 6th Duchess of Bedford, led him to refuse the Presidency of the Royal Academy when it was offered to him in 1865. He was knighted in 1850, an expression of the high regard in which he was held by the Royal Family. His first Royal commission had come in 1836 from the Duchess of Kent, Queen Victoria's mother, and the Queen and the Prince Consort were both to become great patrons of the artist. They particularly shared Landseer's affection for the Scottish Highlands and its wildlife, especially the deer, and he painted several large pictures of the Royal family on their Scottish estates. After his death, the Queen wrote in her diary: 'he kindly had shown me how to draw stags heads, and how to draw in chalk . . . I possess 39 oil paintings of his, 16 chalk drawings (framed), two frescoes and many sketches'. Landseer's special talent for child and animal genre, and the transference of human emotions to animals in such works as *Dignity and Impudence* and *The Old Shepherd's Chief Mourner* which were widely disseminated in engravings, led to immense contemporary popularity. Subsequently his reputation has shared in the vicissitudes of fashionable reactions to the art of the Victorian period, but recent exhibitions have revealed anew his unparalleled gifts as a brilliant draughtsman, and the controlled discipline of his landscape painting. (A. Graves, *Catalogue of the works of the late Sir Edwin Landseer*, 1874; F.G.Stephens, *Sir Edwin Landseer*, 1880; J.A.Manson, *Sir Edwin Landseer RA*, 1902; exhibition catalogue, *Sir Edwin Landseer RA*, 1961; exhibition catalogue, *Landseer and his world*, Mappin Art Gallery, Sheffield, 1972.)

***187 Windsor Castle in modern times** L
Canvas: 113 × 143.5
Exh: Royal Academy 1874 Memorial Exhibition (173); Royal Academy 1946 *The King's Pictures* (52); Brussels *Queen Victoria and King Leopold* 1953 (188); Royal Academy *Sir Edwin Landseer* 1961 (95); Mappin Art Gallery; Sheffield *Landseer and his world*, 1972 (79)
Lent by Her Majesty The Queen

Queen Victoria and the Prince Consort, who is wearing thigh-length hunting boots and a costume reminiscent of the hero's in Weber's *Der Freischütz*, watch the infant Princess Royal playing with dead game in the Green Drawing Room at Windsor. Through the window, the Queen's mother, the Duchess of Kent, can be seen in her bathchair. The dogs are the Skye terriers Dandie, Islay and Carnach, and the famous Eos, the Prince Consort's favourite greyhound (1833–44). Eos was buried on the slopes at Windsor and the Prince himself worked on her monument. There is a sketch in pastel for the figure of Eos in this picture also in the Royal Collection, and Landseer's oil portraits of her are in the Royal Collection and the Towneley Hall Art Gallery, Burnley. Queen Victoria wrote in her diary for 2 October 1845: 'Landseer's Game picture (begun in 1840!) . . . is at last hung up in our sitting room here, and is a very beautiful picture, and altogether very cheerful and pleasing'. As John Woodward has pointed out (*op cit* 1961 p.vii), Landseer's loose handling of paint changed under the influence of the Prince Consort and 'a highly finished Germanic surface became noticeable'.

†188 The Monarch of the Glen
Canvas: 63.8 × 68.9
Prov: Lord Londesborough 1851; Lord Otho Fitzgerald 1884; Lord Cheylesmore; Barratt, sold Christie's 11 May 1916 bt. Sir Thomas Dewar
Exh: Royal Academy 1851 (112); Royal Academy 1874 Memorial Exhibition (436); Royal Academy 1961 *Sir Edwin Landseer* (90)
Lent by Messrs John Dewar and Sons Ltd.

Landseer was long reputed in the Highlands to have painted this picture from a famous stag killed at Braemore in Ross-shire in 1868 (G.Kenneth Whitehead *The Deerstalking Grounds of Great Britain and Ireland* 1960 p.310), but it was in fact first exhibited at the Royal Academy in 1851. It was painted for the Refreshment Room of the House of Lords, but the Commons refused to vote the money for its purchase. It was consequently sold to Lord Londesborough for the large sum of 800 guineas. Landseer also made a small bronze of the Monarch. Like Millais's *Bubbles*, this picture became one of the most famous pictures in the world, mainly through engravings, and particularly through its use as an advertising image.

187
Edwin Landseer
Windsor Castle in modern times

189 Stag on the rocks L
Canvas: 180.3 × 278.4
Lent by Hazlitt, Gooden and Fox Ltd.

190 The falconer L
Canvas: 138.4 × 110.5
Exh: Royal Academy 1961 *Sir Edwin Landseer* (88)
Lent by Henry P. McIlhenny Esq.

Painted in the 1830s, when Landseer executed several
paintings of falcons and hawking. This picture was
formerly identified as 'Lord William Russell', but the
age of the sitter makes this improbable; he may however
have been Lord William's son William Russell
(1800–1884).

Sir Francis Grant 1803–1878

The younger son of a Perthshire laird, Grant was
educated at Harrow and Edinburgh High School. By
1830 Grant had spent his £10,000 inheritance, and became
a professional painter; Queen Victoria said he was 'a very
good-looking man, was a gentleman, spent all his fortune
and now paints for money'. Grant had already taken
lessons from Ferneley in the early 1820s, and by 1840 he
had achieved some success as a portrait painter, partly
due to his social status and partly to his ability to produce
a flattering likeness. The turning point in his career
occurred in 1840 with *The Queen riding at Windsor* (Royal
Collection). After this, Grant became one of the most
famous and fashionable painters of his day. He was
elected ARA in 1842, RA in 1851, and after Eastlake's
death in 1865, and Landseer's refusal to succeed him on
grounds of ill health, Grant became PRA. Queen Victoria
did not approve of this, and wrote to Lord John Russell
in 1866: 'The Queen will knight Mr Grant when she is at
Windsor. She cannot say she thinks his selection a good
one for Art. He boasts of *never* having been in Italy or
studied the Old Masters. He has decidedly much talent,
but it is much the talent of an Amateur'. Grant never
allowed his career to interfere with his foxhunting at
Melton where he died.

(J. Steegman 'Sir Francis Grant PRA; The artist in High
Society' in *Apollo* LXXXIX 1964, pp.479–85.)

191 Queen Victoria hunting with the Quorn L
Canvas: 91.5 × 152.4
Dated: *1838*
Private collection

In the early years of her reign, before her marriage, the
young Queen Victoria was a keen rider to hounds.

★192 Queen Victoria riding out L
Canvas: 99.5 × 137.2
Lent by Her Majesty The Queen

★193 Lady riding side-saddle with her dog c.1840
Canvas: 111.8 × 141
Private collection

A portrait with the fresh, easy directness and charm which
characterise so many of Grant's early portraits of the rural
aristocracy. It is comparable with his portrait of Lady
Sophia Pelham (in the collection of the Earl of
Yarborough).

194 Charles Trelawney c.1850 L
Canvas: 62.2 × 42
Inscribed with the name of the sitter
Exh: Agnews *Victorian Painting* 1961 (38)
Private collection

A spirited and forceful unfinished sketch, which shows
how vivaciously Grant could combine the painterly
tradition of Sir Thomas Lawrence with the elegance of a
Ferneley sporting composition to produce an individual
and delightful portrait.

Charles Cooper Henderson 1803–1877

Henderson was born on 14 June 1803 at Chertsey in
Surrey. Like Sir Francis Grant, he differed from the
majority of sporting artists by his affluent background.
His father was an amateur artist of some distinction, and
as a boy he was taught drawing by Samuel Prout. In 1829
he married against his father's wishes, was disinherited,
and consequently was obliged to earn his own living.
He turned to painting, and although he only exhibited
twice at the Royal Academy (in 1840 and 1848, both
coaching subjects), he became the greatest painter of the
coaching age. To say this is not to disparage James Pollard,
whose work provides a unique and attractive documentary
record of the coaches of the time, but Pollard's work lacks
the purely painterly qualities that distinguish
Henderson's, whether in oil or watercolours. In 1850 he
inherited a fortune from his mother, and painted only as a
hobby; this was fortunate for him, as his affluence
coincided with the virtual end of the coaching era. As
early as 1842, the eighty mail coaches leaving London
daily had dwindled to eleven. Henderson died on 21
August 1877.

195 The Bristol Coach meeting the Bath Coach
Canvas: 53.3 × 76.2
Private collection

Sir George Harvey 1806–1876

Born at St. Ninian's, near Stirling, Harvey began life as a
bookseller's apprentice. From 1823 to 1825 he studied at
Trustee's Academy, Edinburgh. He specialised in painting
scenes from Scottish religious history, and also in genre
and landscape subjects. In 1864 he became President of

192
Francis Grant
Queen Victoria riding out

193
Francis Grant
Lady riding side-saddle with her dog

196
George Harvey
The curlers

the Royal Scottish Academy, was knighted in 1867, and died in 1876.

*196 The curlers
Canvas: 35.8 × 79.3
Exh: Scottish National Portrait Gallery, Edinburgh, *Sport in Scotland*, 1962 (2)
Lent by the National Gallery of Scotland

Curling, a distinctively Scottish sport, has been popular since the early seventeenth century. Pennant, in his *Tour of Scotland* in 1769, described the sport as 'an amusement of the winter and played on ice by sliding from one man to another great stones of forty to seventy pounds weight of hemispherical form, with an iron or wooden handle at the top. The object of the player is to lay his stone as near the mark as possible, to guard that of his partner, which has been well laid before, or to strike off that of his antagonist'. In this picture, on the right the minister, watched by the laird, has just thrown the penultimate stone which travels over the ice, amid the excited 'sooping up' of the other players, to the end where the stones lie in a thick cluster. This is a study for the large painting exhibited at the Royal Society of Artists in 1835.

Edmund (or Edwin) Gill *fl.*1810–1835

Little is known of this artist. In 1810 an artist of this name exhibited at the Royal Academy *Evening, Wearied Sportsmen*; Paviere records two humorous angling subjects of 1812. In 1819 James Pollard engraved some now very rare hunting prints after E.Gill Esq. In Guy Paget's *Melton Mowbray of John Ferneley* (1931 p.74), there is a reproduction of the race between Clinker and Clasher of 1831 after a painting by E.Gill of Northampton, and three coaching paintings signed and dated 1835 are noted by Paviere.

197 The Silver Arrow of Harrow
Canvas: 167.5 × 106.8
Private collection

William Barraud 1810–1850

Barraud was the eldest of seventeen children. His maternal grandfather was the miniature painter Thomas Hull. He trained with Abraham Cooper, and exhibited for the first time in 1829, both at the Royal Academy and the British Institution. In 1831 he painted John Warde, the 'father of foxhunting', on his celebrated horse Blue Ruin, a picture which was engraved for the *New Sporting Magazine* and which made his name as a sporting painter. He specialised in painting horses and dogs, and collaborated with his brother Henry not only on sporting pictures but also on subjects like *The blessing of the animals in Rome on the feast of St. Anthony* and *The Claims of St. Francis*. His work has a pleasing, if uninspired, directness.

(F.Gordon Roe 'The Brothers Barraud' in *The British Racehorse* September 1965; E.M.Barraud *Barraud: the Story of a Family* 1967.)

198 Mr S.Block and his son
Canvas: 68.6 × 101.5
Private collection

Richard Ansdell 1815–1885

Ansdell was born in Liverpool on 11 May 1815, and was educated at the Bluecoat School. As a young man, he studied with W.C.Smith, a portrait painter, and then worked for an art dealer in Liverpool. In 1836, aged 21, he studied at the Liverpool Academy. He exhibited for the first time at the Royal Academy in 1840, two pictures of which one was *Grouse-shooting–luncheon on the Moors* (485) (see no.199), a field sport subject of a type to which he was to return again and again. He also frequently painted historical subjects with sporting associations, like *Mary Queen of Scots returning from the Chase* (Royal Academy 1844). Ansdell was elected President of the Liverpool Academy in 1845 and 1846, but he settled in London permanently in 1847. There he collaborated with both the landscape painter Thomas Creswick and W.P.Frith in scenes of rural genre. In 1855 he accompanied John Phillips RA to Spain, and for several years thereafter produced pictures with Spanish subjects. Elected an ARA in 1861, he became RA in 1875, and died in 1885. Ansdell was, far more than that other Liverpool artist William Huggins, the great rival of Edwin Landseer in the large, vigorously painted pictures of field sports in the Highlands which so appealed to High Victorian England. His work, so long forgotten, is now, like Landseer's, once more being reappraised.

*199 Shooting party in the Highlands
Canvas: 97 × 161.2
Signed and dated: *Richard Ansdell / 1840*
Prov: Presented by Oliver Ormerod Walker of Bury and Captain Edgar J.Garston in 1887
Exh: Royal Academy 1840 (485) as *Grouse-shooting–luncheon on the Moors*; Liverpool Academy 1840 (179); Walker Art Gallery *Historical Exhibition of Liverpool Art* 1908 (515); Walker Art Gallery *150th Anniversary Exhibition of the Liverpool Academy* 1960 (46)
Lent by the Walker Art Gallery, Liverpool

Ansdell's first exhibited painting at the Royal Academy. His power of composing a group of people in a large open air setting was to remain an important feature of his work throughout his career.

†200 The Waterloo Cup Coursing Meeting 1840 L
Canvas: 142.2 × 238.8
Signed and dated
Prov: The Earl of Sefton, Croxteth Hall
Lent by Roy Miles Fine Paintings, London

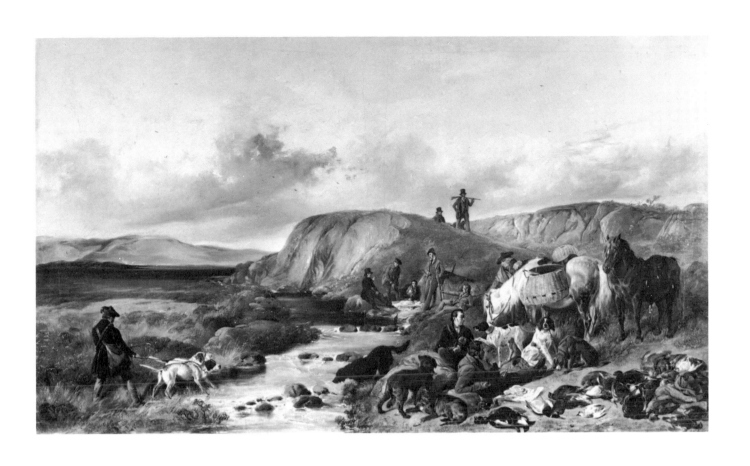

199
Richard Ansdell
Shooting party in the Highlands

It was Queen Elizabeth I who first established the laws of coursing, ordering the Duke of Norfolk to draw up a code of rules. The sport's interest lies in testing the speed and skill of the individual greyhound by pitting it against the hare. In the late eighteenth century regular meetings were held at Swaffham, Ashdown, Amesbury, Newmarket, Deptford, and Altcar, Liverpool, where the chief events of the coursing year were decided, the most important fixture, then as now, being the Waterloo Cup. Until recently Altcar was part of the Sefton estate, and prominent among those represented in this picture are the Earl of Sefton (mounted centre right), the Countess of Sefton, the Earl of Eglinton, the Earl of Stradbroke, Earl Talbot, Sir Hesketh Fleetwood Bart, the Marquess of Douglas (all mounted to the right), Mr W.Nightingale the Judge (mounted centre), Mr William Warner the slipper (holding two greyhounds on a leash to the left), Newby the trainer (kneeling left centre), Mr Nicholas Blundell and Mr James Aspinall.

201 The Sefton family shooting in Scotland

Canvas: 109.5 × 198
Signed and dated: *Richard Ansdell 1841–2*
Prov: Earl of Sefton and thence by descent
Exh: Royal Academy 1841 (1192); Liverpool Academy 1841 (180) as *The Earl of Sefton and party returning from Grouse Shooting, with a view of Glen Lyon, Perthshire*
Property of Her Majesties Government, on loan to the Walker Art Gallery

The sitters are Lord and Lady Sefton, Colonel the Hon H.R.Molyneux, Colonel the Hon C.H.Molyneux, and the Hon F.K.Craven.

202 Mr Stephen Blair fishing in the River Spean

Canvas: 66 × 122
Dated: *1855*
Prov: Major F.E.Harrison
Lent by Peter Baily Esq.

203 Jonathan Blundell with his greyhounds

Canvas: 71.1 × 91.5
Prov: Mrs J.A.Pollen (daughter of Major Cuthbert Blundell-Hollinshead-Blundell); presented to the Walker Art Gallery by her estate 1962
Lent by the Walker Art Gallery, Liverpool

The low viewpoint and the striking silhouette of the man and his dogs against the sky are characteristic of Ansdell, and here particularly result in a powerful and dashing image of the sportsman.

204 The equestrian L

Canvas: 101.5 × 127
Private collection

Anonymous

205 The fight between Carter and Oliver, Gretna Green 1816

Canvas: 72.4 × 106.7
Private collection

Tom Oliver, born in Buckinghamshire in 1789 was one of the most distinguished pugilists of his day, and would have been champion of England if he had been a stone or two heavier. The description of his fight with Ned Painter in 'Lavengro' by George Borrow with its panegyric of 'The Bruisers of England' is one of the finest descriptions of a fight in English prose.

Jack Carter, from Manchester, born in 1789, lost to Molyneux and Power, but beat the hitherto undefeated Oliver at Gretna Green, and assumed the still unrelinquished title of Tom Cribb, to the latter's annoyance. Although turned publican and four stones over his fighting weight, Cribb fought a short bout with Carter, before arranging for a real fight for the Championship between his protegé Tom Spring and Carter, which the latter lost.

Philip John Ouless 1817–1885

Born in St. Helier on 7 April 1817, Ouless studied painting in Paris, and then established himself in Jersey as a 'Portrait, Landscape and Marine Painter' and a teacher. He painted many pictures of ships, published albums of local views, and illustrated volumes of local history. His sketchbooks are in the possession of the Société Jersiaise, and the Barreau Gallery has two of his large oil paintings, *Jersey Races* (see below) and *St. Aubin's Bay* (1873). He died on 22 June 1885.

206 Jersey Races 1850

Canvas: 83.8 × 127
Signed and dated
Prov: Mrs W.Gregory
Lent by the Société Jersiaise

Ouless, eight years before Frith painted *Derby Day*, provides in this picture a similar vivid cross-section of a race-course crowd, with its carriages, performing acrobats, and fairground booths. Yet the scene here is not Epsom Downs, but surely one of the most impressive settings for a provincial race-course – Grouville Common, with Mont Orgueil Castle seen in the distance.

Samuel J.E.Jones *fl.*1820–1845

Little is known of this artist, who seems to have specialised in shooting scenes, although he also painted horses and coaching subjects. He exhibited from a London address 14 times at the Royal Academy portraits and

landscapes, 14 times at the British Institution, and 19 times at the Society of British Artists. Many of his paintings were engraved.

207 Pheasant-shooting
Canvas: 63.5 × 76.2
Private collection

E.F.Lambert *fl.1823–1846*

Little is known of this artist, who exhibited from a London address 15 times at the Royal Academy and seven times at the Society of British Artists.

208 The Brighton Coach at the 'Bull and Mouth'
Canvas: 86.3 × 111.8
Lit: W.C.A.Blew, *Brighton and its coaches* 1894;
N.C.Selway, *The Regency Road: the Coaching Prints of James Pollard* 1957
Private collection

The Prince Regent's frequent journeys between Carlton House and the Brighton Pavilion made easy communication between the capital and the seaside resort desirable, and during his association with the town the journey changed from a difficult two-day expedition to one of the fastest runs in England. The coaches ran on the three main routes via Lewes, Horsham, or Cuckfield. Some of the great London coaching inns were almost small towns; the 'Bull and Mouth' in St. Martins-le-Grand had underground stables large enough to accommodate 400 horses. It was kept by Sherman, who was one of the most enterprising of the coach proprietors. The 'Bull and Mouth' sign is preserved in the Guildhall Museum.

Anonymous

209 Bill Neat
Canvas: 43.2 × 34.2
Private collection

William Neat(e) of Bristol, stood 6 foot 0½ inches tall and fought at 13st 7lb. His encounter with Hickman the 'Gasman' for the Championship left vacant by Tom Cribb forms the subject for one of Hazlitt's finest essays in the *New Monthly Magazine* of 1821. Neat won the fight, but lost the championship to Tom Spring on 20 May, 1823, retiring with a broken arm after the eighth round. While training for the fight Neat encountered Elizabeth Fry the Quakeress who attempted for two hours to make him forego the engagement. In later years Neat often said that he would rather face Tom Spring for two hours than Mrs Fry for half the time and double the money.

H.Broughton *fl.1828*

Nothing is known of this artist.

210 The Defiance Coach 1828
Canvas: 71.2 × 91.5
Private collection

George Morley *fl.1831–1860*

He exhibited 40 paintings at the Royal Academy and two at the British Institution, from a London address. They are chiefly pictures of horses and dogs, and there are several examples of his work in the Royal Collection.

211 Clinker L
Canvas: 61 × 78.7
Dated: *1831*
Lent by the Earl of Ancaster

Clinker was one of the most celebrated steeplechase horses of the 1830s. Owned by Captain Ross, who had the animal painted on no less than five occasions by John Ferneley, Clinker's most famous race took place against Clasher in 1831, the result of a 1500 guinea wager between Ross and Osbaldeston. Dick Knight, the famous huntsman of the Pytchley, rode Clinker, but Squire Osbaldeston on Clasher won the five mile race from Great Dalby Windmill to near Tilton-on-the Hill in sixteen minutes. Both riders wrote lively accounts of the race, which are printed in *The Melton Mowbray of John Ferneley* (Guy Paget, 1931, pp.74–7).

Harry Hall *fl.1838–1868*

Hall was a prolific artist working in London and Newmarket who specialised in competent, if uninspired, paintings of racehorses, and provided an excellent documentary coverage of most of the notable horses on the English turf in the mid-nineteenth century. His work filled the gap left by Herring's defection from racehorse painting to animal genre, but he lacked Herring's feeling for a high spirited blood horse. 114 plates after his work appeared in the *Sporting Magazine*, and sixty of his portraits of racehorses were engraved.

★212 Sir Tatton Sykes and Sir Tatton Sykes c.1845–50
Canvas: 71.1 × 91.5
Prov: 5th Earl of Rosebery
Exh: Virginia Museum of Fine Arts *Painting in England 1700–1850*, 1963 (369)
Lit: Sir Theodore Cook *A History of the English Turf* 1901–4 vol 2, ii (repro. facing p.436); Roger Longrigg *The History of Horse Racing* 1972, p.131
Lent from the collection of Mr and Mrs Paul Mellon, Upperville, Virginia

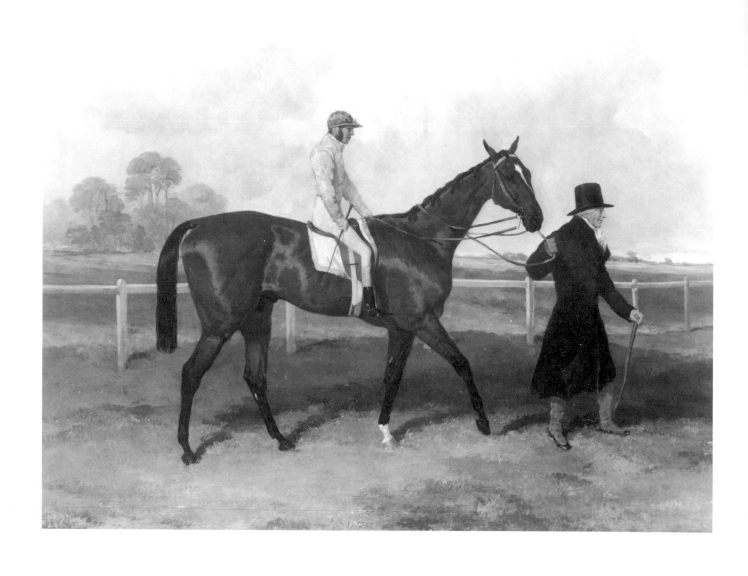

212
Harry Hall
Sir Tatton Sykes and Sir Tatton Sykes

This bay horse, by Melbourne out of a mare by Margrave, was foaled in 1843, and was first named Tibthorpe after his Yorkshire birthplace. In 1844 he was bought by the jockey William Scott. In 1846 Scott, not a noticeably religious man, went down on his knees after riding this horse to victory in the 2000 guineas, and thanked God 'for at last having sent me a hell of a horse'. He renamed the horse in honour of Sir Tatton Sykes. Scott, a hard drinker, was then drawing to the end of a long and distinguished career. At the start of the Derby of 1846, Scott was very drunk, argued the toss with the starter, and started several lengths down the field. He managed to make up lost ground, and at the two furlong post was comfortably in the lead, when Scott passed out, and John Gulley's Pyrrhus the First snatched victory by a neck. Sir Tatton Sykes went on to win the St. Leger, Scott's ninth and last St. Leger win, and is seen here being led in by his namesake, the famous Yorkshire racehorse owner.

John Dalby fl.1840–c.1853

There is considerable confusion surrounding the work of the Dalbys (see above), and it is difficult to assert with confidence whether certain undated pictures should be attributed to John or David. Certainly both artists produced attractive cabinet-sized paintings.

★213 A steeplechase
Canvas: 45.8 × 63.5
Signed and dated: *Dalby 1849*
Prov: Presented by Miss K. Worrall to the Walker Art Gallery in 1948
Lent by the Walker Art Gallery, Liverpool

John Dalby is best known for his small paintings of hunting scenes, and the slightly larger format adopted for this picture may be due to its subject. Steeplechasing, in which the riders were very often the owners themselves, began through individual challenges between gentlemen like the famous race between Clinker and Clasher of 1831 (described under no.211). But parallel with such matches developed a chase of several riders across country, who took every fence that came and followed the lead of a professional rider like Dick Christian, of whom the famous Captain Becher said: 'If I had Christian's nerve, I'd give all I have in the world'. In 1830 Thomas Coleman, an innkeeper in St. Alban's, arranged the first St. Alban's Steeplechase, on a circular route that started and finished near his inn, the Turf Hotel. The increase of interest was rapid, and by 1842 there were 66 annual meetings, the most important being Aintree, Cheltenham and the Vale of Aylesbury.

214 Racing at Hoylake
Canvas: 35.5 × 78.2
Signed and dated: *Dalby/ 1851*
Prov: Walter Stone; bequeathed by Miss Mary Stone to the Walker Art Gallery in 1944

Exh: Bluecoat School, Liverpool, *The Walter Stone Collection* 1953 (6); National Gallery, *Walker Art Gallery Acquisitions 1945–55* 1955 (96)
Lit: Walker Art Gallery Picture Book, no.5 *Twenty Sporting Pictures* 1949 (pl.5)
Lent by the Walker Art Gallery, Liverpool

This picture may represent the Sports Handicap at Hoylake on 11 September 1850.

R.James fl.1841–1851

Very little is known of this artist, except that he sent from a Nottingham address four pictures to the Royal Academy and one to the British Institution between 1841 and 1851. His style in the following, his sole surviving work, has the honest charm of John Opie.

215 Tossing for innings
Canvas: 64.8 × 49.5
Prov: E.R. Wilson
Lit: Sir Pelham Warner *Lord's 1787–1945* 1946
Lent by the Marylebone Cricket Club

The painting shows some ragged boys on a common; one has just tossed a bat into the air and is watching it along with two of the others, while another is piling up the boys' coats to make an improvised wicket. This is the smaller of two versions in the M.C.C. Collection and another version in a private collection shows in the background a distant view of Nottingham Castle.

Thomas Henwood fl.1842

★216 The scorer – Portrait of William Davies 1842
Canvas: 35.5 × 30.5
Inscribed: *The Scorer, William Davies at Brighton*
Lit: Sir Pelham Warner *Lord's 1787–1945* 1946
Lent by the Marylebone Cricket Club

Nothing is known of this artist except the present picture, which was also issued as a lithograph. Davies was scorer to Lewes Priory Cricket Club and died in 1842.

T.Yeomans fl.1850

Nothing is known about this artist except that he was a painter in Grantham who produced pictures of the well-known breed of sheep, the Leicestershire Longwools.

217 Fighting cock
Canvas: 66 × 81.2
Private collection

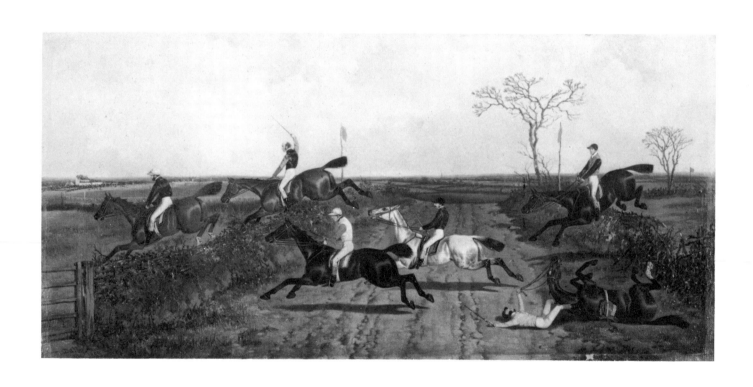

213
John Dalby
A steeplechase

216
Thomas Henwood
The scorer – portrait of William Davies

John Ritchie *fl.*1855–1875

Ritchie exhibited 18 times at the Royal Academy, and also at the British Institution and the Society of British Artists, sending his pictures from a London address. He was a prolific and competent painter of sentimental landscapes reminiscent of Myles Birket Foster.

218 Village cricket 1855
Canvas: 80 × 125.8
Prov: Sir Jeremiah Colman
Exh: Tate Gallery, *Cricket Pictures from the collection of Sir Jeremiah Colman* 1934; City of Birmingham Art Gallery, *Victorian Pictures 1837–1870* 1937 (44); National Book League 1950; Graves Art Gallery, Sheffield 1955
Lit: Sir Jeremiah Colman *The Noble Game of Cricket* 1941; Sir Norman Birkett *The Game of Cricket* 1955
Lent by the Marylebone Cricket Club

One of the numerous paintings of village cricket executed in this period, and this is one of the most imaginative. It has been suggested that it is of a match at Hambledon, but it could be of almost any village ground in the south of England, and the church tower is not that of Hambledon.

Anonymous

*219 A rat pit c.1860
Canvas: 68.6 × 88.9
Private collection

This picture, which can be dated by costume evidence to the early 1860s, depicts a rat pit. In the white circle in the ring a bull terrier is vigorously killing rats, supervised by the second. The ring is surrounded by a large male crowd, all painted as sharply defined individual portraits. On the walls hang a Ben Marshall cockfighting print, and what appears to be the mezzotint portrait of John Gulley the prizefighter, also after Marshall. Above this portrait hang the Tricolour and Union Jack, possibly a reference to the Crimean War, as several soldiers wearing pill box hats are in the room.
The prohibition of cockfighting in 1849 led to a vogue for ratting. Dogs were backed to kill a given number of rats within a set time, the dogs being weighed (weight in relation to performance was crucial) and timed by a stop watch.
Cuthbert Bede in *Mr Verdant Green*, and Disraeli in *Sybil*, describe respectively undergraduate and working class attitudes to the sport, but the most extensive contemporary account of a rat pit, almost an exact description of the present picture, occurs in Henry Mayhew's *London Labour and the London Poor*: 'Sporting pictures hang against the dingy walls. . . . The pit . . . consists of a small circus, some six feet in diameter, fitted with a high wooden rim that reaches to elbow height. Over it the branches of a gas lamp are arranged, which light up the white-painted floor, and every corner of the little arena'.

Rats and sporting dogs appealed to widely differing social classes. In the Royal Collection, on long-term loan to the Victoria and Albert Museum, is a table-centre, designed by the Prince Consort for Queen Victoria, bearing silver gilt figures of the Royal dogs. One, a terrier, has killed a rat, another, the dachshünd 'Waldemann' looks eagerly at a cage containing a live rat.
The faces that surround the pit in this picture, so clearly individualised, were obviously once easily identifiable. One might hazard that the young man prominently placed in the left foreground of the picture was the young Marquess of Hertford, Harry Hastings, the 'perfect Cocker', the greatest gambler and practical joker of his day, who once introduced a sack of live rats into a crowded London ballroom. He was certainly a keen supporter of the sport, which is said to linger on today in the Black country. Another painting of a rat pit is in the collection of the London Museum.

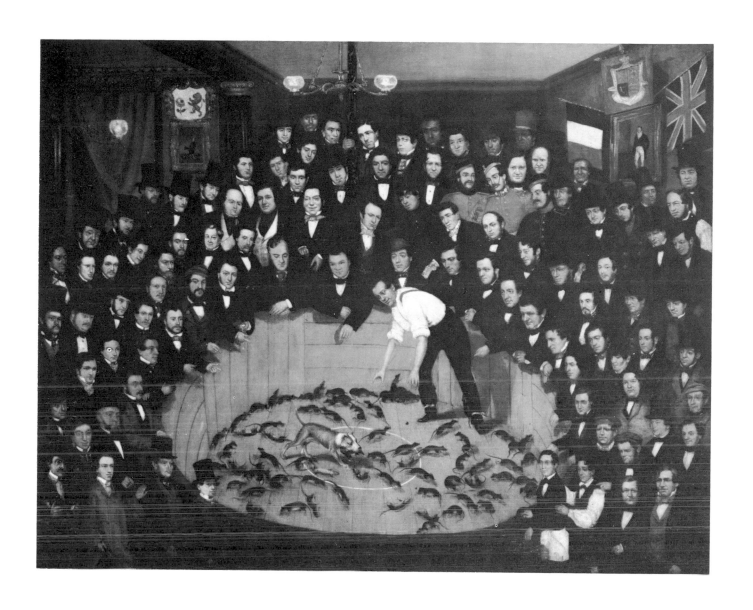

219
Anon
A rat pit

The English Sporting Print
c.1650–1850
by David Coombs

There is a paradox about sporting prints: for while there is no doubt that they are in a sense reproductive, it does them no good to be compared directly with any oil paintings that may have inspired them. They are not reproductions in the modern sense of a more or less faithful imitation of an original. They are primarily illustrations, meant to be enjoyed, and often composed of a series of related miniatures or vignettes. They are a kind of document or record and therefore will be examined closely and critically by those interested in their subjects. This is why the methods used for making prints are so important to their success. All of which goes some way towards explaining why prints have to be looked at in a different way to oil paintings, and why they need to be understood before they can be appreciated.

With most people during the period either living in or dependent on the country, there was a very large potential demand for sporting prints – which is why there were so many varieties and also why so many have survived. It was a strictly commercial operation. Those principally concerned might include: the artist, engraver, publisher, printer, papermaker, colourist and printseller. Even these specialities were not exclusive – for instance an artist or engraver might act as his own publisher (no.240).

It was the publisher who organised the whole operation, bringing the artist and engraver together, providing the finance, organising the distribution, and arranging the publicity. The prints were sold as like as not through the publisher's own shop, through other printsellers in large cities as like London, and in towns throughout the kingdom (no.224). Major prints or series might be advertised in advance for sale on subscription; that is at a lower prepaid price. A dedication to an important sportsman, whether with his permission or as a way of seeking his patronage, was a method widely used to give a print extra authority or as an additional guarantee of its authenticity (no.272). Publishing might also cross national boundaries with the cost of an edition shared, for example, between London and Paris (no.297).

Many prints carried quite precise details of their date of publication: the problems and delays that led to some carrying dates that were erased, changed or added can be easily understood in a complicated operation (no.262). These dates can be interesting in another way too. For instance, the etching of the Humphreys/Mendoza fight (no.252) was on sale little more than a week after the event. And the lithograph relating to an incident during the great blizzards that swept the whole country round Christmas 1836 (no.303) was published barely five weeks later, despite the complication of hand-colouring.

Several engravers would be responsible for prints of real quality, the repetitive or basic work being given to apprentices. The major outlining or

toning would be done by the man named on each print. Many of the prints have splendid, sometimes even rather beautiful, inscriptions (no.273). These are more often than not an integral part of the print, engraved on the same plate as the picture, and containing information important, and sometimes even vital, to a proper appreciation of the whole. As likely as not, these inscriptions were the work of specialist engravers.

How and when any particular print has been coloured is not always immediately obvious. Original old colouring can be sometimes recognised by its relative crudity. The matter is complicated by the practice of printing in colour, a few examples entirely, the rest either partly printed in colour and partly hand-coloured, or entirely hand-coloured. Those prints that were originally hand-coloured would be done by one of a team of colourists working to a master pattern provided by the artist. Only very rarely is the name of the colourist recorded (no.290).

The paper used for prints is of a crucial importance. The fact that until the very end of the eighteenth century it was still made by hand explains why there was a practical restriction on the maximum possible size. Hence the prints in this exhibition made from two or more separate sheets (no.225). The prime reason for the fine quality of the old paper was the pure linen, rope or rags, from which it was made. Always scarce, efforts over many decades to find suitable replacement materials were not finally successful until the middle of the nineteenth century when a method of obtaining the necessary fibres from wood was discovered.

It soon becomes obvious when comparing prints that much of their effect was dependent on the skill of the printer. Few carry his name; those that do are invariably of the highest quality (no.277). In practice all sporting prints had as their foundation a thin copper plate. On to this the picture would be engraved in one or other of the standard methods (see below), and the inscription added. Printing could then begin.

The ink was made from a variety of basic ingredients; for example Frankfurt black, French black and linseed oil. It was spread over the whole plate with a dabber or roller; the surface was then wiped until only the lines or pittings were full of ink. The plate was then placed face up on the bed of the press. The earliest forms of presses were of the screw and then of the lever type – where the paper is pressed down hard on to the plate. Later the roller press was introduced, with metal cylinders between which the plate and paper were squeezed with uniform pressure from above and below.

The paper was dampened before use (otherwise it would not absorb the ink), then laid on to the surface of the engraved plate, covered by a protective blanket, and the press operated. It was then that some prints became wrinkled or creased (no.269). Each print pulled was called an impression. On each

sheet of paper there is a distinct mark, or indentation, surrounding the engraved surface. This is the plate mark, the result of the pressure of the paper against the edges of the copper plate, which would have been bevelled (or blunted) in advance to make sure it did not break through the paper when in the press.

At the beginning of this essay I emphasised how misleading it is to think of prints solely as reproductions of paintings. They were certainly the result of a commercial decision which, among other things, provided an opportunity for the artist to increase his income as well as to make his name more widely known. William Hogarth was probably the first British artist to exploit the potential of engravings to any extent. In fact, it was largely his agitation that secured the passing of the 1735 Copyright Act which, for the first time, gave an artist exclusive right to his own designs. This was perpetuated for a number of years in that part of a print's inscription which read 'Published According to Act of Parliament' (no.228).

Hogarth was his own engraver in most cases and so was able to exercise absolute control over the quality of his prints. Even if it was merely to protect his own reputation, any artist who relied on other engravers would certainly have been very deeply involved in the making of the prints. (Turner and Constable are two of those best documented in this regard.) And the evidence of our own eyes confirms this. (no.268).

Many of the best sporting prints were the product of artists who engraved their own prints, and who were also keen and knowledgeable sportsmen in their own right: Henry Alken and the two Wolstenholmes are the prime examples. But this is not so surprising in a situation where a high degree of technical accuracy and considerable practical knowledge was absolutely necessary

The vexed question of what exactly was the original inspiration for a print is surprisingly difficult to answer. Some sporting prints were obviously directly inspired by particular paintings, this was by no means always the case. Sometimes a finished watercolour or the merest sketch would be enough for the engraver to work from, especially if the artist was his own engraver (nos.267 & 336). At the other extreme, a very successful print might lead to a commission for a painting based on the engraving. There might even be several versions of a particular drawing or watercolour – any or all of which might quite reasonably be an original for the print, in the sense that individually they were the designs for the several stages necessary to the making of a print.

Line engraving: probably the most ancient of all methods, its origin lies in a development of the decorative engravings technique used by goldsmiths. It was quite widely used for making prints in Europe about the middle of the fifteenth century, but it did not reach England until the sixteenth, with the influx of refugees from the Low Countries. This dependence on Continental engravers lasted almost until the end of the seventeenth century, as the earliest print in the exhibition, after Diepenbeeck, shows. (no.220).

For sporting prints the foundation was almost invariably a thin copper plate, on to which the basic design would be drawn or scratched. The lines would then be cut with an edged tool called a burin. This was pushed through the surface of the plate at a variety of angles to give finer or thicker grooves. The end of a line was generally pointed, where the burin would have been pushed up clear of the surface. Generally used by itself, line engraving was also found sometimes in combination with stipple. A few hundred good impressions could be taken before the plate began to wear; and probably several thousands before it was finally finished.

Etching: the earliest known etchings date from about the turn of the sixteenth century in northern Europe. The method probably developed from that used to decorate armour. The most important influence on English practice was exerted by the Czech artist Wenzel Hollar in the late seventeenth century. He inspired Francis Barlow (no.221) and etched some of the plates for Blome's *Gentleman's Recreation*.

As in line engraving the foundation was a copper plate, and its surface was dabbed all over with a hard, blackened ground made from beeswax, bitumen and resin. The design was drawn on this and the lines were cut through to the copper with a blunt-ended needle. The whole plate was then submerged in a bath of acid which would bite the surface of the copper through the lines opened by the needle. The relative thickness of the etched line would depend on the number of immersions: those already satisfactory would be protected, or stopped-out, with varnish.

In the eighteenth and early nineteenth centuries etching was commonly used in conjunction with aquatint, and sometimes with mezzotint, to give a more or less important visual edge or line to the various parts of a design. (nos.283 & 290). The ground and varnish were removed before printing and no more than a hundred or so satisfactory impressions were usual, but more was possible for simple designs.

Mezzotint: this was invented in the middle of the seventeenth century by Lieutenant-Colonel Ludwig von Siegen who disclosed the secret to Prince Rupert. The Prince introduced the process to England and to John Evelyn,

the diarist, who wrongly credited Prince Rupert with its invention. It was taken up by several engravers and its eventual success was so considerable that it came to be dubbed abroad as engraving in 'the English manner'.

As before, the foundation was a thin copper plate on to which the main lines of the design would have been previously etched or engraved. The whole of the surface was then roughened with a curved, toothed chisel called a rocker; were this ground to have been inked and a print taken the result would have been a uniformly rich, velvet black impression. In practice the ground was scraped and burnished so that the design when finally printed appeared by means of a multitude of different densities of tone. (no.270).

The mezzotint burr was relatively delicate, so that only twenty or perhaps thirty really fine impressions were possible. After a hundred or so, the plate would have been reworked. In the early nineteenth century, mezzotints were made on a steel plate; this was much harder to work but as many as fifteen thousand impressions could be taken from one plate. The problem was met later by the introduction of a steel facing on a previously worked copper plate.

Stipple: although the technique seems to have been in use about the turn of the sixteenth century, it first came to prominence in France in the eighteenth century. It was introduced into England by George III's engraver, William Ryland, who taught the method to Francesco Bartolozzi, a Florentine and a founder member of the Royal Academy, with whom it has since become indissolubly identified.

Again, the foundation was a copper plate on to which a hard etching ground had been laid. The main lines of the design were dotted through the ground to the surface with a needle which might have one or several points. A denser effect was obtained by using roulettes: spiked wheels or drums. The plate would then be successively etched in an acid bath (as previously described), and the lightest tones engraved afterwards with a burin. This was a technique that lent itself especially to being used for colour printing. (no.270). In monochrome or colour the number of fine impressions would have been relatively small, perhaps about a hundred. As this was a composite technique more impressions might have been possible, but of sharply deteriorating quality.

Aquatint: the original method was first patented in France by Jean-Baptiste Le Prince in 1768. There were a number of variations, that using spirit was an English invention by Peter Burdett of Liverpool in 1771. The watercolour artist Paul Sandby claimed to have introduced it to England; he certainly wrote a treatise on the subject in 1775 and was largely responsible for popularising it. The technique was ideal for protagonists of the English watercolour as the design was formed from a variety of soft tones and, at first glance, a really fine aquatint is hard to distinguish from a watercolour.

Once again the foundation was a copper plate. Resin dissolved in alcohol was poured over the whole surface. When the spirit had evaporated the plate would be covered with a fine ground of granules which, when immersed in an acid bath, would etch to form a fine network of lines: the invariable sign of an aquatint. The various shades of tone would be obtained by stopping-out (protecting) the lighter areas with varnish, the darker areas being successively etched as the design required.

Aquatints were almost invariably printed in a coloured ink other than black – brown or blue perhaps, sometimes both on the same print (no.248). They were then coloured by hand. Fine impressions would have been few, twenty or thirty perhaps, with two hundred or so more or less satisfactory impressions. Usually aquatints were made with the outlines of the principle features separately etched. Because hand-colouring was necessary, the use of etched outlines meant more impressions could be taken: for although the aquatint background quickly wore away (the thinnest areas – the sky – would go first) this could be disguised for the unwary purchaser by more extensive use of the hand colouring.

Soft-ground etching: this method came into use only in the second half of the eighteenth century. Thomas Gainsborough is said to have been its inventor, and some examples by him were published in 1797. Among sporting artists only Henry Alken seems to have used it, and then rarely. (no.287). It is a very sensitive technique requiring considerable accuracy and skill, as mistakes are virtually impossible to correct effectively.

The copper plate foundation was heated and on to it rolled an etching ground made as before with beeswax, bitumen and resin but softened through being mixed with tallow. Once cool, a piece of thin paper already drawn with the design, was laid on the ground. The lines were then traced with a stylus or pencil. The paper was then removed, lifting with it that ground that had stuck to it through pressure from the tracing. When submerged in an acid bath, the surface of the plate will have been etched in a series of microscopic pits. When printed the whole effect was of a drawing done with a very soft pencil. Soft-ground etchings were generally hand coloured afterwards, and perhaps up to a hundred impressions were possible.

Lithography: this process was invented and patented by Alois Senefelder in Bavaria in 1798. First known as Polyautography it is based on the principle that oil and water will not mix. Senefelder brought it to England in 1801 with Philip André, brother of his German partner, who stayed on to promote it. The first English lithographs were published in 1803 but the process was slowly accepted partly perhaps because of the thick stones that were the foundations. About 1830 these could be replaced by zinc plates, easier to handle and less liable to break.

The original lithograph foundation was a thick, porous limestone. The surface was ground smooth and the design drawn on it with a greasy pencil or crayon: this was then fixed (made permanent) with acid and gum arabic. Before printing, the stone was wiped over with water which would impregnate any area not already drawn upon. A greasy ink would then be rolled across the surface adhering only to the greased design. Drawings were very easily transferred direct from paper to stone if drawn in greasy ink. Several hundred impressions could be taken. Lithographs were generally hand coloured at this period (no.317), and some partly printed in colour.

Late impressions and reproductions: inevitably most, if not all, methods of printmaking could be abused by printing more impressions than each technique warranted. Some plates (especially line engravings) were passed from publisher to publisher, not all of whom would bother even to change the original date of publication. So a date on a print is no guarantee of its being an original, that is early, impression. The matter was further complicated with coloured prints where the thinness of the impression could be disguised by ever thicker gouache or watercolour.

Not even a watermarked paper is an absolute guarantee as late impressions can always be printed on a batch of unused, old paper. The only guide is experience based on a fair knowledge of a number of excellent prints – such as those included in this exhibition. The same also applies to the need to distinguish between original impressions, late impressions, and reproductions made by a mechanical process: even some of these are hand coloured. It is a matter of experience and instinct. As for prints being taken from books: this still continuing practice is of ancient origin and is complicated by the fact that many prints now found bound were originally issued unbound or in paper covers.

The exhibition: the prints have been chosen primarily for their individual quality and the intrinsic interest of their subject matter. Space did not allow more than a token representation of sets – a particular characteristic of sporting prints. All the principal methods of printmaking are represented by prime examples, and most of the basic sports with the notable exception of cock fighting for which no suitable print has been found in time.

The catalogue: within the limits of the space available, the entries are designed to highlight the major points of interest for each picture, as regards both subject and technique. The traditional method of cataloguing prints, which is simply to transcribe their inscriptions has been generally abandoned here. All prints were published in London unless otherwise stated. The measurements relate to the engraved surface only, height by width.

PRINTS

Abraham van Diepenbeeck 1596–1675

For biography see p.31.

220 Balottade par le droite,
one of the first movements used in dressage which was introduced to England by the Duke of Newcastle
Line engraving by P.Clouvet: 38.1 × 50.8
Published for the Duke of Newcastle, Antwerp, 1658
Lent by the Parker Gallery

Francis Barlow c.1626–1704

For biography see p.33

221 Netting birds in darkness,
when dazzled by torch or lantern light
Etching: 33.6 × 20
From Richard Blome's *Gentleman's Recreation*, 1686
Lent by the British Museum

222 The last horse race run in the presence of King Charles the Second,
near Windsor in 1684, the year before he died. The small compact horses are typical of those raced before the introduction of the Thoroughbred
Etched by the artist: 39.7 × 50.8
Published by P.Tempest and S.Baker, 1687
Lent by the British Museum

John Wootton 1686?–1764

For biography see p.34.

223 Tregonwell Frampton,
'Keeper of the Running Horses at Newmarket' to four successive monarchs until his death in 1727, and the owner of Dragon (pictured behind him) whom he cruelly gelded and raced to death for a 2000 guineas wager
Mezzotint by John Jones: 54 × 35.2
Published by Messrs Bodger, Weatherby, Tattersall etc, London and Newmarket, 1791
Lent by Her Majesty The Queen

224 Sir Robert Walpole, Colonel Charles Churchill and Mr Turner with hounds
Line engraving by D.Lipiniere: 47 × 58.4
Published by John Boydell, 1778
Scratched letter proof
Private collection

Peter Tillemans 1684–1734

For biography see p.34.

225 View of a horse match over the Long Course at Newmarket
Line engraving by Claude Du Bosc: 46.3 × 111.1
Published by Carrington Bowles, c.1723
One of a set of four, each made up from two separate plates
Private collection

James Seymour 1702–1752

For biography see p.40.

226 Death of a fox
Etchings and mezzotint by T.Burford: 42.5 × 60
Published by the engraver, 1760
One of a set of four
Private collection

227 Death of a fox
Etching and mezzotint by T.Burford: 35.3 × 50.8
Hand coloured
Published by the engraver, c.1760
This plate has been cut down from that used for the previous print (no.226), probably because of damage. The right-hand side and the top are missing, and the right-hand figure in the previous print has been replaced in miniature to balance the picture
Private collection

228 Carriage match 1750
The conditions of the wager for 1000 guineas involved constructing within two months a carriage with four wheels carrying one person, and drawn by four horses to race nineteen miles in one hour. It was successfully performed in 53 minutes 27 seconds on Newmarket Heath. The harness was made of silk and a silk line controlled by the passenger held the draw pole steady; the axles were continuously oiled from tin cases by each wheel, and the rider of the near leader 'who had the conducting of the rate to go at', wore a timepiece on his arm. The background scene including a view of the carriage on its circuit was the engraver's own addition – John Bodger was a land surveyor
Engraved by John Bodger: 42.5 × 69.8
The inscription describes the print as being made in 'Mr Bartolozzi's style of engraving' which is line and stipple, although this print looks remarkably like an aquatint and etching

Published by the engraver, Messrs Boydell and Mr
Weatherby, London and Newmarket, 1789
Lent by the Stewards of the Jockey Club

Francis Hayman 1708–1776

Best known for ornamental paintings at Vauxhall. Friend
of Hogarth and Garrick. He was one of the founding
members of the Royal Academy. He later taught
Gainsborough.

229 Cricket in Marylebone Fields:
the original Lord's cricket ground; the runs are being
marked by notches on a stick
Line engraving: 23.5 × 34.2
Published 1748
A larger, related version was engraved by C.Grignion:
perhaps he did this one too?
Lent by the Marylebone Cricket Club

W.Mason 1724–1797

Born at Kingston-upon-Hull. His paintings were
engraved by several eminent engravers of the eighteenth
century.

★230 A country race course
Etching by J.Jenkins; aquatint by F.Jukes: 48.9 × 64.5
Published by J.Phillips, 1786
Lent by the British Museum

There was considerable trade in prints between France and
England, as the two-language title indicates.

Anonymous

231 Coursing the hare
Mezzotint; hand coloured: 25 × 35.3
Published by Carrington Bowles, 1787
One of a series of six
Private collection

George Stubbs, A.R.A. 1724–1806

For biography See p.48.

232 Sweet William,
bred in 1768 by Lord Grosvenor who was a great patron
of the Turf
Aquatint by George Townley Stubbs: 30.2 × 35.6
Published by J. Harris, 1789
Details of the breeding have been engraved on a separate
plate
Private collection

George Stubbs and Amos Green

233 Game keepers
Mezzotint by Henry Birche: 43.2 × 65.4
Published by Benjamin Beale Evans, 1790
Private collection

Amos Green painted the landscape; the engraver 'Birche'
may be Richard Earlom.

George Stubbs, A.R.A. 1724–1806

For biography see p.48.

234 Dungannon,
son of Eclipse, bred and owned by Dennis O'Kelly, with
a sheep that was his constant companion.
Stipple by George Townley Stubbs. Hand coloured and
partially printed in colour
Published by Messrs Stubbs Turf Gallery, 1794
Lent by the Stewards of the Jockey Club

235 Bull baiting
Mezzotint and etching by William Say: 52.7 × 75.2
Proof before inscription was engraved. The publisher and
date of issue is unknown. Say lived from 1768–1834.
Stubbs died in 1806, his print of 'Bulls Fighting' was
engraved by G.T.Stubbs in 1788, which may be a clue
to the date of this print
Lent by the British Museum

Johann Zoffany, R.A. 1733–1810

For biography see p.57.

236 James Sayer,
son of the print publisher Robert Sayer
Mezzotint by Richard Houston: 49.8 × 35.5
Published by Robert Sayer, 1772
Private collection

Francis Sartorius 1734–1804

For biography see p.60.

237 Cotton Decks of Stanfield,
a noted trainer of pointers
Mezzotint by Robert Lowrie: 27.7 × 34.9
Published by Robert Sayer, 1772
Private collection

238 Oatlands Sweepstakes, Ascot 1791,
won by the Prince of Wales's Baronet
Etching and aquatint by J.Edy: 38.6 × 52.3
Published by J.Harris, 1792
Private collection

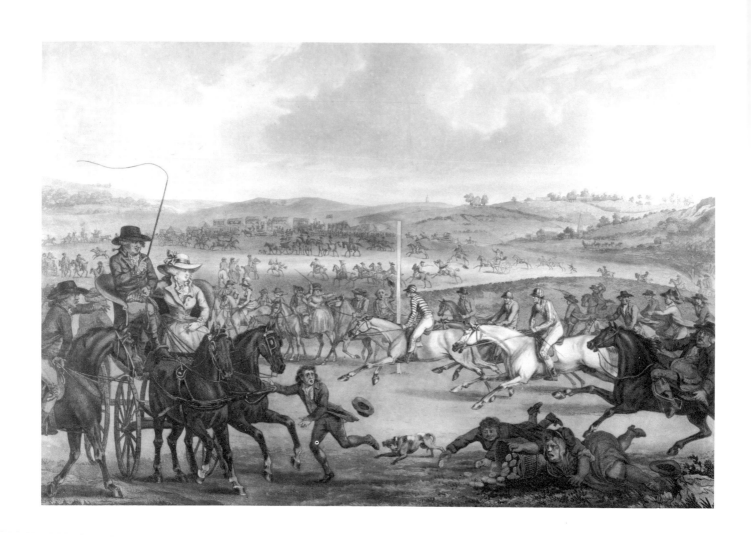

230
W.Mason
A country race course

239 Coach horses owned by Sir John Lade:
an enthusiastic amateur coachman and friend of the
Prince of Wales
Mezzotint by Edward Dayes: 32.7 × 41.9
Published by E.Bull, *c.*1795
Private collection

Better known as an aquatinter, this is Dayes' only known
mezzotint; as the inscription infers he did it under the
guidance of William Pether, the ground being laid for
him by I.Jeffryes.

Thomas Beach 1738–1806

For biography see p.60.

240 Mr Tattersall,
founder in 1766 of the horse auctioneers, originally at
Knightsbridge Green
Mezzotint by John Jones: 50.2 × 34.9
Published by the artist, 1787
The title is engraved over part of the mezzotint grounding:
a rare feature
Lent by Her Majesty The Queen

John June *fl.*1740–1770

Engraver, who made engravings after the paintings of
Hogarth and Sartorius.

241 The death of the fox
Line engraving: 103.5 × 112.7. Hand coloured with sepia,
blue and grey washes
This print is made up from four separate plates
Lent by the British Museum

John Hamilton Mortimer, A.R.A. 1741–1779

For biography see p.60.

242 Monsieur Masson,
celebrated Frenchman who came to play 'real' tennis in
England, *c.* 1760 (cf.no.317)
Mezzotint by R.Brookshaw: 50.4 × 35.5
Published by I.Wesson, 1769
Lent by Her Majesty The Queen

Anonymous

243 Duck shooting
Etching and mezzotint: 24.7 × 35.2
Published by Laurie and Whittle, 1799
Private collection

Philip Reinagle, R.A. 1749–1833

For biography see p.

244 Moor shooting
Aquatint and slight etching by Lewis & Nichols:
40.2 × 48.9. Hand coloured and partially printed in colour
Published by Random & Sneath, 1807
Lent by the British Museum

245 Otter hunting
Etching and aquatint by John Scott: 37.5 × 52.6
Published probably *c.*1810
A proof before inscription, no publisher is known and the
attribution to the line engraver John Scott seems uncertain.
Slightly damaged
Lent by the British Museum

★246 Breaking cover:
Colonel Thomas Thornton, a flamboyant patron of many
field sports. He was largely responsible for the revival of
falconry (See no.80)
Stipple and line engraving by John Scott: 50.4 × 64.4
Published by James Cundee and John Scott, 1811
Print slightly damaged in foreground
Lent by the British Museum

John Raphael Smith 1752–1812

Portrait painter and engraver. Began life as a linen draper.
Famous for engravings after Reynolds, Romney and
Gainsborough.

247 Henry Angelo,
son of the founder, and later the head, of a fashionable
Soho fencing school
Mezzotint by B.F.Scott: 29.8 × 19.3
Published by the engraver, 1791
Date handwritten in ink
Lent by Her Majesty The Queen

Robert Smirke 1752–1845

Exhibited with the Royal Academy and Society of
Artists from 1786–1813.

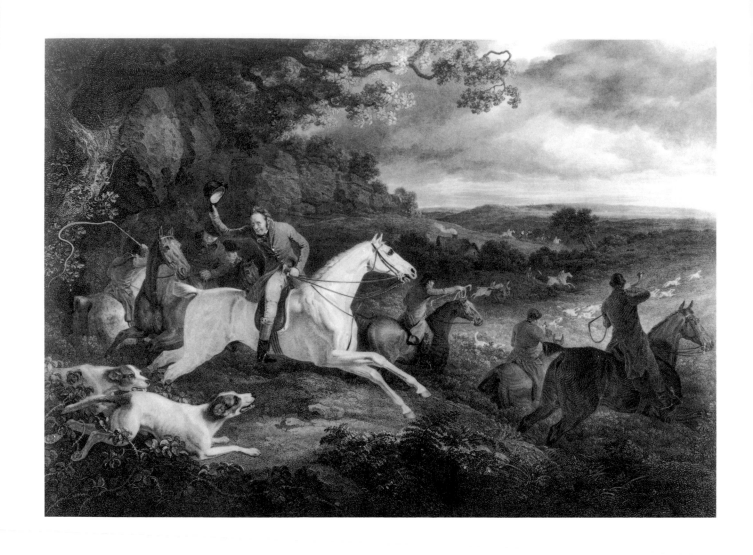

246
Philip Reinagle
Breaking cover

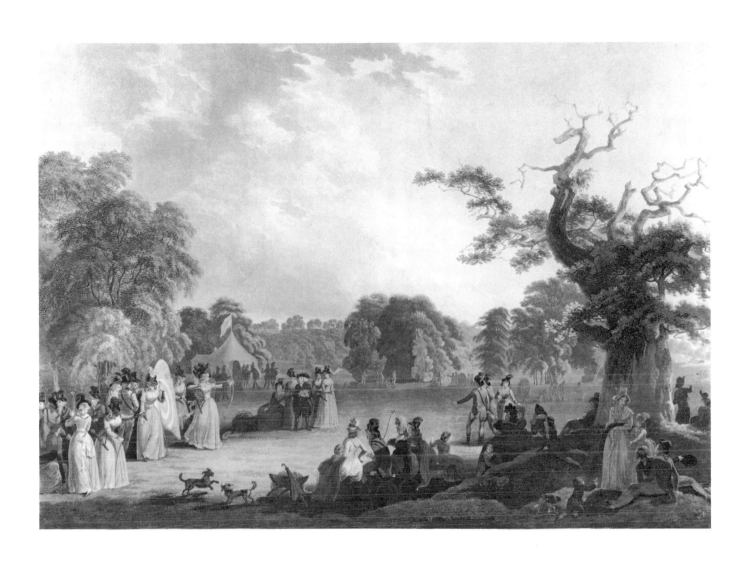

248
Robert Smirke and John Emes
The meeting of the Society of Royal British Archers in
Gwersyllt Park, Denbighshire

John Emes *fl*.1785–1805

Engraver and watercolour painter.

Robert Smirke and John Emes

***248 The meeting of the Society of Royal British Archers in Gwersyllt Park, Denbighshire**
Figures by Smirke, landscape by Emes
Etching and aquatint by C.Apostool: 46.3 × 58.4
Printed in brown and blue
Published by J.Emes, 1794
Example of an aquatint prior to its being hand coloured
Lent by the British Museum

Thomas Rowlandson 1756–1827

Started as a painter of serious subjects and portraits, but after gambling away his fortune, paid his debts with a stream of drawings. Greatly encouraged by Rudolph Ackermann the publisher

249 The refreshment
Etching by the artist: 45.7 × 56.5
Hand coloured
Published by J.Harris, 1788
This and no.250 are two of a series of four
Lent by the British Museum

***250 The return**
Etchings by the artist: 47.6 × 56.2
Hand coloured
Published by J.Harris, 1788
Lent by the British Museum

251 The Jockey Club or Newmarket Meeting
Etching and wash: 22.6 × 33
Published *c*.1795
Lent by the Stewards of the Jockey Club

James Gillray 1757–1815

Prolific caricaturist. Apprentice letter-engraver until 1780 when he executed mainly political subjects.

252 Match between Mendoza the Jew and Richard Humphreys, September 1790
Accompanied by a detailed account of the fight which Mendoza won in 72 rounds
Etching and letterpress: 42.5 × 35.2
Published by S.W.Fores, 1790
Lent by the British Museum

The print was published only ten days after the fight, and separately from the letterpress.

Dean Wolstenholme Snr 1757–1837

Spent his youth hunting and shooting. Reduced to poverty through a law suit and had to turn to painting for a living.

253 Shooting
Aquatint by R.Reeve: 47.3 × 55.2. Hand coloured
Published by the engraver, 1806
Plate one of a set of four
Private collection

254 Harriers:
a cross between a fox hound and beagle, for hunting hares. Young hounds are coupled to older hounds for experience
Etching and aquatint by R.G.Reeve: 47 × 58.7
Hand coloured
Published by the engraver, 1812
Lent by the British Museum

John Hoppner *c*.1758–1810

For biography see p.67.

255 Richard Humphreys,
celebrated boxer, particularly famous for his fights with Mendoza the Jew
Mezzotint by J.Young: 57.2 × 42.8
Published by H.W.Billington, 1788
Lent by Her Majesty The Queen

John Nost Sartorius 1759–after 1824

Son of Francis Sartorius. He had many well-known patrons including the Prince of Wales and Charles James Fox. See page 67.

256 At Fault:
the hounds have temporarily lost the scent of the fox
Stipple and line engraving: 45.7 × 60.6
Figures by J.Neagle. Landscape by J.Peltro
Published by J.Harris, 1790
Plate three of a set of four. Proof before title
Lent by the British Museum

Lemuel Francis Abbott 1760–1803

Portrait painter, especially celebrated for his portraits of Nelson, Cowper and Hood.

257 William Innes,
captain of the Blackheath Golf Club, with his caddy on the course where King James I introduced golf to England from his native Scotland in 1608
Mezzotint by V.Green: 63.7 × 42.8

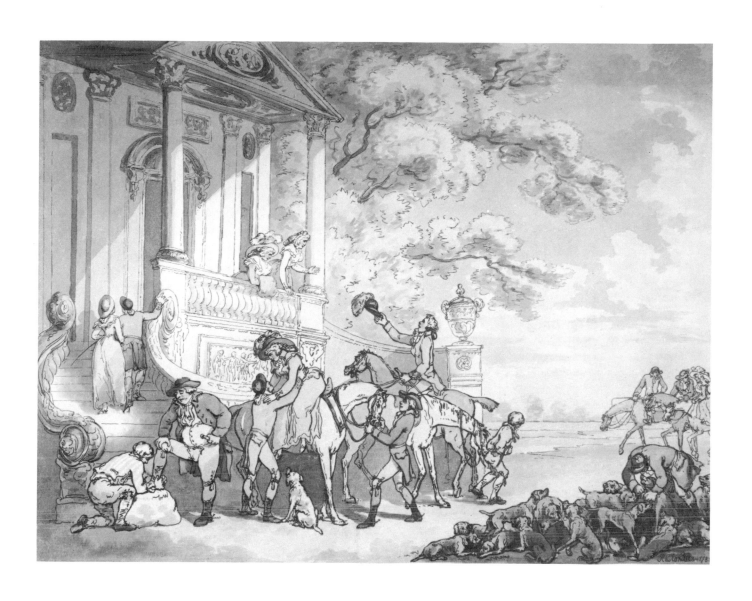

250
Thomas Rowlandson
The Return

Published by the artist, 1790
Publication line cut
Lent by Her Majesty The Queen

George Morland 1763–1804

For biography see p.69.

258 Snipe shooting
Stipple and slight engraving by C.Catton: 32.7 × 38.3
Printed in colour
Published by T.Smith, 1789
Proof before inscription was engraved
Lent by the British Museum

259 Snipe shooting
Etching by Thomas Rowlandson. Aquatint by Samuel
Alken: 40.6 × 53.7
Hand coloured and partially printed in colour
Published by J.Harris, 1790
One of a set of four
Private collection

260 Duck shooting
Etching and aquatint by Thomas Rowlandson:
43.2 × 54.6. Printed in blue
Published by S.Vivares & Son, 1792
Lent by the British Museum

261 A bear hunt:
hounds were slipped from their leashes when in sight of
their quarry
Mezzotint by S.W.Reynolds: 32.4 × 37.4
Published by the engraver, 1796
This is probably an early proof, as the inscription is not
fully engraved and the day of publication has been
changed
Lent by Her Majesty The Queen

Charles Towne 1763–1840

For biography see p.79.

262 Bulldogs and Badger
Mezzotint and line engraving by Richard Earlom:
49.2 × 57.3. Partially printed in colour
Published by Robert Laurie and James Whittle, 1806
Scratch letter proof with artist's name incorrectly
engraved
Private collection

Samuel Howitt 1765–1822

Brother-in-law to Rowlandson. Enthusiastic sportsman
and lived careless existence until he ran out of money and
turned to painting for a living. Self-taught.

263 Woodcock shooting
Etching: 17.8 × 25.4. Sepia wash added by hand
Published by Laurie and Whittle, 1791
Proof before inscription. Slightly foxed. Single plate
Set of six known
Lent by the British Museum

Benjamin Marshall 1768–1835

For biography see p.84.

***264 Hap-Hazard:**
Unbeaten over four miles from 1801–4. Owned by the
Earl of Darlington, shown with his trainer Samuel
Wheatley and jockey William Pierce
Stipple and line engraving by W. & G.Cooke: 50.5 × 60.3
Published by the artist, 1805
Lent by the British Museum

265 Francis Const,
probably the lawyer who became chairman of the
Westminster sessions
Etching and mezzotint by Charles Turner: 55.9 × 68.7
Published by the engraver, 1806
Private collection

266 The Earl of Darlington with the Raby Pack
The Earl also owned the racehorses, Memnon and
Hap-Hazard
Stipple by J.Dean: 51.4 × 59
Printed in colour
Published by W.& D.Jones, Cambridge, 1810
One of a pair
Lent by Lord Carington P.C., K.C.M.G., M.C.

Jacques Laurent Agasse 1767–1849

For biography see p.82.

267 After running
Etching and aquatint by C.Turner: 23.5 × 28.8
Hand coloured and partially printed in colour
Published by the engraver, 1807
Single plate. Set of six known
Private collection

268 The Wellesley Arabian:
stallion brought to England in 1803 by the Duke of
Wellington's brother
Mezzotint by C.Turner: 48.2 × 56.7
Published by the artist, 1810
Proof before inscription
Lent by Her Majesty The Queen

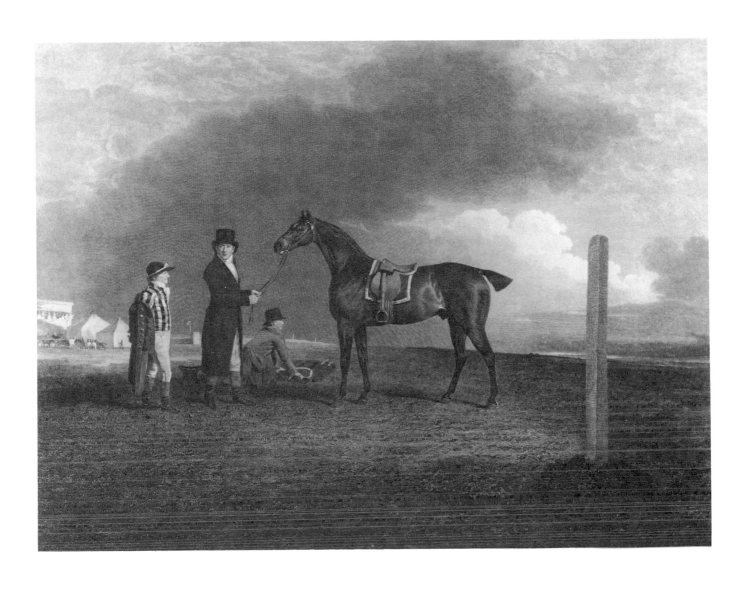

264
Benjamin Marshall
Hap-hazard

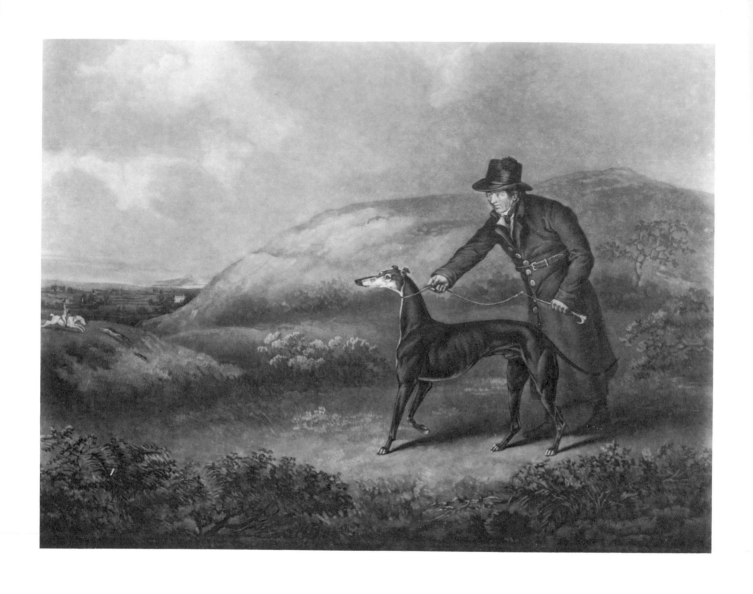

270
Henry Bernard Chalon
Snowball

Henry Bernard Chalon 1771–1849

For biography see p.91.

269 The Earl of Chesterfield's State Carriage
Friend of King George III, the Earl was Master of
the Horse 1798–1804
Mezzotint by William Ward: 45.4 × 57.5
Published by the engraver, 1800
Printed by I.Shore. The inclusion of the printer's name
was a rare privilege
Lent by Her Majesty The Queen

***270 Snowball:**
greyhound owned by Edward Topham and shown with
William Poshby, the old groom who always trained him
Mezzotint by William Ward: 49.5 × 58.5
Published by Random and Sneath, 1807
Lent by the British Museum

271 The Raby Pack,
owned by the Earl of Darlington, with Leonard the dog
feeder, their huntsman Sayer and Jasper the terrier
Mezzotint by William Ward: 52.1 × 59.6
Published by Edward Orme, 1814
Lent by the British Museum

272 Sir Mark Masterman Sykes:
an eccentric master of hounds, and famous as a collector
of books and pictures
Mezzotint by William Ward: 58.7 × 73
Published by J.Wolstenholme, York, 1821
Private collection

James Howe 1780–1836

Scottish animal painter who visited London to make
studies of animals in the Royal Mews.

***273 Sir John Maxwell of Pollock,**
with his Scottish falconer John Anderson and his
assistant William Harvey
Mezzotint and stipple by Charles Turner: 54 × 60.3
Published by Alex Finlay, Glasgow, 1816
Print slightly damaged bottom right
Lent by the British Museum

L. Attbalin

Nothing is known about the life of this artist.

**274 The duc d'Orleans' carriage and house at
Twickenham**
where he lived 1815–16; an exile in Britain (and America)
after the Revolution, he became King Louis Philippe of
France 1832–48, dying at Clermont, Surrey, 1850
Etching and aquatint by J.C.Stadler: 41 × 72.3

Hand coloured
Publication line cut, but probably c.1816
Private collection

Richard Barrett Davis 1782–1854

Animal painter to King William IV. Followed hounds on
foot carrying his sketch pad with him. Son of huntsman
to King George III's Harriers and brother of the Royal
Huntsman, Charles Davis.

275 Treeing the Fox:
an obsolete way of exciting the hounds after the kill
Etching and aquatint by Thomas Sutherland: 30.2 × 69.2
Hand coloured
Published by R.Ackermann, 1819
Cut inscription. Slightly damaged in sky
Single plate. Set of four known
Lent by the British Museum

276 Charles Davis,
huntsman of the Royal Buckhounds.
Lithograph by J.W.Giles: 40 × 41.3. Hand coloured
Published by the artist, 1836
One of a series of illustrations for the 'Hunter's Annual',
which contained pedigrees, keys to the hounds, and a
history of each hunt
Lent by the British Museum

C. Blake

Nothing is known about this artist.

***277 The Fives Court, James Street, Haymarket**
with Randall and Turner sparring; a composite portrait
of prize-fighters and others at one of their principal
London meeting places. The Prince Regent was a patron,
and Randall, with Cribb and Richmond, attended his
coronation
Etching and aquatint by Charles Turner: 51.1 × 66
Printed in sepia
Published by Charles Turner, 1821
Printed by McQueen and Company
Example of aquatint before hand colouring
Lent by the British Museum

Henry Alken 1785–1841

For biography see p.93.

278 Throwing off

279 Breaking cover

280 In full cry

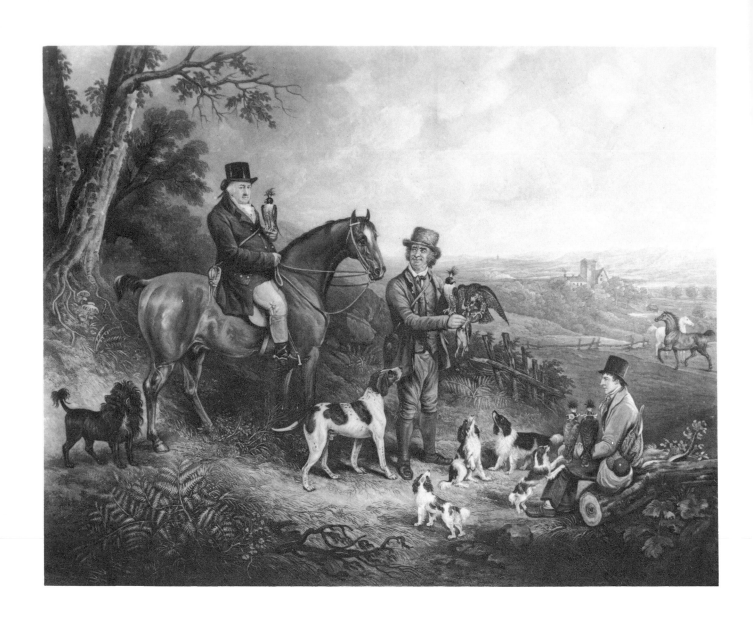

273
James Howe
Sir John Maxwell of Pollock

Pencil, pen and wash drawing: 6 × 51.4
Lent by the British Museum

Six of eight prints comprising forty two scenes. Apart
from being published in individual sections, they could
also be joined to make a long panorama (155 inches)
rolled into a wooden cylinder. The drawing exhibited is
the artist's original sketch for the first six scenes. The
missing section relates to scenes round Hampton Court.

James Pollard 1792–1867

For biography see p.100.

293 Returning home by moonlight
Etching and aquatint by R.Havell & Son: 35 × 46
Hand coloured
Published by R.Pollard, Holloway, 1817
Proof before inscription, publication line cut
Plate four of set of four
Lent by Donald North Esq.

294 Stage coach passengers at breakfast:
the guard is blowing his horn for the departure.
Passengers were only allowed twenty minutes for the
breakfast stop
Etching and aquatint by the artist: 33.6 × 45.1
Hand coloured
Published by R. Pollard, Holloway, 1819
Lent by Donald North Esq.

**295 Easter Monday, turning out the stag at Duckits
Hill, Epping Forest:**
an example of carting; this is a form of hunting using
a tame stag which is recaptured at the end of the chase
Etching and aquatint by the artist: 35 × 62.8
Hand coloured
Published by R. Pollard, Holloway, 1820
Private collection

296 Memnon,
unbeaten in all his races, including the St. Leger in 1825.
Bred by Richard Watt and later owned by the Earl of
Darlington
Etching and aquatint by the artist: 32.8 × 45.1
Hand coloured and partially printed in colour
Published by R. Pollard, Holloway, 1825
Lent by Donald North Esq.

297 Hyde Park Corner
Etching and aquatint by R. & C.Rosenberg: 44.5 × 61.2
Hand coloured
Published by J.Watson, 1828
Lent by Donald North Esq.

298 Hunters on their way to the hunting stables
Etching and aquatint by H.Pyall: 37.1 × 43.4
Hand coloured
Published by Thomas McLean, London,
and Giraldon Bovinet, Paris, 1829
Lent by the British Museum

299 Approach to Christmas
the Norwich 'Times' in the Mile End Road
Etching and aquatint by George Hunt: 41.9 × 52.3
Hand coloured and partially printed in colour
Published by J.Moore, c.1830
One of a pair
Lent by Donald North Esq.

300 Bottom fishing
Etching and aquatint by R.G.Reeve: 35.5 × 42.5
Hand coloured
Published by T.Helme, 1831
Lent by Donald North Esq.

301 Crossing the brook
Northampton Grand Steeplechase, March 1833
Etching and aquatint by H.Pyall: 35.2 × 42.8
Hand coloured
Published by T.McLean, 1833
Plate two of set of six
Lent by Donald North Esq.

302 Epsom Grand Stand
The winner of the Derby
Etching and aquatint by R.G.Reeve: 28.2 × 37.5
Hand coloured
Published by Thomas McLean, 1836
Inscription cut and separated
Plate two of a set of four
Lent by the British Museum

303 The Birmingham Mail fast in the snow
Lithograph by G.B.Campion: 27.3 × 37.4. Hand coloured
Published by Ackermann, 1837
Printed by J.Graf
Issued only five weeks after the great snowstorm of
Christmas 1836. The grey-coloured paper is unusual
Plate three of a set of four
Lent by the British Museum

304 The Four-in-Hand Club, Hyde Park
Gentleman drivers parading past their founder, Lord
Chesterfield
Etching and aquatint by J.Harris: 39.7 × 54.6
Hand coloured and partially printed in colour
Published by R.Ackermann, 1838
Lent by Donald North Esq.

283
Henry Alken
The Toast

281 The death
Etching and aquatint by Clark & Dubourg: 38.1 × 44.1
Hand coloured
Published by S & J.Fuller, 1813
Set of four, Alken's name incorrectly spelt by the
engraver
Lent by the British Museum

282 Easter Monday:
hunting a carted (i.e. trained) stag near Epping, a
townsman's day out
Etching by the artist: 34.2 × 43.8. Hand coloured
Published by S. & J.Fuller, 1817
Lent by the British Museum

***283 The Toast**
Etching by the artist. Aquatint by George Hunt: 29.2 × 40
Hand coloured
Published by Thomas McLean, 1824
Lent by the British Museum

284 Keepers on the lookout
Etching and aquatint by George Reeve: 26.6 × 21
Hand coloured
Published by Thomas McLean, 1828
Lent by Mrs Donald North

**285 Members of the Red House Club shooting for the
Gold Cup 1828**
Live pigeons were released from traps: a precursor of
modern clay-pigeon shooting
Etching by the artist. Aquatint by R.G.Reeve: 32.4 × 47.6
Hand coloured and partially printed in colour
Published 1828
The print shows signs of foxing
Lent by the British Museum

286 Going to cover
A neat cover hack – a nice, comfortable ride on the way
to find a fox
Soft ground etching by the artist: 24.8 × 28. Hand coloured
Published by R.Ackermann, 1831
One of a set of six
Lent by Donald North Esq.

287 The first steeplechase on record
The last Field near Nacton Heath. The participants were
some cavalry officers quartered at Ipswich in 1803, who
after night stable inspection decided on a race to Nacton
Church across country, hiding their uniforms with
nightshirts. The most famous of all early steeplechases,
but unlikely to be the first
Etching and aquatint by J.Harris: 33.6 × 36.5
Hand coloured and partially printed in colour
Published by R.Ackerman, 1839
Plate three of a set of four
Lent by the British Museum

Shadow of the five-barred gate is inaccurately engraved;
remedied in the second issue but re-engraved for the third
and following issues as in the original.

Sir Robert Frankland 1784–1849

Seventh baronet and amateur artist.

288 Shooting signals:
an unofficial semaphore for use in the field
Etching: 27.7 × 19.6. Hand coloured
Doubtless etched and published by the artist, probably
c.1815
Lent by the British Museum

289 Delights of fishing
Etching and aquatint probably by the artist: 22.5 × 27
Hand coloured
Published by Charles Turner, 1823
One of a series of six
Lent by the British Museum

The handwritten quotations from Virgil's Aeneid and
Georgics can be translated: 'Here the tent throws him
bodily into the water', and 'He is caught up in the fast
flowing branches'.

J.Townshend

Nothing is known about this artist.

**290 The Royal British Bowmen meeting in the grounds
of Erddig, Denbighshire, 1822**
Etching and aquatint by Bennett: 24.5 × 29.8
Hand coloured and partially printed in colour,
highlighted with gum arabic
Published 1823
Coloured from the original drawing by W.H.Timms
Lent by the British Museum

Isaac Robert Cruikshank 1789–1856

Caricaturist and miniature-painter. Gave up life of seaman
to be an artist. He also illustrated many books.

291 Archery
Mezzotint: 35.2 × 24.8
Published by Robert Sayer and Company, 1792
Pair
Lent by the British Museum

292 Going to a fight:
scenes on the road from Hyde Park Corner to a boxing
match and bull baiting at Molesey
Etching and aquatint by the artist: 6 × 49.2–50.2
Printed in sepia
Published by Sherwood, Neely and Jones, 1819

277
C.Blake
The Fives Court, James Street, Haymarket

305 Scenes on the road to Epsom
The Cock at Sutton
Aquatint by J.Harris: 36.2 × 49.5
Hand coloured and partially printed in colour
Published by R.Ackermann, 1838
Plate three of a set of four
Lent by Donald North Esq.

306 Grand Entrance to Hyde Park Corner
Etching and aquatint by R. & C.Rosenberg: 42.5 × 61.6
Hand coloured, and highlighted with gum arabic
Published by Messrs Fores, 1844
Lent by the British Museum

This is a re-issue of no.297. The three vehicles in the
foreground, for instance, have been brought up to date
in style. The inscription has been cut and there are signs
of waterstain in the sky.

E.F.Lambert

For biography see p.117.

★307 American trotting horse, Tom Thumb,
owned by George Osbaldeston, 'The Squire', a famous
sportsman of his day, who once drove this horse 100 miles
in ten hours
Etching and aquatint by G. & C.Hunt: 35.2 × 43.8
Hand coloured and partially printed in colour
Published by J.Moore, 1829
The inscription has been cut
Lent by the British Museum

Dean Wolstenholme Jnr 1798–1882

For biography see p.107.

308 Shooting: going out
Etching and aquatint by Thomas Sutherland: 27 × 32.8
Hand coloured
Published by R.Ackermann, 1823
Plate one of a set of four
Lent by the British Museum

309 Meeting

310 Fox breaking cover

311 Full cry

312 Fox run to earth
The so-called 'Small Surrey Views' of scenes associated
with Colonel Jollyfe's Hounds; distinguished by his blue
velvet coat, the Colonel would be out to hunt early
however late the sitting of Parliament, where he
represented Petersfield
Etching and aquatint by the artist: 24.2 × 33
Hand coloured
Published by J.Brooker, 1824
Set of four
Private collection

Sir Edwin Henry Landseer, R.A. 1802–1873

For biography see p.108.

313 The stag at bay:
a red deer with deer hounds at the edge of a loch.
Mixed method engraving by Thomas Landseer:
55.9 × 92.1
Published by Thomas McLean and E.Gambart, London
and Paris, 1848
Printed by W.Day
Lent by Her Majesty The Queen

Edward Duncan 1804–1882

Worked first for aquatinters Robert Havell, father and
son. Better known as a marine artist in later years.

314 The burial of Tom Moody:
whipper-in who requested that his coffin be borne by six
earth stoppers, his horse carry his tack and last fox's brush,
and that three View Halloos be given over his grave when,
if he didn't lift his head, his friends could conclude him
fairly to be dead
Etching and aquatint by Christian Rosenberg: 40.6 × 46.3
Hand coloured
Published by W.J.Wade, 1831
Lent by the British Museum

315 Wild duck shooting
Aquatint and slight etching by the artist: 18.4 × 25.7
Hand coloured and highlighted with gum arabic
Published by T.Gosden. Undated
Lent by the British Museum

Samuel J.E.Jones fl.1820–1845

Exhibited frequently in London, mainly at the Royal
Academy, British Institute and Suffolk Street from
1820–1845.

316 The Elephant and Castle, Newington,
on the Brighton Road was probably the busiest coaching
inn in England

307
E.F.Lambert
American trotting horse, Tom Thumb

Etching by W.R.Smart. Aquatint by George Hunt:
56.2 × 75.2
Hand coloured and partially printed in colour
Published by George Hunt, 1826
Private collection

George Frederick Watts 1817–1904

Painter of portraits of many Victorian beauties and other
eminent celebrities, also of allegorical and historical works.

317 Alfred Mynn:
hop merchant and first round-arm bowler who played for
Kent, All England and the Gentlemen, i.e. professional
cricketer of independent means
Lithograph by G.F.Watts: 33 × 25.4
Published c.1847
Lent by the Marylebone Cricket Club

Anson A.Martin

Nothing is known about the life of this artist.

318 Jockeys of the South of England
Lithograph by G.B.Black: 41 × 50.5. Hand coloured
Published by Day and Haghe c.1840
Private collection

Anonymous

319 The first tennis court at Lord's Cricket Ground:
opened in 1838 and demolished sixty years later to make
way for the Mound Stand; this is the so-called 'real' as
opposed to modern lawn-tennis (see no.343)
Coloured lithograph. 18.4 × 25
Published by R.S.Croom, Wilkinson and Company,
c.1850
Lent by the Marylebone Cricket Club

DRAWINGS

Francis Barlow c.1626–1704

For biography see p.33.

320 Hawking for pheasants
Bistre, pen and wash drawing: 14.9 × 21.5
Lent by the Ashmolean Museum, Oxford

321 Snipe and grouse stalking
the stalker moving up hidden by a grazing horse
Brush drawing in grey wash: 20 × 29.5
Signed
Lent by the British Museum

★322 Hare-hunting
Pen and wash drawing: 14.9 × 21.5
Lent by the Ashmolean Museum, Oxford

Jan Wyck 1652–1700

Dutchman who lived the greater part of his life in England
where he specialised in hunting subjects.

323 The death of the hart
Pen and ink with brown and grey washes: 29.8 × 21
Lent by the British Museum

The whips are whipping off the hounds after the kill.

324 Rabbit catching
Pen and ink with grey and brown washes: 29.8 × 22.3
Lent by the British Museum

Several methods are shown, netting, ferretting and
dogging.

Thomas Sandby 1721–1798

Private secretary and draughtsman to William Augustus,
Duke of Cumberland. Deputy-ranger of Windsor Great
Park 1746–98 where he formed Virginia Water. First
Professor of architecture at the Royal Academy in 1770.

Paul Sandby 1725–1809

Watercolour painter and engraver. Director of Society of
Artists in 1765. Chief drawing master of the Royal
Military Academy. Popularised the process of aquatinting.
Pioneer of topographical art.

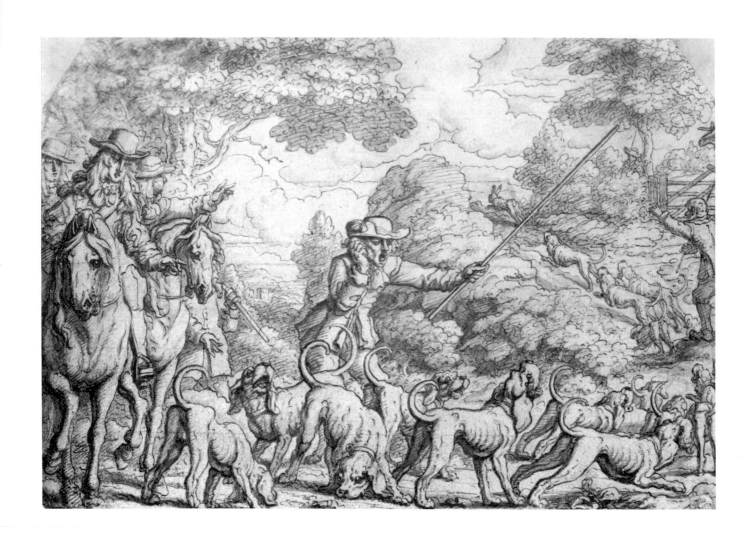

322
Francis Barlow
Hare-hunting

Thomas and Paul Sandby

325 Ascot Heath Races
Pencil, pen and watercolour: 48.9 × 90.5
On two sheets of paper, waterstained, the watercolour
faded through exposure
Lent by Her Majesty The Queen

The races were re-established there in 1746 by the Ranger,
William, Duke of Cumberland.

George Stubbs, A.R.A. 1724–1806

For biography see p.48.

**326 Anatomical profile of a partially stripped down
horse**
Black chalk: 36.2 × 49.5
Prov: Bequeathed by Stubbs to Mary Spencer in 1806; by
Edwin Landseer to Charles Landseer in 1873, and by him
to the Royal Academy in 1879
Exh: Whitechapel, *George Stubbs*, 1957 (57)
Engr: By Stubbs for *The Anatomy of the Horse*, 1766,
First Anatomical Table
Lent by the Royal Academy

About 1758 Stubbs began the studies which he published
in *The Anatomy of the Horse*. He worked at a lonely
farmhouse at Horkstow, Lincolnshire in company with
Mary Spencer, his common-law wife. Ozias Humphrey's
manuscript, *Life of Stubbs* (Picton Library, Liverpool),
describes how the artist suspended a horse from the ceiling
and supported it throughout many weeks work. '. . . He
first began by dissecting and designing the muscles of the
abdomen proceeding through five different layers of
muscles until he came to the peritoneum and the pleura,
through which appeared the lungs and the intestines –
afterwards the bowels were taken out and cast away. Then
he proceeded to dissect the head by first stripping off the
skin and after having cleaned and prepared the muscles for
the drawing he made careful designs of them and wrote
the explanation which usually employed him a whole day.
He then took off another layer of the muscles which he
prepared, designed and described in the same manner as is
represented in the work – and so he proceeded until he
came to the skeleton.'
Stubbs' finished drawing for: The First Anatomical
TABLE of the Muscles, Fascias, Ligaments, Nerves,
Arteries, Veins, Glands and Cartilages of the HORSE.

**327 Anatomical drawing of a partially stripped down
horse, facing three-quarters left**
Pen, black and red chalk: 47.6 × 30.5
Inscribed: *a part of the pectoralis inserted into the inside of
γᵉ head of humerus and forms a ligament that bind down
the head of γᵉ biceps.
bcd what I think analogous to the serratus minor anticus
arises at d from the sternum & part of the first rib or collar*

*bone and from the cartilaginors endings of the 2ᵈ 3ᵈ &
4ᵗʰ ribs near their ioin to the sternum.
is inserted into the shoulder blade and tendinous surface of
the supra spinatus scapula at c.*
Prov: Bequeathed by Stubbs to Mary Spencer in 1806; by
Edwin Landseer to Charles Landseer in 1873, and by him
to the Royal Academy in 1879
Exh: Whitechapel, *George Stubbs*, 1957 (57)
Engr: By Stubbs for *The Anatomy of the Horse*, 1766,
Seventh Anatomical Table
Lent by the Royal Academy

Stubbs' detailed working drawings for: The Seventh
Anatomical TABLE of the Muscles, Fascias, Ligaments,
Nerves, Arteries, Veins, Glands and Cartilages of a
HORSE, biewed in front, explained.

Sawrey Gilpin, R.A. 1733–1807

For biography see p.54.

328 Horses frightened by a thunder storm 1796
Watercolour: 52.7 × 74.3
Prov: G.P.Fores
Lit: W.Shaw Sparrow, *A Book of Sporting Painters*, 1931,
p.40
Lent by S.C.Whitbread Esq.

A realistic study of fear and movement in horses. A
preliminary sketch for the Diploma Picture Gilpin
presented to the Royal Academy in 1797.

329 Stallions startled by a passing hunt 1795
Watercolour: 52.7 × 74.3
Lent by S.C.Whitbread Esq.

330 Sketch of two gentlemen on horseback
Watercolour and chalk: 42 × 62.9
Prov: John 6th Duke of Bedford; by descent
Lent by the Trustees of the Bedford Estates

331 Hunting scene
Watercolour: 40 × 57.4
Prov: John 6th Duke of Bedford; by descent
Lent by the Trustees of the Bedford Estates

Thomas Rowlandson 1756–1827

For biography see p.138.

**332 Women's cricket match at Balls Pond, Stoke
Newington, 1811**
Watercolour: 22.8 × 34.2
Lent by the Marylebone Cricket Club

The match was played between eleven of Surrey and
eleven of Hampshire for 500 guineas.

Julius Caesar Ibbetson 1759–1817

Great friend of George Morland and had a similarly hard life being often in debt. Painted mainly landscapes and figures.

333 Woodcock shooting
Watercolour: 14 × 17.8
Private collection

Samuel Howitt 1765–1822

For biography see p.140.

334 The earth stopper
Ink and watercolour: 23.5 × 35.5
Private collection

The earth stopper's job was to close all known fox earths, or refuges, before a hunt.

T. Blake *fl.*1821–1831

In 1821 C. Turner engraved a 'singerie' subject by T. Blake entitled '*The Duellists*', showing monkeys duelling with pistols. In 1831, while living at 22, Clarence Gardens, Regents Park, T. Blake exhibited at the Society of British Artists a portrait of –. *Westcar Esq.* These meagre facts are regrettably all that is known about this painter, who possessed considerable ability, to judge from the brilliant observation of character and feeling for character in the picture below, his only surviving work.

335 Interior of the Fives Court with Ned Turner and Jack Randall sparring
Watercolour with body colour: 46.3 × 66
Private collection

This watercolour has become well known in the form of a coloured aquatint published after it in 1825 by C. Turner, 'dedicated to the Noblemen, Gentlemen, Patrons and Lovers of the Art of Self Defence'. It provides one of the most complete and vivid evocations of the Regency prize ring that we possess. The Fives Court was situated in St. Martin's Street or James Street. Randall and Turner, who are shown sparring in the four foot high ring, had previously fought thirty-four rounds on Crawley Downs. A key exists to the picture, in which the other characters shown are said to include Ward, Spring, Larkin, Cribb, Richmond and J. and T. Belcher.

Jacques-Laurent Agasse 1767–1849

For biography see p.82.

336 Oxford Races, after running
Watercolour, highlighted with gum arabic: 21.6 × 29.1
Private collection

Original drawing for the aquatint published 1807.

Henry Alken 1785–1841

For biography see p.93.

The Leicestershire Covers:

337 The Meeting, Kirby Gate

338 Breaking cover, Billesdon Coplow

339 Full cry, Whissendine Pasture

340 The Death, View of Kettleby
Pencil with coloured washes: 20.3 × 69.8
Set of four: the original drawings for the prints published in 1824
Private collection

Covers, or coverts, are known lurking-grounds of foxes.

Sefferin Alken 1821–1873

Son of Henry Alken Senior, see p.93. He painted watercolours in his father's style.

341 Shooting: going out
342 and the return
Pair of watercolours over pencil: 26.7 × 35
Private collection

BOOKS

343 Tennis: M. Merian

*The True Effigies of our most Illustrious Soveraigne Lord,
King Charles, Queene Mary, with the rest of the Royall
Progenie*
London, for John Sweeting, 1641, 4to
On page 10 is an etching of 'The high borne Prince James
of York' – the future King James II – at the age of eight on
a 'real' tennis court, with a racket in his hand
Signed: *M. Merian I* [invenit], probably Matthäus Merian,
the younger
Lent by the British Library (C.38.f.10)

344 Angling: Pierre Lombart (?)

Izaac Walton. *The Compleat Angler*
London, T. Maxey for Rich. Marriot, 1653, 12mo
The first edition of the most famous of English sporting
books. There is an engraved cartouche on the title-page
and six small copperplates of fishes in the text. They have
been attributed to Pierre Lombart
Lent by the British Library (G.2295)

345 Horsemanship: Abraham van Diepenbeeck

William Cavendish, Duke of Newcastle. *Methode et
invention nouvelle de dresser les chevaux*
Antwerp, Jacques van Meurs, 1658, fol
The first edition of the first scientific English work on
horsemanship, translated into French when the author
was in exile with Charles II. The numerous double-page
plates were engraved after Abraham van Diepenbeeck
Lent by the British Library (64.i.14)

346 Otter-hunting: Francis Barlow

Richard Blome. *The Gentleman's Recreation.
In two parts; the second part treats of horsemanship,
hawking, hunting, etc.*
London, S. Roycroft for R. Blome, 1686, fol
With engravings after various artists, that of Otter-hunting
being by Nicholas Yeates after Francis Barlow
Lent by the British Library (G.7428)

347 Horsemanship: Abraham van Diepenbeeck

William Cavendish, Duke of Newcastle. *A General
System of Horsemanship*
London, John Brindley, 1743, fol
The first edition in English, with the original plates
considerably re-worked
Lent by the British Library (64.i.4)

348 Fencing: James Gwyn

Domenico Angelo, *L'Ecole des armes*
London, R. & J. Dodsley, 1763, obl. fol
The plates by James Gwyn were engraved on copper by
John Hall, William Wynne Ryland, Charles Grignion and
others. Angelo was a London fencing master. He posed for
the principal figure in every plate. This is King George III's
large paper copy
Lent by the British Library (3 Tab. 58)

349 Anatomy of the horse: George Stubbs

George Stubbs. *The Anatomy of the Horse. including A
particular Description of the* BONES, CARTILAGES, MUSCLES,
FASCIAS, LIGAMENTS, NERVES, ARTERIES, VEINS, *and* GLANDS.
In Eighteen TABLES, *all done from* NATURE. *By George Stubbs,
Painter*
London: Printed by J. PURSER, for the AUTHOR, 1766, fol
In 1759, Stubbs moved to London to find an engraver to
engrave the drawings he had made at Horkstow (nos. 326,
& 327). This proved to be impossible, and Stubbs himself
engraved all the plates, and saw the book through the
press
Lent by the Royal Academy

350 The Chase: Bewick

William Somerville. *The Chase. A poem*
London, W. Bulmer & Co., 1796, 4to
All the designs but one are by John Bewick. He died in
1795 and they were engraved on wood by Thomas
Bewick. The dedication copy to King George III printed
on vellum
Lent by the British Library (C.7.c.12)

351 Swordsmanship: Thomas Rowlandson

Thomas Rowlandson. *Hungarian & Highland Broad
Sword designed and etched under the direction of Messrs
H. Angelo and Son, fencing masters to the Light Horse
Volunteers*
London, H. Angelo, 1799, obl. 4
In this book, with its coloured etchings by Rowlandson,
Harry Angelo, son of Domenico, turned his fencing
knowledge to the more serious problems of repelling
Napoleon's invading armies
Lent by the British Library (59.d.12)

352 Field Sports: Samuel Howitt

*Orme's Collection of British Field Sports Illustrated. Twenty
beautifully coloured engravings from designs by S. Howitt*
London, Edward Orme, 1807, obl. fol
Coloured aquatints by Clark, Merke, Godby and Vivares
The majority of the plates are of shooting or hunting
scenes
Lent by the British Library (3 Tab. 18)

353 Boxing : Anonymous

[Pierce Egan.] *Boxiana : or sketches of antient & modern pugilism*
London, G. Smeeton, 1812, 8ᵛᵒ
The engravings are unsigned. The frontispiece shows 'Thomas Cribb, the Champion of England' and the facing engraved title-page has a vignette of Humphries v Mendoza
Lent by the British Library (7920.g.30)

354 Bull Baiting : Henry Alken

Henry Alken. *The National Sports of Great Britain*
London, Thomas McLean, 1821, fol
Fifty hand coloured aquatints by I. Clark after Alken. The first of the two Bull Baiting plates is shown
Lent by the British Library (C.70.i.6)

355 Boxing : Robert Cruikshank

Annals of Sporting and Fancy Gazette ; a magazine. 2, vol. 11, July to December 1822
London, for Sherwood, Neely, and Jones, 1822, 8ᵛᵒ
Most of the coloured engravings which appeared in the first four volumes of the Annals of Sporting are by Henry Alken, but 'A Visit to the Fives Court', showing a prize fight between Neal and Spring, was designed and etched by Robert Cruikshank
Lent by the British Library (L.R.226.a)

356 Driving : Henry Alken

Nimrod [C. J. Apperley]. *Memoirs of the Life of the late John Mytton, Esq.* Second edition
London, Rudolph Ackermann, 1837, 8ᵛᵒ
With colour plates drawn and etched by H. Alken, aquatinted by E. Duncan. 'What! never upset in a gig?' shows Mytton repairing this omission on the part of a nervous passenger
Lent by the British Library (C.70.f.15)

357 Deer Stalking : Edwin Landseer

William Scrope. *The Art of Deer Stalking*,
London, John Murray, 1839, 8ᵛᵒ
Illustrated by engravings and lithographs. The frontispiece and engraved title-page are engraved by Thomas Landseer after Sir Edwin Landseer
Lent by the British Library (C.70.f.12)

358 Salmon Fishing : Sir David Wilkie

William Scrope. *Days and Nights of Salmon Fishing in the Tweed*
London, John Murray, 1843, 8ᵛᵒ
Illustrated by lithographs and wood engravings by various artists and engravers. 'Working the net' is lithographed by L. Haghe after Sir David Wilkie
Lent by the British Library (C.70.f.13)

359 Cricket : George Frederick Watts

[Nicholas Wanostrocht]. *Felix on the Bat*
London, Bailey Brothers, 1845, 4ᵗᵒ
With coloured engravings by G. F. Watts
Lent by the British Library (785.i.32)

360 Hunting : John Leech

R. S. Surtees. *Handley Cross ; or, Mr Jorrocks's Hunt. With illustrations by John Leech*
London, Bradbury and Evans, 1854, 8ᵛᵒ
'Mr Jorrocks', says the preface 'having for many years [since 1843] maintained his popularity, it is believed that, with the aid of the illustrious LEECH, he is now destined for longevity'
Lent by the British Library (C.70.d.3)

OBJECTS

361 The Rules of Cock Fighting
Frame: 45.8 × 34.2
Private collection

A frame containing a handwritten list of 'The Rules and Orders of Cocking' surrounded by the needle-sharp spurs attached to the cock's feet, and some cock's plumes.

> The | Rules and Orders of Cocking |
> 1. All cocks to fight with faire hacket and | metal sharpe.
> 2. All cocks to fight with spurs girte of same | length.
> 3. There to be in all Pits as follows: |
> One Master |
> Two Wardens |
> One holder of Stakes |
> 4. All fines and dues to be paid to the Master | of the Pit.
> 5. All harsh words and disputes shall be taken before the Master.
> 6. The word of the Master to be taken as final | in all cases.
> 7. All members of the Main shall paye forty | shillings a year for the up keep of the Pit | .
> 8. No cock's eye to be blinded under penalty | of forty shillings
> 9. No pricks or goads to be used under penalty | of twenty shillings.
> 10. All Pits to be of same size – nine feet | circle | .
> 11. No dogs or other beasts shall be allowed | in the Main | .
> 12. Any man who makes a wager and losses but | payes not and makes another wager, he shall | be put in a basket and hung up to the edge of | the Pit where all men may see him and there | he shall remain until the end of the session when | he shall be cut down and banished from the | Main | .
> 13. Anyone who has been banished from the Pit | shall not again enter without word from the | Master.
> 14. No cock with wing clipt shall fight with | a conck with wings not clipt.
> 15. The master of the Main shall be chosen by ballot | .
> 16. The Master shall sit above all men on a | railed chair | .
> 17. All new comers to the Pit shall first go | before the Master. |
> 18. The same rules to be used | in all Pits. |
> These rules have been signed | and sanctioned by Mr Ardesois, |
> St. James Park London. |
> The forth day of June, in |
> the year One Thousand Seven |
> Hundred and fifty six |
>
> John Ardesois

362 A fighting cock container
Octagonal, height: 76.2 circumference: 61
Private collection

The fighting cock container is accompanied by a set of fighting spurs. See no. 361 for the rules of cock fighting.

363 Mantrap
Metal; height: 17.8 length: 67.7 width: 53.3
Private collection

The severe game laws allowed the use of mantraps and spring guns to catch poachers.

Index of Lenders

References are to catalogue numbers.

General Index

of artists and authors whose work is represented in the exhibition. Sitters, places and animals named in titles are included. The index is not exhaustive. References are to page numbers.